Rowlandson Drawings
from the Paul Mellon Collection

ROWLANDSON DRAWINGS

FROM THE PAUL MELLON COLLECTION

By John Riely

An Exhibition

YALE CENTER FOR BRITISH ART · NEW HAVEN

16 November 1977 to 15 January 1978

ROYAL ACADEMY OF ARTS · LONDON

4 March to 21 May 1978

This catalogue was composed in Fournier types by Michael Bixler,
plates printed by the Meriden Gravure Company and text by Eastern Press, Inc.
on Mohawk Superfine papers, bound by the Mueller Trade Bindery,
and designed at the Yale University Printing Service.

Preface

Although eighteenth-century England produced an unusually large and diverse group of competent draughtsmen, none was more accomplished or prolific than Thomas Rowlandson. The blend of wit and feeling with which he portrayed the life and manners of his time was uniquely his own, and the countless drawings he produced, from which he derived his livelihood, are equally interesting to us today as social documents and as creations of beauty and sophistication. In subject matter his works range from humorous vignettes showing the activities of everyday life to the more serious topographical views of the places he visited. His exuberant and flowing contours owe much to French, and particularly Rococo, art, but his handling of tone, with its carefully muted effects, and his accumulation of detail belong to an English tradition of illustration that begins at the time of Hogarth. Rowlandson's art stands midway between the *tableau vivant* of Hogarth and the topical caricatures of Cruikshank, his earthy humor being as much a part of his age as the earnest strivings for beauty and truth in other realms—science, literature, and the art of painting practiced in the Royal Academy.

This exhibition of 120 drawings from the Paul Mellon Collection of Rowlandson's works—many of which are now housed in the recently opened Yale Center for British Art in New Haven and are freely available for the first time to interested students—has two purposes. The first is to demonstrate the variety and range of the artist's drawings in relation to his stylistic development. The Mellon Collection makes such an endeavor possible because of its size—presently some 400 drawings—and because of the quality of individual examples. The second purpose is to mark the publication of the fully illustrated *catalogue raisonné* of the Collection written by John Baskett and Dudley Snelgrove, who in recent years have had an instrumental part in assembling the Collection. The plates alone will ensure this volume its place as a valuable reference work for anyone interested in the artist or the period.

In view of this significant contribution to the literature on Rowlandson, and the general enthusiasm for Rowlandson's work shown over the years by the English public, it is a source of pride and pleasure for the Center to be able to send the exhibition to England. We are grateful to the Royal Academy of Arts for agreeing to show the exhibition, and are confident that on their walls the drawings will receive the wider exposure which they fully deserve but have never enjoyed.

Many people have helped with the organization of the exhibition. It is to Paul Mellon's generosity that we owe the two beautiful catalogues and the opportunity to ship the exhibition to England. Both he and his staff, in particular Beverly Carter, have enthusiastically supported the project from its inception and have given essential assistance by providing photographs and documentation. We must also gratefully acknowledge our debt to John Baskett and Dudley Snelgrove for their catalogue, which served as the starting point for the exhibition. The selection of the drawings to be shown was made by John Riely, Associate Research Editor of the Yale Edition of Horace Walpole's Correspondence, who is responsible for the excellent catalogue of the exhibition, containing many new ideas about the chronology of Rowlandson's drawings and his use of earlier sources. Since Dr. Riely took on the job in addition to his regular duties as a Walpole editor and was obliged to carry out the work entirely in his free time, he deserves our special thanks. We also wish to express our gratitude to Sidney Hutchison, Secretary of the Royal Academy of Arts, who has been a most cooperative and helpful co-sponsor of the exhibition; to John Peckham and Donald Dehoff of the Meriden Gravure Company, which produced the outstanding plates for both the catalogues; and to Greer Allen, University Printer, who not only designed the handsome catalogue for the exhibition but oversaw its production with unfailing dedication.

EDMUND P. PILLSBURY
Director
Yale Center for British Art

Introduction

Thomas Rowlandson was born in Old Jewry in July 1756,[1] the son of a respectable London wool and silk merchant. His father's speculations in textile manufacture during the next two years proved disastrous, for in 1759 William Rowlandson found it necessary to declare bankruptcy. James Rowlandson, William's brother, and his wife Jane (née Chevalier) assumed responsibility for raising and educating their nephew Thomas and his younger sister Elizabeth. On the death of her husband in 1764, Jane Rowlandson moved to Soho and Thomas attended Dr. Barvis's academy in Soho Square, an establishment of considerable distinction. Rowlandson is said to have displayed a precocious talent for drawing at an early age. At all events, he was admitted to the recently founded Royal Academy Schools in November 1772, when he was sixteen. Stories of his pranks and high spirits are retailed in Henry Angelo's *Reminiscences* —an important source of biographical information, even though not a model of accuracy. Angelo also tells us that he first met Rowlandson when the latter was 'studying in the French school' at Paris during the summer of 1774. While there is no documentary evidence of Rowlandson's receiving formal training there, it seems clear that he visited France around this time at least long enough to become exposed to French art.

In 1775 he exhibited for the first time at the Royal Academy. The catalogue lists a drawing entitled *Dalilah payeth Sampson a visit while in prison at Gaza*, a biblical subject which apparently has not survived. Rowlandson was then still living in Soho with his aunt, but by 1777 he had secured lodgings of his own in Wardour Street. In this, the penultimate year of his enrollment as a student, he was awarded the Academy's silver medal in recognition of his achievements as a draughtsman. The same year he began his lifelong friendship with John Bannister, who had entered the Academy schools but left soon afterwards for a career on the stage at Drury Lane. If the inscription on a small sketch in the Mellon Collection is to be credited, Rowlandson paid another visit

1. His birth date is variously given as 1756 or 1757; the weight of evidence favors 1756. See John Hayes, *Rowlandson Watercolours and Drawings* (London, 1972), p. 13. The outline of Rowlandson's life in Hayes, pp. 13–27, is the most accurate account available. A more detailed but in many respects less informative account is given in Bernard Falk's *Thomas Rowlandson: His Life and Art* (London, [1949]). Documentation for the biographical summary given here can be found in Hayes except as noted. I am much indebted to his essay.

to France in 1778,[2] and he again travelled on the Continent for some time during the early 1780s. Up to this point his exhibits at the Academy were mostly small whole-length portraits, perhaps showing the influence of John Hamilton Mortimer, whom he was considered to rival in figure drawing. Unfortunately, documented works from the early 1780s are unknown today, so that it is impossible to explain precisely the shifts in style which led to the *Place des Victoires*, exhibited at the Society of Artists in 1783, and to *Vauxhall Gardens* (Catalogue No. 4) and *The Serpentine River*, shown at the Royal Academy the following year. Though his development had proceeded gradually, Rowlandson seems to emerge suddenly at the height of his powers while still in his twenties.

His friendship with Henry Wigstead comes into focus at the time of an excursion they made together to the Isle of Wight in the fall of 1784. The extensive series of drawings that resulted from the tour brilliantly demonstrates the versatile technique and varied subject matter that Rowlandson could now command. Wigstead himself was an amateur artist given to caricature, and his artistic relations with Rowlandson are of sufficient interest to warrant a brief digression on the subject.

A well-to-do, hospitable man perhaps ten years older than Rowlandson, Wigstead was also living in Soho in 1785. On his death in 1800 he was described as being 'of Kensington, an active magistrate for the county of Middlesex. He was a man of considerable talent, and contributed to the celebrity of the Brandenburgh theatre both by his pen and his pencil. He was a good caricaturist, which naturally made him more enemies than friends.'[3] Yet Wigstead, as an artist, is an extremely elusive figure. His style of drawing seems to have been very similar to that of Rowlandson—so similar, in fact, that a newspaper critic of the Royal Academy exhibition of 1785 accused Wigstead of exhibiting drawings by Rowlandson under his own name.[4] One of these works, *John Gilpin's Return to London* (signed 'H Wigstead 1785'), is now in the Victoria and Albert Museum.[5] If indeed the drawing is entirely by Wigstead's hand, it is easy to see why the critic became suspicious: the technique and handling immediately call to mind Rowlandson.

A drawing of the interior of the Brandenburgh House Theatre, in a rather different style but given to Wigstead, is in the Mellon Collection. At the exhibition of *Caricatures et mœurs anglaises 1750–1850* at Paris in 1938, No. 138 was a watercolor, said to be jointly by Rowlandson and Wigstead, entitled *The Coach Booking Office*; Wigstead allegedly contributed some of the figures. The Metro-

2. See John Baskett and Dudley Snelgrove, *The Drawings of Thomas Rowlandson in the Paul Mellon Collection* (London, 1977), No. 117. The drawing is inscribed in pencil *A French Nobleman in his Shooting dress—sketched at Boulogne 1778*.

3. *Gentleman's Magazine*, 70, Part 2 (Oct. 1800), 1007–08.

4. See *St. James's Chronicle*, 17–19 May 1785 (quoted in William T. Whitley, *Artists and their Friends in England 1700–1799* [London, 1928], II, 396–97).

5. Repr. Hayes, p. 45, Fig. 41.

politan Museum of Art has two watercolor versions of *The Tithe Pig*, a subject that was etched and first published in 1786 after a design by Wigstead; the versions are different enough from each other to suggest that Wigstead may have been responsible for the weaker one. In the Huntington Collection there is a political caricature signed (genuinely) 'H Wigstead invent' but very close in style to Rowlandson.[6] Wigstead was the designer of the famous *Bookseller and Author* and *Box Lobby Loungers* according to the inscriptions on the prints, but drawings of both subjects indisputably by Rowlandson are extant.[7] The late Iolo Williams has written: 'No doubt Wigstead's original drawings were amateurish and Rowlandson merely appropriated the ideas they contained; but it seems going rather far to exhibit the result as by Wigstead. I have never seen an undoubted drawing by the latter.' John Hayes, on the other hand, does not doubt Wigstead's authorship of *John Gilpin's Return to London*, and notes that 'his work can be detected by the thin, less supple quality of his pen line and by the comparative emptiness of his characterization.'[8] The fact is that we still lack sufficient evidence to make confident attributions to Wigstead. The extent of his collaboration with Rowlandson remains uncertain.

To return to Rowlandson's career: his first important foray into political caricature was made during the hotly contested Westminster Election of 1784. Though he continued to turn out political prints fairly regularly, they make up the least memorable part of his *oeuvre*—not simply because the issues themselves are long forgotten, but because the essential ingredients of personal conviction and *saeva indignatio* are usually missing. It is here that Rowlandson parts company with his friend and fellow artist James Gillray, perhaps the most virulent political satirist that England has ever produced.[9] Indeed, the question of whether Rowlandson can properly be described as a satirist at all is one that must be confronted later on.

In 1786 Rowlandson exhibited five drawings at the Royal Academy, including *The English Review* and *The French Review*, two of the most ambitious and carefully executed compositions he ever undertook. They were evidently purchased before the exhibition by the Prince of Wales (later George IV), a sure sign of Rowlandson's growing reputation. He entered four works in the

6. Repr. Robert R. Wark, *Rowlandson's Drawings for a Tour in a Post Chaise* (San Marino, 1964), p. 22, Fig. 3. See also ibid., pp. 4–5, 17, 20; Frank Davis, 'Wigstead—Thomas Rowlandson's Artist Friend,' *Illustrated London News*, 189 (12 Sept. 1936), 452.

7. A watercolor version of *Bookseller and Author*, said to be by Wigstead, was sold at Sotheby's on 7 July 1977, lot 180 (repr.). There is still another version in the collection of Philip Pinsof, and a copy by a different hand in the Mellon Collection (Baskett and Snelgrove, No. 193).

8. Williams, *Early English Watercolours* (London, 1952), p. 138; Hayes, p. 44.

9. Rowlandson did, however, collaborate with Gillray on a small number of political prints.

1787 exhibition, but no more thereafter. Perhaps, as one critic has surmised, the Academy's standards were no longer his, or he became too preoccupied with work for the printsellers.[10] Neither explanation seems altogether satisfactory. His exhibited drawings had received favorable notice in the public press, and there can be no doubt that he sought an audience and new patrons for his work. Whatever the reason for his ceasing to exhibit, it is probably no coincidence that the last of his very large 'spectacle' drawings, *The Prize Fight* (No. 14), dates from 1787. In this year his address changed to 50 Poland Street and he made another trip to France. There he is supposed to have contracted an 'uncontrollable passion for gaming.' When his aunt died in 1789, leaving him what amounted to about £2,000 (a considerable sum for the time), he indulged his passion until he went into debt. We are assured, however, by the person who wrote his obituary—a friend of over forty years—that Rowlandson was 'scrupulously upright' in money matters; after losing heavily at the tables, he would return home, 'sit down coolly to fabricate a series of new designs, and . . . exclaim, with stoical philosophy, "I have played the fool; but (holding up his pencils) here is my resource."'[11]

A trip to Brighton with Wigstead in 1789 yielded a number of drawings that were etched and published, with a commentary by Wigstead, the following year. During the next decade, Rowlandson seems to have weathered a series of ups and downs. Gambling losses may have forced him to seek more modest quarters; he moved several times, occupying the basement of No. 2 Robert Street, Adelphi, in 1793–95. For a while he had rooms next to Morland, the painter, notorious for his intemperate ways. Finally, in 1800, he moved to the attic apartment of No. 1 James Street, in the Adelphi, where he passed the remaining twenty-seven years of his life.

A good deal of time in the 1790s was evidently spent travelling on the Continent, where the cost of living was generally lower. One of the trips, probably in 1794, was made in the company of Matthew Michell, a wealthy banker who by then had become Rowlandson's chief patron. On that tour at least two of his most elaborate topographical views were made for Michell, 'a good-natured and liberal man'[12] who after Wigstead's death in 1800 must have assumed a special place in Rowlandson's affections. Michell amassed a collection of more than five hundred drawings by Rowlandson, and he entertained the artist on numerous occasions at his house outside London and on his country estate in Cornwall.

10. Ronald Paulson, *Rowlandson: A New Interpretation* (London and New York, 1972), p. 121, n. 21.

11. *The London Literary Gazette*, No. 536, 28 April 1827, p. 268. This obituary was reprinted, with minor modifications, two months later in the *Gentleman's Magazine*, 97 (June 1827), 564–65. The anonymous writer may have been Henry Angelo or John Thomas Smith, probably the latter.

12. John Thomas Smith, *A Book for a Rainy Day* (London, 1845), p. 101.

'For many years,' writes Rowlandson's obituarist, 'for he was too idle to seek new employment, his kind friend, his best adviser, Mr. Ackermann, supplied him with ample subjects for the exercise of his talent.' Rowlandson's association with the enterprising bookseller and publisher Rudolph Ackermann, whose 'Repository of Arts' in the Strand was a lively meeting place for artists, began about 1797. From then, off and on, until 1822, Rowlandson drew hundreds of designs to illustrate works published by Ackermann, as well as making numerous drawings that were etched and sold as individual prints. Among the first fruits of this employment were the six *Views of London* (the 'Turnpike' series, issued in 1798) and the *Loyal Volunteers of London and Environs* (1799). The more important later productions include *The Microcosm of London* (1808–10, in collaboration with A. C. Pugin), the three *Tours of Doctor Syntax* (1812–21), *The English Dance of Death* (1814–16), *The Dance of Life* (1817), *The Vicar of Wakefield* (1817), and *The History of Johnny Quae Genus* (1822).

The work Rowlandson did for Ackermann was invariably more inventive and refined than that which he undertook for Thomas Tegg, in Cheapside, whom he supplied with vast numbers of caricatures from 1807 onwards. Many of the elegant aquatints bearing Ackermann's imprint were produced at the same time as the crude potboilers handled by Tegg. This situation, however contradictory it may seem to us today, represents the basic fact of Rowlandson's professional life during his later career.

Our knowledge of his personal life in these years is extremely slight, one reason being that only three letters from his entire correspondence have come to light. One of them, written in 1804 to the engraver James Heath, makes reference to his being 'poor' and having 'little sway . . . with the long pursed gentry.' Another letter was written in 1820 from Grove House, where he was visiting Matthew Michell's widow (Michell had died three years earlier), and was sent to a mutual acquaintance, Mrs. Landon. Rowlandson's easy, sociable nature is attractively displayed as he passes on news of Mrs. Michell's health and chats about various friends of the family.[13] The third letter is addressed to his intimate friend Henry Angelo, the famous fencing master, and is printed here for the first time:[14]

> *Friend Angelo*
> I find the Bill you mentioned becomes due the 27th July—. which being near at hand agreable to request, I give you notice—I got it discounted at Hodsolls & Sterling— – – I hope your finances are prepared for it, for myself I am so poverty struck I ⟨can⟩ afford no assistance. I met our Fr⟨iend⟩ Bannister at Captn Gilstons. he is now

13. The first letter is reproduced in Falk, facing p. 36, the second in Hayes, pp. 24–25. See Bibliography for detailed citations.
14. MS in the collection of the late Hugh D. Auchincloss, Washington, D. C.

⟨at⟩ South end. on his return to town says he shall take an early opportunity of forming a Jovial Trio—if we three jolly Dogs be—that we may still live and enjoy each others society is the hearty wish of your Sincere Old Friend

Tho? Rowlandson

Tuesday 18th July 1815.

If the manuscript did not exist to confirm its authenticity, we might almost suspect the text of being a parody. For here is 'Rolly,' hail-fellow-well-met among his comrades Angelo and Bannister, just as we should have liked to imagine them: 'three jolly Dogs.'[15] This, it appears, is really how they thought of each other. The letter also reinforces the impression left by his earlier letter to Heath, that his day-to-day existence was, and continued to be, financially precarious.

Evidence from surviving drawings suggests that Rowlandson visited Paris in 1814 and went to Italy for a period after 1820. In his last years, before he fell seriously ill in 1825, much of his time was devoted to studies of classical art and comparative anatomy. He died on 21 April 1827, aged seventy, having never married nor (so far as is known) had children. Considering that he was a strong and reasonably handsome man (Bannister's profile sketch, reproduced here, shows him in his late thirties), with a healthy interest in the opposite sex, his bachelorhood seems odd. On the other hand, he is certain to have had numerous *liaisons*,[16] and during his later years a woman named Betsey Winter lived with him as a companion and housekeeper. She evidently regarded herself, at least after his death, as his wife, and she inherited his property.

The several editions of *Doctor Syntax* published in 1812 and following years mark the heyday of Rowlandson's popularity. He was undoubtedly one of the best known artists of his time. Yet it is clear from the remarks made by two of his closest friends soon after his death that his contemporary fame rested very largely on one aspect of his *oeuvre*, the caricatures. 'It should be repeated,' his obituarist wrote, 'that his reputation has not been justly appreciated. . . . No artist of the past or present school, perhaps, ever expressed so much as Rowlandson, with so little effort, or with so small and evident an appearance of the absence of labour.' And Angelo noted in his *Reminiscences* that 'Every one at all acquainted with the arts, must know well the caricature works of that very eccentric genius, Rowlandson; the extent of his talent, however, as a draughtsman, is not so generally known. . . . His powers, indeed, were so versatile, and

15. Joseph Grego, in *Rowlandson the Caricaturist* (London, 1880), II, 418, records a drawing by Rowlandson, in the collection of W.T.B. Ashley, deceased, inscribed 'We three Cunning Dogs be.'
16. A suggestive exchange of notes with a woman named Bess appears on the mount (dated 1795) of a drawing in the Mellon Collection. See Catalogue No. 57.

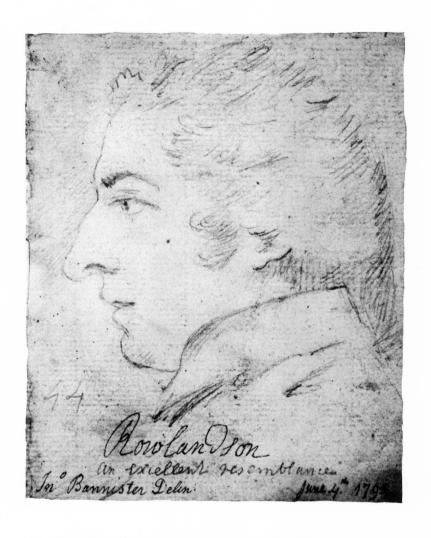

John Bannister (1760–1836): *Portrait of Thomas Rowlandson.*
Signed, dated 4 June 1795, and inscribed. Pencil, 5¼ × 4 in. (134 × 102 mm).
Collection of the late Hugh D. Auchincloss, Washington, D.C.

his fancy so rich, that every species of composition flowed from his pen with equal facility.'[17]

During most of the Victorian era, his reputation was almost totally eclipsed. Thackeray, who has much to say about Hogarth in *The English Humourists* (1853), does not mention Rowlandson.[18] Those who had any familiarity with his work recalled only the *outré* caricatures. Even such an astute and usually temperate critic as William Michael Rossetti elaborated this view:

> Rowlandson, whose water-colours and aquatints are continually
> turning up, and whose 'Dr. Syntax' may be more especially cited, had
> less virulence of feeling and less comicality than Gillray, but fully
> emulated him in the gross overdoing of his personations. In his hands,
> a work-a-day company of human beings, among whom anybody
> might find himself to-morrow, is a conclave of ghouls and ogres; a fat
> person is a mass of shaking blubber, a lean one a living skeleton; and
> the wretches will be howling, stamping, leering, and grovelling in
> brutalism, at the slightest provocation. There was a meagreness in the
> mind and artistic style of Rowlandson which tried to mask itself in all
> this bluster.[19]

As Osbert Sitwell has shrewdly pointed out, Rowlandson's chief sins in the eyes of the Victorians—other than the 'lewdness' of his subject matter—were his supposed indifference to the physical suffering of others and his making fun of people's faces and bodies.[20]

In 1869 William Bates, a professor of classics at Queen's College, Birmingham, and an enthusiastic admirer of Rowlandson's work, observed that 'even among artists and professed "picture-men," few in London, none out, have ever heard of his name.'[21] But signs of new interest began to appear during the 1870s, and towards the end of the decade Bates could write:

> The due appreciation of Rowlandson is yet to come. From their mere
> *vis comica*, his etchings and drawings have always found collectors; but
> as an artist, the world has been slow to recognise his higher merits. A
> comprehensive essay upon his life, times, and genius, long wanted, has
> been recently announced; and due justice may at length be done to his
> marvellous powers.[22]

17. *Reminiscences of Henry Angelo* (London, 1828–30), I, 233.

18. It may be further noted that Hazlitt and Lamb, who published essays on Hogarth during Rowlandson's lifetime, make no reference to him.

19. *Fine Art, Chiefly Contemporary: Notices Re-printed, with Revisions* (London and Cambridge, 1867), pp. 284–85. Rossetti was reviewing an exhibition of works by John Leech held in 1862.

20. Sitwell, 'Thomas Rowlandson,' in *Sing High! Sing Low!* (London, 1944), p. 128.

21. *Notes and Queries*, 4th Series, 4 (2 Oct. 1869), 278.

22. *George Cruikshank: The Artist, the Humourist, and the Man* (London and Birmingham, 1878), p. 4.

The 'comprehensive essay' was Joseph Grego's *Rowlandson the Caricaturist*, published in two volumes in 1880. This massive work is primarily a catalogue of the thousands of prints etched by Rowlandson or after his designs. Though Grego hoped to rehabilitate Rowlandson's reputation by providing a full record of his graphic production, the book perpetuated the prevailing view of Rowlandson as merely a caricaturist—as indeed Grego's title would indicate. To be sure, the majority of Rowlandson's engraved subjects *are* caricatures or broadly comic scenes, and these, in any event, were what Grego usually chose to reproduce as illustrations.

A significant shift in attitude did not in fact occur until early in this century, around the time that Selwyn Image published an article in the *Burlington Magazine* entitled 'The Serious Art of Thomas Rowlandson.' Image's brief essay is by no means remarkable for penetrating insight into Rowlandson's 'serious' drawings, but it is noteworthy for its insistence that Rowlandson, at his best, was a master of composition, movement, aesthetic grace, and color—'one of the great masters of our English School.'[23] Paul Oppé, in the introduction to his book on Rowlandson's drawings and watercolors (1923), offered the first, and in many ways still the most incisive, appraisal in depth of Rowlandson's strengths and weaknesses as a draughtsman. By then several important Rowlandson collections had been formed in which caricature drawings were present but did not predominate. Over the past fifty years, the efforts of scholars have been primarily directed towards more specialized problems of connoisseurship and stylistic analysis, using information gleaned from new research into Rowlandson's biography and the influence of other artists on his work.

His drawings are perhaps held in even higher regard today than during his own lifetime, yet in the general mind he remains first and foremost a caricaturist. Although there is good reason to believe that this may always be so, one of the purposes of the current exhibition is to suggest, without begging the question, the much wider range and variety of his achievement as a draughtsman. Another purpose is to provide a survey of Rowlandson's stylistic development, by ascertaining the dates of the selected drawings as precisely as possible and placing them in chronological order. The Mellon Collection of Rowlandson is now of sufficient size and strength to make such a conspectus feasible. While it cannot claim to encompass every aspect of Rowlandson's art, it is a broadly representative collection that contains many splendid, even spectacular, examples. Individual preferences are bound to vary, but an attempt has been made to include as many as possible of the 'best' drawings in the collection, given the primary aims and extent of the exhibition. Here will be found landscapes and topographical views, sporting and marine subjects, designs for book illustrations or other connected series, genre scenes and grotesques.

23. 'The Serious Art of Thomas Rowlandson,' *Burlington Magazine*, 14 (Oct. 1908), 5.

The earliest drawing in the exhibition dates from about 1778–80, or short-ly after Rowlandson completed study at the Royal Academy; the latest drawing was probably made in 1825, perhaps just before the onset of his final illness. In discussing Rowlandson's style, it is customary to say that it 'remained consistent, without any particular growth or development.'[24] This generalization, like most others, contains a substantial element of truth, but it has tended to discourage efforts to define the subtle and gradual changes that did take place. The art-historical challenge of establishing a Rowlandson chronology was taken up almost forty years ago in a pioneering article by Richard M. Baum.[25] Baum divided the drawings into three periods—early (1774–90), middle or transitional (1790–1800), and late (1800–27)—solely on the basis of what he observed to be three fundamental changes or stages in Rowlandson's style. The evidence which he adduced to support his argument need not be repeated here. Although formal acknowledgment of his contribution is frequently omitted, the usefulness of such an approach is generally apparent in the commentaries of more recent students and, it is hoped, will be confirmed in the present instance.

It must be recognized, nevertheless, that any attempt to describe Rowlandson's style in terms of distinct 'periods' is bound to involve a certain amount of imprecision. In his particular case, the boundaries created by these divisions, wherever they come, will be quite artificial: no dramatic change in style occurs in the year 1800, such that a drawing of 1799 will look very different from a drawing of 1801 or even 1805. Over a decade or more changes in style do become noticeable, and when this kind of evidence is weighed along with other evidence of subject matter, costume, paper type, watermark, and reproduction by published engraving, it is possible to arrive at an approximate date (within five or ten years) for most drawings. But in view of the fact that Rowlandson is likely to work in different manners at the same time, considerable caution must be exercised in assigning dates.

Rowlandson's few surviving drawings from before 1780 are strongly influenced by Mortimer, who used the dot-and-lozenge technique (hatching and stippling) of the engraver to create areas of tone in his drawings. Rowlandson imitated these mannerisms in *A Bench of Artists Sketched at the Royal Academy in the Year 1776* (coll. Denys Oppé, London), his earliest known dated drawing, and continued to do so until at least 1780. The technique can be seen again in *The School of Eloquence* (Royal Collection), etched and published in 1780. There Rowlandson exaggerates the profiles of the heads in the *caricatura* manner of Pier Leone Ghezzi and Thomas Patch, who employed a somewhat similar technique of hatching and close parallel lines in their drawings. In Rowlandson's hands, this highly linear style becomes increasingly flexible and calligraphic. The pen line varies in thickness; short, broad strokes are used for

24. Martin Hardie, *Water-colour Painting in Britain* (London, 1966–68), I, 205.
25. 'A Rowlandson Chronology,' *Art Bulletin*, 20 (Sept. 1938), 237–50.

contour, and thinner, curling lines for modelling. Although the round, flowing quality of Rowlandson's line has much in common with French rococo art, he may have learned at least as much from Canaletto, whose possible influence has been generally overlooked or ignored. Either in England or during his early travels on the Continent, Rowlandson could have seen examples of Canaletto's figure drawing, which exhibits a strikingly similar kind of line, curling and varying in thickness.[26]

All, or nearly all, of Rowlandson's very early works are line drawings without watercolor or wash, but in *A Man Driving a Team of Six Girls* (Catalogue No. 1), colored wash has been brushed over the Mortimer-like pen lines. There is no adequate explanation why Rowlandson was so slow in coming to the tinted drawing, which was current in France and in England (*vide* Paul Sandby) as early as the 1750s. Between 1780 and 1783 Mortimer's influence suddenly diminished and Rowlandson developed his characteristic method of laying decorative, transparent tints with a full brush, often over pale monochrome wash. The technique was fully perfected by the time of *Vauxhall Gardens* (No. 4) and *An Audience Watching a Play* (No. 5). In these and other drawings of the mid 1780s, contours are drawn with a very flexible reed pen charged with India ink; the line is strong and swelling, but at the same time economical and usually without additional reinforcing lines. The brush is often used exclusively to delineate background or landscape features (Nos. 15–18). Color is limited in range (primary reds and blues are common), broadly applied, and of relatively high intensity.

Towards the end of the 1780s, Rowlandson's penwork becomes slightly freer and less controlled, vigorous but in some passages rather fussy. The gradual change taking place can be seen in *A Merchant's Office* (No. 22, dated 1789). Baum's use of the word 'transitional' to characterize the 1790s is valid insofar as it suggests the more varied and complex nature of Rowlandson's draughtsmanship at this period. The line can be clean and tight, as in *Smuggling Out* (No. 35, dated 1792), or loose and spontaneous, as in *Would You Please to Have Another Cup of Tea?* (No. 40). These qualities are combined in *A Worn-out Débauché* (No. 38) to produce a work of considerable elegance and verve. Around the middle of the decade, Rowlandson begins using vermilion (often in a mixture with brown ink) to enrich his penwork, as can be seen in *The Connoisseurs* (No. 37). A thinner, sharper outline is present in some drawings of the later nineties, such as *The Concert* (No. 44); short, curved, broken contours appear in the mannered rococo landscapes of which *The Picnic* (No. 68, dated

26. Among the more notable examples for comparison are six figure studies reproduced in W. G. Constable, *Canaletto*, 2nd ed., rev. J. G. Links (Oxford, 1976), I, Pl. 159, Catalogue Nos. 839–42. See also J. L. Howgego's introduction to the exhibition catalogue *Canaletto and his Influence on London Artists* (London: Guildhall Art Gallery, 1965), p. 5.

1798) is a notable example. Warmer, pastel shades of orange, yellow-green, and brown slowly replace the brighter, cooler colors of the early drawings (Nos. 67, 71–73).

After about 1800, Rowlandson's line tends to be thin and uniform, and consequently less expressive. Initial contour lines are frequently strengthened by coarser secondary lines in vermilion ink. Robert Wark has suggested that these more complicated, worked-over contours may involve the use of different drawing instruments, one sharper or less flexible than another.[27] The wiry, more impersonal, unreinforced line seen in some later drawings, when combined with lean, attenuated proportions, as in *The Gardener's Offering* (No. 82), has an affinity with the neoclassicism of John Flaxman and Thomas Stothard. This kind of line may also occur when Rowlandson makes a tracing from an existing drawing or has in mind the requirements of the etcher. There is an increasing reliance on the brush to model the forms (No. 78). Color is likewise more sophisticated than before: washes are applied locally, one over another, creating a layered or textured effect. This technique may be observed in *The Gaming Table* (No. 77, dated 1801) and in *An Artist's Studio* (No. 101, dated 1814).

Rowlandson's final decade of activity begins in 1814 with *The English Dance of Death*, a work of extraordinary liveliness and ingenuity which, at least temporarily, belies the notion that his powers as a draughtsman were seriously in decline. But it is plainly evident that his line now requires laborious reinforcement to accomplish what had once been possible with a single calligraphic flourish. The quality of Rowlandson's output in following years is extremely uneven and variable. *Plymouth Dock* (No. 108, dated 1817) and *A Potter Going Out* (No. 119) contain penwork that is decidedly weak and flaccid; in the latter example, this deficiency is mitigated by the pretty pastel tints, which recapture some of the beauty and freshness of earlier works. In other late drawings, such as the masterly portrait of *A Sporting Cove* (No. 118), the forms are modelled by subtle touches of darker, more opaque wash; the line is tighter and much more carefully controlled—features that (interestingly enough) distinguish his studies of comparative anatomy made in the early 1820s. Just when Rowlandson appears to have lost his technical facility, and to have degenerated into repetition and mannerism, he surprises with a drawing of great directness and vitality.

In following the evolution of Rowlandson's style over a long and extremely prolific career, one cannot fail to be impressed by the overall consistency of his technique. As Wark has so aptly noted, scrutinizing his style 'is not unlike tracing the evolution of someone's handwriting over a comparable period. There are certainly changes and developments, but they operate within the

27. Wark, *Drawings by Thomas Rowlandson in the Huntington Collection* (San Marino, 1975), pp. 18, 20.

limits of a single, strong, and well-formed personality.'[28] Rowlandson's artistic temperament, fully mature by the mid 1780s, seems to have been so completely in harmony with the rest of his personality that he felt no need to change his outlook or to seek new technical means of expressing himself. And there, no doubt, lies the answer to why Rowlandson, though clearly aware of what his fellow artists were doing, did not assimilate—rather, chose to disregard—their ideas and innovations. He occasionally imitated another artist's manner or a specific work. The Mellon Collection contains a river landscape by Rowlandson, for example, that almost certainly derives from Turner's *Windsor Castle from the Thames* of ca. 1804–05,[29] and one can easily point to other such examples. But exercises of this kind must have been undertaken simply for the fun of it; Rowlandson probably did not expect to 'learn' from them.

Much has been made of Rowlandson as a visual chronicler of his era. 'To think of Regency England,' Martin Hardie has written, 'is to think in terms of Rowlandson.'[30] His drawings are in fact far less valuable to the social historian than the prints of Hogarth or Gillray or Cruikshank. He does not rival any of those artists in accurate, detailed, realistic portrayals of everyday life. Yet his drawings and etchings retain their usefulness as social documents. He provides a vivid and truthful picture of his time, although it is not a literal picture. Many more of Rowlandson's scenes are imagined or recollected than actually taken on the spot, and he is always willing (indeed, finds it difficult not) to alter, adapt, and exaggerate in order to project his larger-than-life vision of the human comedy.

Rowlandson was certainly no moralist, no social reformer. Was he even, properly speaking, a satirist? There is wide disagreement among serious critics. To some he is not only a satirist, but a bitter and merciless critic of his society; to others he is no critic at all, but rather the most normal of human beings, accepting life as he finds it.[31] To a great extent this is a question of Rowlandson's seriousness, or lack of seriousness. Does he become seriously concerned about particular social issues? Does he adopt a definite point of view? It must be admitted that, in general, he does not. On the other hand, Rowlandson is perhaps not so carefree, indifferent, or superficial as some critics would have us believe. *Comforts of Bath*, to cite only one of his most characteristic productions, is a

28. Ibid., p. 18.
29. For Rowlandson's drawing see Baskett and Snelgrove, No. 63. Turner's painting (Petworth House) is reproduced in the exhibition catalogue *Turner 1775–1851* (London: Tate Gallery, 1974), No. 80. I am grateful to Andrew Wilton for pointing out the similarity.
30. *Water-colour Painting in Britain*, I, 205.
31. See Sitwell, op. cit., p. 117; Gert Schiff, *The Amorous Illustrations of Thomas Rowlandson* ([New York], 1969), p. xxxvi; Laurence Binyon, *English Water-colours* (London, 1933), p. 71; Robert Wark, *Rowlandson's Drawings for The English Dance of Death* (San Marino, 1966), p. 10; Hayes, op. cit., p. 26.

very telling commentary on a particular aspect of English society, and is surely
'satirical' by almost any definition. Yet not satire but humor, with its amused
and broadly tolerant outlook on life, is the essence of Rowlandson's work, the
key to his continuing popularity. Brutality and ugliness may sometimes pervade
his scenes, but cheerfulness is always breaking in.

In the Widener Collection at Harvard there is a drawing by Rowlandson
that shows a large group of human heads, mostly caricatured, with a handsome
young man and woman in the center. Rowlandson has inscribed the drawing,

> It holds good through the whole scale of the creation
> That the great and the little have need one of another.

Whether the words are his own or from another source matters little. They ef-
fectively sum up the theme of the drawing and may be understood to have a
fundamental significance for Rowlandson as an artist. Everywhere in his draw-
ings we witness his fascination with the endless variety of the human species—
great and little, young and old, beautiful and ugly. But he is not an aloof ob-
server of the human drama: he is himself an eager participant. And it is this
open-armed acceptance and enjoyment of his fellow man, expressed in his
bounding line and flowing form, that makes his art so universally appealing.

ACKNOWLEDGMENTS

My greatest debts are to Andrew Wilton and Catherine Nicholson, who freely
shared their wide knowledge of Rowlandson and English watercolors, and gave
valuable advice in the selection and arrangement of the drawings in the exhibi-
tion. Mr. Wilton read the complete manuscript of the catalogue, offering many
helpful criticisms and saving me from a variety of errors. I am deeply grateful to
Miss Nicholson for coming to New Haven on two occasions to discuss the
drawings with me in detail, and for allowing me to consult her extensive files on
Rowlandson (including the fullest bibliography of the artist ever compiled) de-
posited in the Boston Public Library's Print Department.

John Baskett and Dudley Snelgrove generously made available before
publication the text of their *catalogue raisonné* of Rowlandson drawings in the
Mellon Collection, thus providing a foundation for my own study and research.
In the dating of individual drawings I have received helpful guidance from John
Hayes and Robert Wark, whose published writings on Rowlandson over the
last two decades have greatly enlarged our understanding of his work. Ronald
Paulson has my thanks for his stimulating comments and ideas about the draw-
ings to be included in the exhibition.

I wish to express my appreciation to W. S. Lewis, not only for the use of
books from the Lewis Walpole Library at Farmington, but particularly for

what he has taught me about English comic and satirical art of the eighteenth century.

Sinclair Hitchings was hospitality itself during my visit to the Boston Public Library, putting before me the treasures of the Wiggin Collection and enabling me to make full use of the Print Department's excellent Rowlandson reference library. For kind permission to publish Rowlandson's letter of 18 July 1815 to Henry Angelo and to reproduce John Bannister's portrait drawing of the artist, both in the Estate of the late Hugh D. Auchincloss, I wish to thank most sincerely Mrs. Auchincloss and also John A. Rowell, of the Riggs National Bank, Washington, D. C., the executor of the Estate.

It gives me pleasure to acknowledge the curatorial assistance provided by the staff of the Print Room at the Yale Center for British Art, in particular Cordelia Rose, who has helped me in ways far too numerous to detail. Gail Sacco and Dolores Gall typed and retyped the manuscript with cheerfulness and efficiency.

Finally, I should like to thank the Director of the Yale Center for British Art, Edmund Pillsbury, for his understanding and support throughout.

J. C. R.

Catalogue

ABBREVIATIONS USED IN THE CATALOGUE

Abbey, *Life*	*Life in England in Aquatint and Lithography 1770–1860 . . . from the Library of J. R. Abbey* (London, privately printed, 1953)
Abbey, *Scenery*	*Scenery of Great Britain and Ireland in Aquatint and Lithography 1770–1860 from the Library of J. R. Abbey* (London, privately printed, 1952)
Baskett and Snelgrove	John Baskett and Dudley Snelgrove, *The Drawings of Thomas Rowlandson in the Paul Mellon Collection* (London, 1977)
B.M. Satires	British Museum, *Catalogue of Political and Personal Satires*, vols. V–IX, compiled by Mary Dorothy George (London, 1935–49)
Bury	Adrian Bury, *Rowlandson Drawings* (London, 1949)
D. (in provenance)	MS catalogue of L. G. Duke's collection of English drawings, in the possession of Judy Egerton and Dudley Snelgrove; copy deposited in the British Museum Print Room
Falk	Bernard Falk, *Thomas Rowlandson: His Life and Art, A Documentary Record* (London, [1949])
Grego	Joseph Grego, *Rowlandson the Caricaturist*, 2 vols. (London, 1880)
Grolier	*Catalogue of Books Illustrated by Thomas Rowlandson Exhibited at the Grolier Club, November 2 to November 23 [1916]* (New York, 1916)
Gully	Anthony Lacy Gully, 'Thomas Rowlandson's *Doctor Syntax*,' Ph.D. Dissertation, Stanford University, 1972
Hayes	John Hayes, *Rowlandson Watercolours and Drawings* (London, 1972)
Lugt	Frits Lugt, *Les Marques de collections de dessins & d'estampes* (Amsterdam, 1921); *Supplément* (The Hague, 1956)
Oppé	A. P. Oppé, *Thomas Rowlandson: His Drawings and Water-colours* (London, 1923)
Paulson	Ronald Paulson, *Rowlandson: A New Interpretation* (London and New York, 1972)
Sutton	Denys Sutton, 'The Cunning Eye of Thomas Rowlandson,' *Apollo*, 105 (April 1977), 277–85
Tooley	R. V. Tooley, *English Books with Coloured Plates 1790 to 1860* (London, 1954)
V.M.F.A., 1963	Richmond, Virginia, Virginia Museum of Fine Arts, Painting in England 1700–1850: Collection of Mr. and Mrs. Paul Mellon, 1963
Wark	Robert R. Wark, *Drawings by Thomas Rowlandson in the Huntington Collection* (San Marino, 1975)

Note to the Catalogue Entries

The difficulty of establishing a chronology for drawings by Rowlandson is due to four factors: the unreliability of his own dates on some of the drawings; the relatively slight changes in his style once it reached maturity in the 1780s; his ability to work in more than one manner at the same time; and his numerous copies and repetitions. Though it has seemed worthwhile to suggest approximate dates for undocumented drawings in the exhibition, these dates should be regarded as strictly conjectural or tentative. A justification for assigning the drawings to four 'periods' is offered in the Introduction. Dimensions in inches are given to the nearest eighth of an inch; height precedes width. The term 'contemporary mount' is used to indicate mounts which are believed to have been made during Rowlandson's lifetime, whether or not by the artist himself. Only dated watermarks are recorded. All of the exhibited items are reproduced in the complete catalogue of Rowlandson drawings in the Mellon Collection, here designated as 'Baskett and Snelgrove.'

1778–1790

1. *A Man Driving a Team of Six Girls. Ca. 1778–80.* PLATE II

Pen and watercolor over pencil, on laid paper, 8¼ × 9⅜ in. (210 × 239 mm).
Inscribed in ink in a later hand, lower left: *J Gilray*
Verso: pencil sketch of figures.
Provenance: Gerald Norman; acquired 1968.
Bibliography: Baskett and Snelgrove, No. 176.

The influence of John Hamilton Mortimer on Rowlandson's early style is strongly apparent in this drawing, which was probably done about the time of Mortimer's death in 1779. The hatching, stippling, and zig-zags—techniques employed by engravers to create areas of tone—are mannerisms adopted from Mortimer. Yet Rowlandson's line already shows much of the freedom and flexibility that is the hallmark of his mature style. He has also begun to use pale shades of wash to suggest contour and depth.

This imagined scene of a man driving a team of girls, however bizarre in itself, seems clearly intended to be satirical. Drawings of a similar figure driving a carriage appear in an early Rowlandson sketchbook now in the Huntington Art Gallery.[1]

'His early works,' wrote one of Rowlandson's contemporaries, 'were wrought with care; and his studies from the human figure, at the Royal Academy, were scarcely inferior to those of the justly admired Mortimer.'[2] An album containing fifty-two pen drawings by Mortimer, testifying to Rowlandson's continued interest in his work, was sold with Rowlandson's collection in 1828.[3]

1. Wark, Nos. 1b, 1e, 1g (versos).
2. 'Rowlandson,' in *The London Literary Gazette*, No. 536, 28 April 1827, p. 268.
3. Lot 425 in Sotheby's catalogue of the sale, 23–26 June 1828.

2. *Study of a Shouting Man. Ca. 1780–83.* PLATE III

Pen, on laid paper, 7¾ × 10 in. (198 × 255 mm).
Inscribed in ink, probably in Rowlandson's hand, on the verso: . . . *ton & Colsons Dividend Advertised for the 23ʳ.ᵈ January.*
Verso: pen sketch of a man wearing a broad-brimmed hat.
Provenance: T. E. Lowinsky (Lugt 2420a); Justin Lowinsky; acquired 1963.
Bibliography: Michael Ayrton, 'British Drawings,' in *Aspects of British Art,*
ed. W. J. Turner (London, 1947), p. 36 (repr.); Baskett and Snelgrove, No. 158.

Rowlandson's virtuosity with the reed pen is brilliantly demonstrated in this early, rapidly executed sketch of a man shouting angrily and raising his clenched fists overhead. The variations in the thickness of line are the essence of his calligraphic style of drawing. Short, broad strokes are used primarily to establish the contour of the limbs, while thin, curling lines model the torso; a few Mortimer-like zigzags set off the figure. In a seemingly effortless manner, Rowlandson creates a feeling of vitality and movement.

3. *John Bannister in his Dressing Room at Drury Lane. 1783.*

Pen and gray wash, on laid paper, 6¾ × 4⅝ in. (171 × 116 mm); contemporary mount.

Inscribed in ink in Rowlandson's hand across bottom: *Sketch'd from Mʳ Bannister Junʳ in his dressing | Room at Drury Lane—Decʳ 23—83—*[in ink in Bannister's hand on mount at top] *From Old Jack Bannister 65 Gower Sᵗ | to his Young Friend Wᵐ Henderson*

Provenance: T. E. Lowinsky (Lugt 2420a); Justin Lowinsky; acquired 1963.
Bibliography: Baskett and Snelgrove, No. 257; Falk, p. 56; Hayes, p. 73, Pl. 9; M. T. Ritchie, *English Drawings* (London, 1935), p. 35 (repr.); Sutton, pp. 277, Fig. 1, 279.

This lively portrait sketch of John Bannister (1760–1836) was done on the spot in his dressing room at Drury Lane, as the dated inscription indicates. Rowlandson worked directly with the pen to capture this intimate theatrical vignette, in which the figure of the hairdresser assumes almost equal importance with the actor himself. The gray wash was very likely added later.

Rowlandson's acquaintance with Bannister began in 1777, when they were fellow students at the Royal Academy Schools and were attracted by each other's high spirits.[1] They became lifelong friends and companions in rambles about London. Though only twenty-three at the time of this drawing, Bannister had been acting at Drury Lane for five years and went on to have a celebrated career as a comedian.

1. *Reminiscences of Henry Angelo* (London, 1828–30), I, 254–55, 261–62; *Angelo's Pic Nic; or, Table Talk* (London, 1834), p. 368.

4. *Vauxhall Gardens. Ca. 1784.* PLATE I

Pen and watercolor over pencil, on laid paper, 13⅛ × 18¾ in. (334 × 476 mm).
Provenance: Sir William Augustus Fraser, Bt., his sale Christie's 3 Dec. 1900, lot 47; Louis Deglatigny (Lugt 1768a); Leggatt Bros.; acquired 1963.
Exhibitions: London, Royal Institute of Painters in Water Colours, The English Humourists in Art, 1889, No. 32; V.M.F.A., 1963, No. 492 (not in catalogue); Victoria, Canada, The Art Gallery of Greater Victoria, British Watercolour Drawings in the Collection of Mr. and Mrs. Paul Mellon, 1971, No. 32; New York, Pierpont Morgan Library, and London, Royal Academy, English Drawings and Watercolors 1550–1850 in the Collection of Mr. and Mrs. Paul Mellon, 1972/73,

No. 71; New Haven, Yale Center for British Art, The Pursuit of Happiness, 1977, No. 110.
Bibliography: Baskett and Snelgrove, No. 12; Falk, p. 78; Martin Hardie, *Water-colour Painting in Britain* (London, 1966–68), I, 212, Pl. 213; Sutton, pp. 280–81, Fig. 8.

Vauxhall Gardens, situated by the Thames on the Surrey side, had been a place of fashionable resort since the time of Charles II. In 1732, under the proprietorship of Jonathan Tyers, the gardens reopened to the public with improvements and amusements that remained popular throughout the eighteenth century. The long wooded walks, bright lights, and elegant supper boxes attracted crowds of visitors. 'It is peculiarly adapted to the taste of the English nation,' Boswell observed in his *Life of Johnson*, 'there being a mixture of curious shew, —gay exhibition,—musick, vocal and instrumental, not too refined for the general ear;—for all which only a shilling is paid; and, though last, not least, good eating and drinking for those who choose to purchase that regale.'[1]

Rowlandson's friend Henry Angelo recalled that 'the artist and myself have often been there, and he has found plenty of employment for his pencil. The *chef d'œuvre* of his caricatures . . . is his drawing of Vauxhall, in which he has introduced a variety of characters known at the time, particularly that of my old schoolfellow, Major Topham, the macaroni of the day. . . . On week days, I have seen many of the nobility, particularly the Duchess of Devonshire, &c. &c., with a large party, supping in the rooms facing the orchestra—French horns playing to them all the time.'[2]

Vauxhall Gardens is doubtless Rowlandson's most famous subject, known chiefly from the aquatint engraving published in 1785[3] after the drawing exhibited the year before at the Royal Academy. That drawing, now in the Victoria and Albert Museum,[4] is larger than the present version, whose numerous different details suggest that it is probably earlier. The scene is the 'Gothick' Orchestra in the Grove, outside the Rotunda, during an evening concert. Many of the foreground figures have been introduced as portraits and, though mildly caricatured, can be more or less reliably identified. The singer is said to be Mrs. Weichsell, mother of the renowned soprano Mrs. Billington. In the audience directly below her is Captain Topham, playwright and purveyor of fashionable gossip in *The World*, who stares at the Duchess of Devonshire and her sister, Lady Duncannon (see below, No. 23), through a quizzing glass. The elderly parson to their left, behind a tree, is reputed to be the Rev. Sir Henry Bate Dudley (the 'Fighting Parson'), but is more probably William Jackson of the *Morning Post*; next to him, in Highland dress, stands James Perry, editor of the *Morning Chronicle*. Further to the right, the Prince of Wales, wearing his star, flirts with his mistress 'Perdita' Robinson while her husband eyes both of them with suspicion. The figures seated in the supper box at the extreme left are traditionally supposed to be Boswell, Dr. Johnson, Mrs. Thrale, and Goldsmith, but these identifications have not been substantiated.[5]

With the exhibiting of *Vauxhall*, along with *The Serpentine River*, at the Royal Academy in 1784, and *Place des Victoires* at the Society of Artists the previous year, Rowlandson emerged at the height of his powers while still in his twenties. Although these large and elaborate compositions are replete with comic incident and grotesque details—Angelo described *Vauxhall* as a caricature, and contemporary reviewers remarked upon its 'humour'[6]—their overall effect is one of elegance and grace. This may be largely due to the delicacy of coloring and pleasing (yet not altogether natural) arrangement of figures against a panoramic background. The impression of elegance seems clearly indebted to French art, which Rowlandson had been able to see on earlier visits to Paris. The Goncourt brothers were the first to point out that he, in turn, influenced artists of the Directoire—Debucourt's celebrated *Promenade de la galerie du Palais Royal* of 1787 owing much to *Vauxhall Gardens*.[7] But the tension between what Paul Oppé has called the 'pretty' and the 'comic' in Rowlandson is never resolved thematically, even if the work succeeds as pictorial art.[8]

1. *Boswell's Life of Johnson*, ed. Hill-Powell (Oxford, 1934–50), III, 308. For detailed information see James Granville Southworth, *Vauxhall Gardens, A Chapter in the Social History of England* (New York, 1941), *passim*.
2. *Reminiscences of Henry Angelo* (London, 1828–30), II, 1–3.
3. Grego, I, 156–62; *B.M. Satires*, No. 6853 (engraved by Robert Pollard, aquatinted by Francis Jukes, and published by John Raphael Smith, 28 June 1785).
4. See Jonathan Mayne, 'Rowlandson at Vauxhall,' *Victoria and Albert Museum Bulletin*, 4 (July 1968), 77–81; Hayes, pp. 80–81, Pls. 16, 17.
5. A drawing by Rowlandson (8⅝ × 10 in.) representing the lower left corner of the design, with the figures in the supper box, was exhibited by Frank T. Sabin in 1933 (No. 111, repr.).
6. *European Magazine*, 5 (April 1784), 248; *Morning Chronicle*, 1 June 1784.
7. Edmond and Jules de Goncourt, *L'Art du dix-huitième siècle* (Paris, 1873–74), II, 255. See also A. Hyatt Mayor, *Prints and People: A Social History of Printed Pictures* (New York, 1971), Figs. 605, 606, and facing page.
8. Oppé, p. 7.

5. *An Audience Watching a Play. Ca. 1785.* PLATE IV
Pen and watercolor over pencil, on laid paper, 9⅜ × 14⅜ in. (239 × 364 mm).
Provenance: Baskett and Day; acquired 1976.
Bibliography: Baskett and Snelgrove, No. 242.

In the mid 1780s Rowlandson produced a number of drawings, some large-scale and highly finished, of scenes in the London theatres. The present example must surely be related (if not identical) to the drawing entitled *Opera House Gallery*, now missing, that was exhibited at the Royal Academy in 1786. It may be compared with the group of four *Side Box Sketches* in the Fogg Art Museum, Harvard University,[1] *Boxes at Covent Garden* in the Wiggin Collection, Boston Public Library,[2] and *An Audience at Drury Lane Theatre* in the Mellon Collec-

tion (not exhibited).[3] The famous *Box Lobby Loungers,* apparently based on a design by Rowlandson's friend Henry Wigstead, also dates from this time.[4]

The composition involves a difficult exercise in perspective, which Rowlandson has dealt with uncertainly. The strong diagonal of the bench in the foreground is continued by the dark figures at the left. Bits of bright color on the men's coats and women's bonnets punctuate the beautiful interplay of light and shadow. Although the figures and faces are of fashionable 'types,' they are not caricatured. The subject expresses Rowlandson's own absorption with the idea of people congregating to see and be seen.

1. Three dated 1785 (repr. Bury, Pl. 10; Hayes, Pl. 28); aquatint engraving by Samuel Alken, published 5 June 1786 (repr. Grego, I, 177–78).
2. Repr. Bury, Pl. 6; Arthur W. Heintzelman, *The Watercolor Drawings of Thomas Rowlandson from the Albert H. Wiggin Collection in the Boston Public Library* (New York, 1947), pp. 116–17.
3. Baskett and Snelgrove, No. 243.
4. Coll. Major L. M. Dent; repr. Bury, Pl. 7; Hayes, Pl. 29; etching by Rowlandson published 5 Jan. 1786 (repr. Grego, I, 181). Cf. also *Tragedy Spectators | Comedy Spectators*, etched and published by Rowlandson 18 Oct. 1787 (repr. Grego, I, 217–18). Later theatrical subjects are discussed in A. Bret Waller and James L. Connelly, 'Thomas Rowlandson and the London Theatre,' *Apollo*, 86 (Aug. 1967), 130–34.

6. *Bucks of the First Head. Ca. 1785.* PLATE VI

Pen and watercolor over pencil, on laid paper, 7⅛ × 8¾ in. (181 × 222 mm). Etched (with variations) and published 1785 as *Bucks of the First Head.*
Provenance: L. G. Duke (D.2169), from Leger, 1950; Colnaghi; acquired 1961.
Exhibitions: London, J. Leger and Son, June 1950.
Bibliography: Baskett and Snelgrove, No. 168; Sutton, pp. 281–82, Fig. 13.

The setting of this attractive drawing in Rowlandson's early mature style is apparently the outskirts of Oxford. The theme is necessarily cynical. Two undergraduates in academic dress have encountered a pretty country girl and are actively enticing her. The nonchalantly posed 'buck' on the right holds in view a well-filled purse, leaving no doubt about their intentions. In the background, a portly don walks off towards the distant spires of Oxford.

7. *Review on Blackheath, 10 May 1785. 1785.*

Pen and watercolor over pencil, on laid paper, 7⅝ × 13 in. (194 × 330 mm). Inscribed in ink in Rowlandson's hand, lower right: *Review on Blacheath May 1785.—*
Provenance: Agnew; acquired 1963.
Bibliography: Baskett and Snelgrove, No. 283.

The London *Daily Advertiser* of 11 May 1785 reported: 'Yesterday Morning his Majesty reviewed on Blackheath the four Troops of Horse and Horse Gren-

adier Guards, who all appeared in new Clothing; his Majesty came on the Grounds about Ten o'Clock, when the Exercises and Manœuvres began, which were performed to the entire Satisfaction of his Majesty, the Prince of Wales, and a great Number of Nobility, &c.'

Rowlandson was a frequent spectator at outdoor public events, and seems to have been particularly attracted as an artist to the crowds and pageantry at military reviews (see below, No. 74). *The English Review* and *The French Review*, both exhibited at the Royal Academy in 1786, are among the grandest of his large-scale works.[1] This interesting x-shaped composition was doubtless begun on the spot; it has rather the appearance of a preliminary study. As is typical of Rowlandson's review scenes, the freely mingling spectators dominate the foreground in contrast to the orderly rows of marchers in the distance.

> 1. Royal Collection, Windsor Castle. See A.P. Oppé, *English Drawings, Stuart and Georgian Periods . . . at Windsor Castle* (London, 1950), Nos. 517, 518, Pls. 77, 78; Hayes, Pls. 48–51.

8. *English Postilion. Ca. 1785.*

Pen and watercolor over pencil, on laid paper, 5⅛ × 8 in. (130 × 202 mm); contemporary mount.
Inscribed in ink in a later hand on mount below drawing: *Rowlandson Del!* | *English Postilion.*
Provenance: John Baskett; acquired 1969.
Exhibitions: London, John Baskett Ltd., Exhibition of Drawings and Prints by Thomas Rowlandson, 1969, No. 18.
Bibliography: Baskett and Snelgrove, No. 151.

This drawing is closely related to the so-called *Tailpiece*, one of sixty-nine drawings by Rowlandson resulting from a tour in a post chaise to the New Forest and the Isle of Wight with his friend Henry Wigstead.[1] The tour, which lasted twelve days in September and October 1784, was probably made to see the wreck of the *Royal George*, a famous man-of-war that had capsized and sunk off Spithead two years earlier.

The Mellon drawing is slightly more finished in style than the *Tailpiece*, but must have been made about the same time. It is possibly a companion to the *French Postilion*, versions of which are in the Courtauld Institute of Art, Spooner Bequest, and in the Birmingham City Museum and Art Gallery.[2]

> 1. The drawings are now in the Huntington Collection. See Robert R. Wark, *Rowlandson's Drawings for a Tour in a Post Chaise* (San Marino, 1964), p. 127, No. 14 (repr.). The *Tailpiece* is of similar size.
> 2. The latter is reproduced in Martin Hardie, *Water-colour Painting in Britain* (London, 1966–68), I, Pl. 210.

9. *Parisian Street Figures. 1786.*

Pen and gray wash, on laid paper, 6¼ × 9⅜ in. (159 × 238 mm).

Inscribed in ink in Rowlandson's hand across bottom: *Figures Sketch'd from a Window at Paris 1786*—[in ink below figures] *Music Grinders | a Savoyard Porter | a Water Carrier*
Verso: color splashes.
Provenance: Lord Farnham; Dyson Perrins; L.G. Duke (D.3577), from Appleby Bros., 1960; Colnaghi; acquired 1961.
Bibliography: Baskett and Snelgrove, No. 172.

These sketches of street figures in Paris show Rowlandson working quickly with the pen to capture images from everyday life. One imagines him observing passers-by from his window and taking up his sketchbook hurriedly to record their appearance. The inscription on this sheet may have been added later. Rowlandson's memory for dates was frequently inaccurate, but he is known to have visited France in 1787.[1]

The sketches were later used in two finished drawings, *Parisian Scene* (location unknown; photograph in the Witt Library, Courtauld Institute of Art) and *Paris Street Scene* in the Courtauld Institute, Sir Robert Witt Collection.[2]

1. His *View of Samer four Leagues from Boulogne,* in the collection of Augustus P. Loring, was 'Drawn on the Spot' in 1787. See Hayes, p. 106, Pl. 42.
2. Repr. Bury, Pl. 76.

10. *Study of Skaters. Ca. 1786–90.*

Pen and gray wash over pencil, on laid paper, 8⅞ × 14⅜ in. (225 × 366 mm); contemporary mount.
Verso: pen sketch of figures seated at a table.
Provenance: L. G. Duke (D.592), from M. de Beer, 1938; Colnaghi; acquired 1960.
Exhibitions: V.M.F.A., 1963, No. 414.
Bibliography: Baskett and Snelgrove, No. 118.

This study of skaters is related thematically to Rowlandson's well-known *Skaters on the Serpentine* (exhibited at the Royal Academy in 1784 as *The Serpentine River*[1]), but differs from it in so many respects that the study seems not likely to be preliminary. The upturned man on the ice at left and the fallen female vendor with two small boys at right are variants of figures in *Skaters on the Serpentine.* Yet the sketch succeeds in being overall a less static composition, the sprightly pair of circling skaters at center contributing much to the rococo sense of movement in the foreground. A date not long after Rowlandson's 1786 repetition[2] of *Skaters on the Serpentine* seems probable for this experiment.

1. Now in the National Museum of Wales; repr. Laurence Binyon, *English Water-colours* (London, 1933), facing p. 69; Andrew Wilton, *British Watercolours 1750 to 1850* (Oxford, 1977), Pl. 21.
2. In the London Museum, signed and dated 1786. See John Hayes, *A Catalogue of the Watercolour Drawings by Thomas Rowlandson in the London Museum* (London, 1960), No. 1, Pls. 1–3.

11. *Horsemen Colliding. Ca. 1785–90.*

> Pen and gray wash, on laid paper, 11¾ × 18⅞ in. (297 × 480 mm).
> *Provenance:* T.E. Lowinsky (Lugt 2420a); Justin Lowinsky; acquired 1963.
> *Bibliography:* Baskett and Snelgrove, No. 133.

Although this boldly sketched monochrome study is squared for transfer, no other version or engraving of the subject has been located. The work is not immediately recognizable as by Rowlandson: the pen technique is unusually scratchy in places, and the scale of the drawing exceptionally large for a rapid study. The style may be compared generally, however, with that of *Ode for the New Year*, etched and published in 1787.[1]

Rowlandson has used the brush extensively for modelling of the horses and riders, and for the mere suggestion of figures in the background. Notice how the legs of the riders follow those of their colliding mounts. This scene of violent action and impending disaster may owe something to Henry Bunbury's *Academy for Grown Horsemen*, a burlesque on equestrian mishaps also published in 1787.[2]

> 1. The drawing, in the collection of Denys Oppé, is reproduced in Hayes, p. 96, Pl. 32. For the etching see Grego, I, 209 (repr.).
> 2. *B.M. Satires*, Nos. 7231–42.

12. *The Hunt Breakfast. Ca. 1785–90.* PLATE VII

> Pen and brown and blue wash over pencil, on laid paper, 5 × 8 in. (127 × 204 mm); contemporary mount.
> Inscribed in ink in a contemporary hand on mount, lower left: *No. 11.*
> *Provenance:* Colnaghi; acquired 1963.
> *Bibliography:* Baskett and Snelgrove, No. 103; Hayes, p. 97, Pl. 33.

This sketch brilliantly expresses the movement and attitudes of the huntsmen and their dogs with great economy of line. It succeeds by suggesting more than is actually delineated. Some features are left uncompleted; nothing is labored. The early-morning sleepiness of the man drawing on his boots is succinctly rendered with a few short pen strokes.

There is another version of this design in the collection of G.D. Lockett, The Clonterbrook Trust, Cheshire. A related hunting subject entitled *The Breakfast* was etched and published in 1789.[1]

> 1. Proof impression in the Wiggin Collection, Boston Public Library. See also Wark, p. 75, No. 213.

13. *The Return. 1787.* PLATE X

> Pen and watercolor over pencil, on laid paper, 7⅝ × 11½ in. (194 × 293 mm).
> *Provenance:* Alfred E. Pearson, his sale Sotheby's 12 July 1967, lot 213, to Colnaghi; acquired 1967.

Exhibitions: London, Ellis and Smith, A Loan Exhibition of Important Drawings by Thomas Rowlandson, 1948.
Bibliography: Baskett and Snelgrove, No. 109.

This is a preliminary study for the drawing, signed and dated 1787, in the Birmingham City Museum and Art Gallery, J. Leslie Wright Collection.[1] The finished version, etched by Rowlandson and published in 1788, is one of a series of six large hunting scenes said to have been executed for the Prince of Wales.

The basic composition apparently derives from Rembrandt's etching *The Good Samaritan*, which in turn was probably inspired by Jan Van de Velde's etching of the same subject.[2] Rowlandson, who amassed a large collection of prints by Rembrandt and other old masters, seems to have enjoyed making this kind of art-historical allusion. Here the allusion involves a comic transformation from a biblical scene to a contemporary sporting picture.

For the finished drawing, Rowlandson revised the right side of the study, so that the hounds (which serve as a *repoussoir*) are more tightly grouped, the separated figure on horseback is replaced by three riders approaching from the extreme right, and the principal huntsman is doffing his hat to the women on the balcony rather than holding up the dead hare.

1. Hayes, pp. 36, 99, Pl. 35; Roger Longrigg, *The History of Fox Hunting* (London, 1975), p. 89 (repr.).
2. Otto Demus, 'Eine Rembrandt-Travestie von Thomas Rowlandson,' *Phoebus*, 2 (1948–49), 80–81. See also Gully, p. 77.

14. *The Prize Fight. 1787.* PLATE XI

Pen and watercolor over pencil, on laid paper, 18¼ × 27½ in. (463 × 697 mm). Signed and dated in ink, lower left: *T. Rowlandson. 1787–*

Provenance: Sold Christie's 12 Feb. 1912 (Property of a Gentleman), lot 112, to Huggins; M. Knoedler and Co., Feb. 1915 (No. 83 in catalogue); Frank T. Sabin, 1956; Arthur Reader; acquired 1960.
Exhibitions: New York, Grolier Club, 1916, No. 5; Bath, Victoria Art Gallery, Art Treasures, 1958, No. 283; New Haven, Yale Center for British Art, The Pursuit of Happiness, 1977, No. 155.
Bibliography: Baskett and Snelgrove, No. 114; Adrian Bury, 'Thomas Rowlandson: Historian of English Social Life,' *History Today*, 6 (July 1956), 472, 467 (repr.); Hayes, pp. 45, 101, Pl. 37; J.H. Plumb, *The First Four Georges* (London, 1975), p. 145 (repr.); Sutton, pp. 279–80, Fig. 6.

The Prize Fight is Rowlandson's 'spectacle' picture *par excellence*, extremely ambitious in conception and perhaps the most successful of his large-scale compositions with figures. The crowd of spectators surges across the whole of the design, a rococo frieze of vast proportions. Animated figure groups, carefully massed and balanced against each other, are united by the diamond-shaped boxing ring in the center. The front edge of the crowd forms an undulating line, broken only by an overturning cart, while the serpentine curve of the horizon follows the silhouette of the roof-top spectators.

11

The scene has been tentatively identified as the fight between the 'Gentleman Boxer' Richard Humphries and Samuel Martin on 3 May 1786. The *London Chronicle* gave the following report: 'Yesterday the long contended battle between Martin, the Bath Butcher, and the famous Humphries, was fought about six miles this side of Newmarket, which lasted about an hour and a half, when the latter beat the former in a terrible manner; upwards of 4000 l. were won and lost on the occasion.'[1] The contest was attended by several hundred people, including members of the English and French nobility.

1. *London Chronicle*, No. 4596, 2–4 May 1786, *sub* 4 May. More detailed accounts are given in Pierce Egan, *Boxiana* (London, 1823–29), I, 103–04, and Henry Downes Miles, *Pugilistica* (London, [1880–81]), I, 84–85. These accounts state that the Prince of Wales and the Duke of York were in attendance, but the Prince had returned to London from Newmarket the previous evening, 'indisposed,' and the Duke of York was then in Germany. The identity of the figure on horseback at right, wearing a star on his blue coat, is therefore uncertain.

15. *Tintagel Castle, Cornwall. Ca. 1785–90.* PLATE XIII

Watercolor over pencil, on laid paper, 9⅝ × 12 in. (244 × 305 mm); contemporary mount.

Provenance: Iolo A. Williams; Colnaghi; acquired 1964.

Bibliography: Baskett and Snelgrove, No. 39; Martin Hardie, *Water-colour Painting in Britain* (London, 1966–68), I, Pl. 211; Iolo A. Williams, *Early English Watercolours* (London, 1952), p. 141.

This and the three following drawings have in common a particular delicacy and range of colors (pale blue-green, pink, tan, gray); the brush is used exclusively for landscape features. Except in the case of *The Dying Sailor* (No. 18), the atmospheric color in these works assumes greater importance than the line—a fairly unusual occurrence for a calligraphic draughtsman like Rowlandson. The brushwork of the foliage in *Loading Sand* (No. 16) and *A Carrier's Waggon* (No. 17) recalls the work of Alexander Cozens, whose treatise on the drawing of trees[1] Rowlandson must have known. This treatment of foliage may be compared with that in *The Return* (No. 13) and *The Prize Fight* (No. 14), both of which date from 1787. Rowlandson drawings of this character have sometimes been assigned to the 1790s, but it seems more likely that they belong to the later 1780s.

This impressionistic view of the rocks at Tintagel, on the north coast of Cornwall, was executed entirely with the brush over very free traces of pencil. Rowlandson used a similar technique in his drawings of the Needle Rocks and St. Christopher's Rock, from his tour to the Isle of Wight in 1784.[2] The square tower of Tintagel Castle stands among the rocks on the cliff, high above the massive boulders in the foreground. As Iolo Williams has noted, even among Rowlandson's pure landscapes this drawing is 'unexpected.' Another drawing

of Tintagel by Rowlandson (14¾ × 9¼ inches) is in the collection of Augustus P. Loring, Prides Crossing, Massachusetts.

1. *The Shape, Skeleton and Foliage of Thirty-Two Species of Trees for the Use of Painting and Drawing* (London, 1771).
2. See Robert R. Wark, *Rowlandson's Drawings for a Tour in a Post Chaise* (San Marino, 1964), Nos. 51, 53 (repr.).

16. *Loading Sand. Ca. 1785–90.* PLATE XIV

Pen and watercolor over pencil, on laid paper, 10⅞ × 13½ in. (277 × 344 mm); contemporary mount.
Provenance: Lord Radcliffe, sold Christie's 27 April 1965, lot 83, to Colnaghi; acquired 1965.
Bibliography: Baskett and Snelgrove, No. 96.

Simplicity of composition and radiance of coloring distinguish this unusually atmospheric drawing of men and horses against an unspoiled landscape. The figures, given definition by the pen, remain very much in the foreground, while the natural forms suggested by delicately brushed wash recede into the distance. Though the figures attract attention, the mood of the scene is controlled by the expansive landscape. See comments under No. 15.

17. *A Carrier's Waggon. Ca. 1785–90.* PLATE XV

Pen and watercolor over pencil, on laid paper, 10⅛ × 15¼ in. (258 × 387 mm).
Provenance: Gilbert Davis; John Baskett; acquired 1970.
Exhibitions: London, John Baskett Ltd., 1969, No. 26; Tokyo, National Museum of Western Art, and Kyoto, National Museum of Modern Art, English Landscape Painting of the Eighteenth and Nineteenth Centuries, 1970–71, No. 83.
Bibliography: Baskett and Snelgrove, No. 89; Hayes, p. 171, Pl. 107.

A feeling of tranquil lyricism emanates from this beautiful drawing of a carrier's waggon stopping in a village to change horses and let off travellers. The overarching trees dominate the composition, which shows great sensitivity in the delicate pink and gray-blue tones of wash. The tip of the brush is used with controlled freedom to create the soft luxuriance of the foliage. The woman and child drawing water from a well add balance and charm to the peaceful scene. See comments under No. 15.

18. *The Dying Sailor. Ca. 1787–90.*

Pen and watercolor over pencil, on wove paper, oval 10⅞ × 12¾ in. (275 × 324 mm).
Provenance: T. E. Lowinsky (Lugt 2420a); Justin Lowinsky; acquired 1963.
Bibliography: Baskett and Snelgrove, No. 278.

In his *Reminiscences* Henry Angelo tells of visiting Forton prison with Row-

landson to view the French sailors held there, following Lord Howe's naval victory on the 'Glorious First of June,' 1794:

> In one of the sick wards we saw one of the prisoners, who, an officer told us, had been a tall, handsome man, previous to the battle; but, having received a shot that had lacerated his side, a mortification had taken place. He was then making his will; his comrades were standing by, consoling him, some grasping his hand, shedding tears.
>
> This scene was too much for me, and made such an impression on my mind that I hastened away; but I could not persuade Rowlandson to follow me, his inclination to make a sketch of the dying moment getting the better of his feelings. After waiting some time below, for my friend, he produced a rough sketch of what he had seen.[1]

This episode has frequently been cited as evidence of Rowlandson's insensitivity to human suffering, but it reveals at least as much about his powers of concentration as an artist. The present drawing, which was probably done several years earlier, is much less a realistic portrayal of 'the dying moment' than a romantic conception of Rowlandson's imagination. The subject matter, the oval presentation, and even the coarse, vigorous penwork on the dying sailor, all suggest the possible influence of de Loutherbourg, whose scenes of shipwrecks and 'banditti' (some exhibited at the Royal Academy) are striking for their drama and emotional directness.[2] Pictures of 'banditti' by Mortimer, who was an early influence on Rowlandson (see above, No. 1), may also have inspired this work.

1. *Reminiscences of Henry Angelo* (London, 1828–30), II, 293.
2. The two genres are treated together in Rüdiger Joppien's exhibition catalogue *Philippe Jacques de Loutherbourg, RA, 1740–1812* (London, 1975), following No. 13.

19. *Inquiring the Way. Ca. 1785–90.*

Pen and watercolor over pencil, on wove paper, 7 × 7¾ in. (179 × 197 mm).
Provenance: L. G. Duke; Iolo A. Williams; Colnaghi; acquired 1964.
Bibliography: Baskett and Snelgrove, No. 75.

In this close-up glimpse of a traveller stopping to ask directions, Rowlandson adopts a low angle of vision so that the horse and rider are silhouetted against the bright sky. The background is treated in a quick, sketchy manner. The heavily inked contours of the horse suggest a date in the later 1780s for the drawing.

20. *The Prospect Before Us. 1788.*

Pen and gray wash over pencil, on laid paper, 8¾ × 12⅛ in. (221 × 307 mm).
Etched by Rowlandson and published by 'Tom Brown Spa Fields Chelsea'
20 Dec. 1788 as *The Prospect Before Us* (Grego, I, 230–31; *B.M. Satires*, No. 7383).

Provenance: Zeitlin and Ver Brugge; acquired 1966.
Bibliography: Baskett and Snelgrove, No. 336.

Throughout his career Rowlandson produced political cartoons (often based on ideas supplied by others), but relatively few of his preliminary drawings have survived. The topics satirized in the cartoons quickly lost currency, and the original designs for the prints were apparently seldom preserved. Six pencil sketches by Rowlandson for his *Westminster Election* series of 1784 are in the Huntington Collection.[1] The present pen-and-wash drawing is one of several designs engraved by him concerning the Regency crisis of 1788–89, during George III's incapacitating illness.

The crisis lasted from November to February, a period of bitter political controversy in which the younger William Pitt, the prime minister, sought to limit the powers of the would-be Regent, the Prince of Wales. The Prince and his followers maintained that the Regent should be permitted to exercise the full powers of sovereignty as if the King were dead. Pitt was suspected of trying to form a Regency council headed by himself, aided and abetted by Queen Charlotte. Of the Queen Sir Gilbert Elliot wrote on 29 December 1788: 'She is playing the devil, and has been all this time at the bottom of the cabals and intrigues against the Prince.'[2]

In Rowlandson's hastily sketched cartoon, the Queen is held in leading-strings by Pitt; 'I follow Billy's advice,' she says. In his other hand, Pitt grasps a paper which asserts that he is 'as much entitled to be regent as the Prince of Wales.' The Queen is preceded at left by Mrs. Schwellenberg, the Keeper of the Queen's Robes (greatly caricatured), who holds the bag of the Great Seal and the Mace; she announces her intention of presiding at Pitt's council meetings. At the extreme right is Warren Hastings, former governor-general of India, who expresses the hope that his influence with the Queen will improve his fortune (he was then on trial in the House of Lords). The drawing omits a number of satirical details found in the print.

The legends contained in the balloons are possibly in the hand of Rowlandson's friend Henry Wigstead, who contributed other cartoons on the Regency crisis and may have suggested this one.[3] The Mellon Collection has another political drawing (not exhibited) that appears to be largely Wigstead's work in collaboration with Rowlandson.[4]

1. Wark, pp. 39–40, Nos. 4–9.
2. *Life and Letters of Sir Gilbert Elliot First Earl of Minto*, ed. the Countess of Minto (London, 1874), II, 252.
3. Cf. *The Private Secretary Bestowing Alms* (signed by Wigstead), reproduced in Robert R. Wark, *Rowlandson's Drawings for a Tour in a Post Chaise* (San Marino, 1964), p. 22, Fig. 3. See also Grego, I, 231.
4. Baskett and Snelgrove, No. 334.

21. *Four O'Clock in the Country. Ca. 1788–90.*

Pen and watercolor over pencil, on wove paper, 9⅜ × 12¼ in. (237 × 312 mm).
Provenance: Mrs. C. Carr, sold Sotheby's 5 April 1973, lot 158, to Baskett and Day; acquired 1973.
Bibliography: Baskett and Snelgrove, No. 102; Sutton, pp. 281–82, Fig. 14.

The original version of *Four O'Clock in the Country* and its companion drawing *Four O'Clock in Town*, both signed and dated 1788, were etched by Rowlandson and published by John Harris on 20 October 1788.[1] The present version of *Four O'Clock in the Country* is a repetition probably made not long afterwards; it differs in various background details from both the signed drawing and the etching.

Four O'Clock in Town shows a drunken and dishevelled young rake, returned from an expensive night of frivolity, being undressed and helped to bed by maids while his distressed wife looks on. *Four O'Clock in the Country* presents the scene in reverse: a hardy young sportsman is up at dawn, preparing to set off for a day of hunting, amidst the bustle of the groom and the dogs; an attentive spouse and a peacefully sleeping child are indications that he is happily domesticated.[2] The country squire and his wife are drawn with a crisp, sharp line against a background notable for its chiaroscuro.

The excesses of town life contrasted with the wholesome pleasures of living in the country are a familiar theme in Rowlandson's work. The theme is elaborated in a similar pair of drawings, both signed and dated 1815, in the collection of the Achenbach Foundation for Graphic Arts.[3]

1. The pair of drawings, formerly in the National Gallery of British Sports and Pastimes, are reproduced in Falk, facing pp. 96, 104, and in Hayes, pp. 122–23, Pls. 58, 59. Impressions of the etchings (one signed in the plate *Rowlandson 1788*) published by Harris are in the collection of the Colonial Williamsburg Foundation. The prints were reissued by S. W. Fores and J. Jones with the publication date 20 Oct. 1790 (*B.M. Satires*, No. 7769; Grego, I, 280–82).
2. A different interpretation of *Four O'Clock in the Country* that seems strangely at odds with Rowlandson's intention is given in Paulson, p. 75.
3. California Palace of the Legion of Honor, San Francisco. These drawings, entitled *The Gamester Going to Bed* and *The Huntsman Rising*, are apparently repetitions of earlier designs that were etched and published by Rowlandson as a pair in 1809 and reissued in 1811; see Grego, II, 135, 208–10 (repr.).

22. *A Merchant's Office. 1789.* PLATE XVI

Pen and watercolor over pencil, on laid paper, 11⅛ × 13¼ in. (284 × 337 mm); contemporary mount.
Signed and dated in ink, lower right: *Rowlandson. 1789.*
Provenance: Somerville and Simpson; acquired 1976.
Bibliography: Baskett and Snelgrove, No. 200; Sutton, pp. 282, 284, Fig. 21.

This drawing of a busy merchant's office serves to illustrate the gradual change

taking place in Rowlandson's penwork towards the end of the 1780s. Although thick outlines of India ink are still used for contour, the line is becoming freer and less controlled, vigorous but in places (such as the coat of the elderly merchant at right) somewhat fussy. Two of the colors used—the magenta of the merchant's cap and of one clerk's coat, the bright green of another clerk's coat—are rarely found in Rowlandson drawings as early as 1789. The same colors appear in *Dr. Graham's Earth Bathing Establishment* (below, No. 29), which was possibly done a few years later. A very similar standing figure of a merchant, with a magenta cap and a green coat, is the subject of a drawing in the Museum of Fine Arts, Boston, John T. Spaulding Collection.[1]

1. Repr. Bury, Pl. 65. The drawing is clearly of the same period.

23. *The Duchess of Devonshire and Lady Duncannon. 1790.*

PLATE XVII

Pen and watercolor over pencil, on laid paper, 19⅝ × 16⅞ in. (499 × 427 mm). Signed and dated in ink, lower left: *Rowlandson—1790.*

Provenance: George, 5th Duke of Gordon; Elizabeth, Duchess of Gordon; The Brodie of Brodie; Agnew; acquired 1963.

Exhibitions: New Haven, Yale Center for British Art, The Pursuit of Happiness, 1977, No. 66.

Bibliography: Baskett and Snelgrove, No. 260; Hayes, pp. 138–39, Pl. 75; Sutton, pp. 282–83, Fig. 18.

Georgiana, Duchess of Devonshire (1757–1806), and Henrietta Frances, Viscountess Duncannon (1761–1821), later Countess of Bessborough, were daughters of the first Earl Spencer. Both were celebrated beauties and leaders of fashion in the aristocratic circles of their day. Rowlandson featured them prominently in his famous *Vauxhall Gardens* of 1784 (see above, No. 4). This handsome drawing of the Duchess (on the right) and her sister is in the typical mode of society portraits of the period. The heads, which are evidently good likenesses though rather stylized,[1] especially recall the manner of Francis Wheatley and John Downman.[2] Notice how the flowing pen line and subtle shades of wash serve to suggest the mass and contours of their dresses.

Another version of this double portrait (three-quarter length and without the musician, but otherwise very similar) was etched and published in 1787 with the title *The Syrens*.[3]

1. Cf. Sir Joshua Reynolds's portrait of the Duchess with her daughter, exhibited at the Royal Academy in 1786 and now in the Devonshire Collection at Chatsworth (Ellis Waterhouse, *Reynolds* [London, 1973], Pl. 119), and his portrait of Lady Duncannon, ca. 1785, at Althorp (K. J. Garlick, 'A Catalogue of Pictures at Althorp,' *Walpole Society*, vol. XLV [1976], Pl. 18).
2. Downman's large (38½ × 25½ in.) watercolor portrait of the Duchess, signed and dated 1787, is in the Devonshire Collection, Chatsworth. He did other portraits of her as well as of Lady Duncannon, including one showing them together with two other 'ladies of quality,' exhibited at the Royal Academy in 1788.

3. The drawing is reproduced in Falk, facing p. 85 (present location unknown); an impression of the etching, published 10 April 1787 by E. Jackson, is in the Metropolitan Museum of Art.

24. *A Woman Reclining on a Sofa. Ca. 1790.*

Pen and watercolor over pencil, on laid paper, 7¾ × 11¾ in. (197 × 298 mm).
Provenance: Colnaghi; acquired 1964.
Bibliography: Baskett and Snelgrove, No. 256.

During the period of his early maturity as an artist, roughly from 1784 to 1790, Rowlandson made numerous portrait studies of fashionable young women, of which this drawing and the preceding one are distinguished examples.[1] The portraits are usually three-quarter or full length, in a pretty, rather sentimental manner reminiscent of Wheatley.

This charming view of a woman reclining on a sofa is said to represent Mrs. Abington, the actress, but solid evidence for the identification is lacking. The woman's appearance seems too youthful for Mrs. Abington, who would have been in her early fifties when this drawing was made. The appeal of the portrait lies chiefly in the informal elegance of the pose and the delicate coloring of the figure. The flowing lines of the woman's dress are nicely set off against the more regular curves of the sofa.

1. For other examples in the Mellon Collection, see Baskett and Snelgrove, Nos. 204–07.

25. *The Stable of an Inn. Ca. 1790.* PLATE XVIII

Pen and watercolor over pencil, on laid paper (two joined sheets), 8 × 16 in. (203 × 405 mm); contemporary mount.
Provenance: Maas Gallery; acquired 1964.
Bibliography: Baskett and Snelgrove, No. 137.

The inspiration for this scene, if any were needed, could have come directly from Rowlandson's friend and fellow artist George Morland, but there can be little doubt that the drawing was done from life. Morland may in fact be represented by the tall figure in profile on the right.[1] The outstanding feature of the drawing is the chiaroscuro of mellow browns and tans, the three small windows and the doorway providing the only visible sources of light. Rowlandson employs the pen only on the figure group, the dog, and the horses, relying on the softer technique of the brush to create a work of great warmth and beauty.

1. I owe this suggestion to Andrew Wilton. Cf. Rowlandson's early full-length portrait drawing of Morland in the British Museum, reproduced in Hayes, p. 102, Pl. 38.

26. *Two Greyhounds Lying under a Tree. Ca. 1790.*

Pen and watercolor over pencil, on wove paper, 7⅛ × 9⅞ in. (180 × 250 mm); contemporary mount.

Verso of mount: pen-and-pencil drawing of three men and a woman drinking (not by Rowlandson).

Provenance: L. G. Duke (D.831), from Squire Gallery, 1932; Colnaghi; acquired 1961.

Exhibitions: London, Royal Academy, British Art, 1934, No. 698; Washington, National Gallery of Art, An Exhibition of English Drawings and Water Colors from the Collection of Mr. and Mrs. Paul Mellon, 1962, No. 59.

Bibliography: Baskett and Snelgrove, No. 155; Martin Hardie, *Water-colour Painting in Britain* (London, 1966–68), I, 215; Iolo A. Williams, *Early English Watercolours* (London, 1952), p. 141, Fig. 231.

Critics have sometimes overlooked Rowlandson's very considerable abilities as an animal draughtsman while praising his virtuosity in figure drawing. He had a good knowledge of animal anatomy and movement—perhaps a surer grasp of the anatomy of the horse than of the human figure. Even in such modest drawings as this one of dogs or the following one of pigs, his gifts for vivid characterization are fully evident. The study of pigs is an accurate observation of barnyard activity, but here Rowlandson has gracefully posed the greyhounds and provided them with a picturesque setting.

27. *Pigs at a Trough. Ca. 1790.*

Pen and brown wash over pencil, on laid paper, 3⅝ × 6¼ in. (91 × 159 mm).

Provenance: L. G. Duke (D.4144), his sale Sotheby's 16 July 1970, lot 155; Spink; Davis and Long; acquired 1975.

Bibliography: Baskett and Snelgrove, No. 157.

See comments under No. 26.

28. *A Timber Waggon. Ca. 1790.* PLATE XIX

Pen and gray wash over pencil, on laid paper, 4⅝ × 7¼ in. (117 × 185 mm).
Falsely signed in pencil, lower right: *Rowlandson*
Etched in the reverse direction and published by S. W. Fores as Pl. 5 for *Outlines of Figures, Landscape, & Cattle, Etch'd by T. Rowlandson, for the Use of Learners,* 18 June 1790 (Grolier, No. 5).

Provenance: George, 5th Duke of Gordon; Elizabeth, Duchess of Gordon; The Brodie of Brodie; Agnew; acquired 1962.

Bibliography: Baskett and Snelgrove, No. 98; Hayes, p. 167, Pl. 102; Paulson, pp. 30, [64], Fig. 26.

Between 1784 and 1788 Rowlandson engraved the series of prints published as *Imitations of Modern Drawings,* mostly landscape and figure subjects after

Gainsborough, George Barret, Sawrey Gilpin, and others.[1] This scene, though doubtless taken from life, is strongly reminiscent of landscapes by Gainsborough. The gently undulating lines of the terrain and the loose, animated character of the foliage (cf. No. 26 above) give the picturesque composition its rhythmic pattern. The large, oddly shaped logs piled on the cart have a sinuous life of their own.

1. See Grego, I, 151, and Grolier, No. 52.

29. *Dr. Graham's Earth Bathing Establishment. Ca. 1790–95.*

Pen and watercolor over pencil, on wove paper, 10⅜ × 16⅜ in. (264 × 416 mm); contemporary mount.

Provenance: Louis Deglatigny (Lugt 1768a); Paul Prouté et ses fils, 1964 (catalogue 'Colmar,' No. 64); Colnaghi; acquired 1968.

Bibliography: Baskett and Snelgrove, No. 4.

James Graham (1745–94), a notorious quack doctor, attracted a numerous and fashionable clientele by his elaborately outfitted healing establishments and clever advertisements. Horace Walpole visited his 'Temple of Health' in the Adelphi in 1780 and described it as 'the most impudent puppet-show of imposition I ever saw, and the mountebank himself the dullest of his profession, except that he makes the spectators pay a crown apiece.'[1]

Graham described his most famous nostrum in a pamphlet published in 1779, entitled *A Treatise on the All-Cleansing, All-Healing, and All-Invigorating Qualities of the Simple Earth, when Long and Repeatedly Applied to the Human Body.* Rowlandson's drawing possibly depicts his less-than-elegant earth bathing facilities at 26 Fleet Street, London.[2] Graham, dressed in a blue coat and bag wig, is shown attending a grossly fat and gouty 'patient' who has just emerged from the earth bath. Men and women, separated by a loosely hung sheet, are up to their necks or waists in the mud. On the extreme right, a man on crutches, just arrived, hobbles out of a sedan chair.

Rowlandson fully exploits the ludicrous aspects of Graham's establishment in this somewhat diffuse (and contrived) composition. Most of the faces and bodies are caricatured, but an effective contrast is provided by Graham himself and the pretty young woman undressing at the rear. See comments under No. 22.

1. To the Countess of Upper Ossory, 23 Aug. 1780 (*Yale Edition of Horace Walpole's Correspondence*, ed. W. S. Lewis et al. [New Haven, 1937–], XXXIII, 217).
2. On the verso is an inscription in a contemporary hand, presumably copied from one of Graham's eloquently styled handbills, advertising a public exhibition of earth bathing, to be held at 26 Fleet Street, and soliciting patronage.

30. *A Review in a Market Place. Ca. 1790.*

Pen and watercolor over pencil, on wove paper, 11⅜ × 17½ in. (290 × 443 mm); contemporary mount.

Inscribed in pencil in a later hand on mount below drawing: *Review in the Market Place Winchester | T. Rowlandson ca. 1790*
Provenance: Gilbert Davis (Lugt 757a); Colnaghi; acquired 1961.
Exhibitions: Birmingham, City Museum and Art Gallery, Exhibition of Works by Thomas Rowlandson from the Collection of Gilbert Davis, Esq., 1949–50; London, Whitechapel Art Gallery, 1953, No. 92; Washington, National Gallery of Art, An Exhibition of English Drawings and Water Colors from the Collection of Mr. and Mrs. Paul Mellon, 1962, No. 62; V.M.F.A., 1963, No. 432; New York, Pierpont Morgan Library, and London, Royal Academy, English Drawings and Watercolors 1550–1850 in the Collection of Mr. and Mrs. Paul Mellon, 1972/73, No. 69.
Bibliography: Baskett and Snelgrove, No. 286; Frank Davis, 'Rowlandson at Birmingham [City Art Gallery],' *Illustrated London News*, 26 Nov. 1949, p. 830 (repr.); Hayes, p. 143, Pl. 79.

Rowlandson's topographical drawings invariably lack the minute detail and exact perspective found in works by such draughtsmen as Paul Sandby or Thomas Malton.[1] His restless pen was obviously unsuited to precise delineation of architectural features. The buildings of this country market place are rendered with as much care as any Rowlandson ever drew, possibly excepting those in the elaborate townscapes begun on the Continent in the 1790s (see below, No. 33). Such trouble as he took, however, was quite sufficient for his purpose, which in most instances was simply to provide a lively setting or backdrop for his figures.

This scene was at one time thought to represent Winchester, but the identification is no longer accepted. The disposition of the townsfolk into isolated groups is somewhat uncharacteristic of Rowlandson, who often favors a frieze-like arrangement in the foreground. But the composition is perfectly natural and logical as it stands, with the line of soldiers at left contrasting nicely with the other figures. The pot-bellied drill sergeant (who, along with his recruits, is caricatured by Rowlandson) makes a close-up appearance in the drawing which follows.

1. For Rowlandson's collaboration with Malton on a drawing of Bradwell Lodge, Essex, see Baskett and Snelgrove, No. 18. Topographical studies of considerable precision are found in an early Rowlandson sketchbook now in the Huntington Art Gallery; see Wark, No. 1. His collaboration with Augustus Pugin on *The Microcosm of London* is discussed below under No. 93.

31. *The Recruiting Sergeant. Ca. 1790.*

Pen and watercolor over pencil, on laid paper, 12 × 8¼ in. (305 × 211 mm); contemporary mount.
Inscribed in ink in a later hand on mount below drawing: *The Recruiting Serjeant*
Provenance: Desmond Coke (his label pasted on verso), his sale Sotheby's 21 July 1931, lot 86; T. E. Lowinsky (Lugt 2420a); Justin Lowinsky; Agnew; acquired 1964.
Bibliography: Baskett and Snelgrove, No. 280.

The recruiting party, touring the countryside in search of potential enlistees, was lampooned in George Farquhar's popular comedy of 1706, *The Recruiting Officer*, and later found its way into the plots of numerous eighteenth-century novels. Bunbury's *Recruits*, engraved and published in 1780, is an amusing example of visual satire on the subject.[1] Recruiting parties, real or fictional, were notorious for the devious practices they used to get young men to join the ranks.

Rowlandson's recruiting sergeant (only slightly caricatured, one suspects) tosses a coin—'His Majesty's bounty'—towards the country bumpkin on the left, who tries to catch it; an amused bystander observes the ritual. The bright colors of the sergeant's uniform are typical of those used by Rowlandson in the early 1790s. The extremely free but vigorous penwork on the other figures characterizes his very rapid sketches made at this period.[2]

1. *B.M. Satires*, No. 4766.
2. Cf. Hayes, pp. 134–35, Pls. 70, 71 (two pen-and-wash sketches dated 1789).

32. *The Dutch Packet. 1791.*

Pen and watercolor over pencil, on laid paper, 7¾ × 10¾ in. (197 × 274 mm).
Signed and dated in ink, lower left: *Rowlandson 1791*
Inscribed in ink in Rowlandson's hand, lower center: *Dutch Packet—*

Provenance: Sir Bruce Ingram; Leger Gallery; C. A. Hunter, his sale Christie's 11 March 1969, lot 97, to John Baskett; acquired 1969.
Bibliography: Baskett and Snelgrove, No. 272; Anthony Burgess and Francis Haskell, *The Age of the Grand Tour* (London and New York, 1967), p. 40, Fig. 46; Hayes, p. 41, Fig. 33; F. Gordon Roe, 'Drawings by Rowlandson: Captain Bruce S. Ingram's Collection,' *Connoisseur*, 118 (Dec. 1946), 87, Fig. VII.

Rowlandson almost certainly visited Holland and Germany in 1791. This is one of several surviving drawings, inscribed and dated, which document the tour.[1] A packet-boat crosses the Channel, the choppy sea making the passage unpleasant for at least two of the passengers on board.

The composition involves a complex pattern of diagonals, stabilized by the horizontal line of the horizon. The colors are bright and unfaded. Two repetitions of the drawing are known, one in the possession of the Earl of Stair and the other in a private collection.[2]

1. See No. 33 below.
2. Repr. Hayes, p. 41, Figs. 34, 35. The repetitions (undated) are in all respects weaker versions.

33. *View of the Market Place at Juliers in Westphalia. 1791.*

PLATE XX

Pen and watercolor over pencil, on wove paper, 12⅜ × 21 in. (314 × 533 mm); contemporary mount.
Signed and dated in ink, lower right: *Rowlandson 1791*

Inscribed in ink in Rowlandson's hand on mount below drawing: VIEW OF THE
MARKET PLACE AT JULIERS IN WESTPHALIA. | *The dutchy of Juliers is*
situate between the Maase and the Rhine, and bounded by the Prussian
Guilderland on the north, | *by the electorate of Triers on the south, by the electorate*
of Cologne on the east, and by the netherlands on the west, being | *about 60 Miles*
long, and 30 broad. This is a very plentiful country, abounding in corn, cattle and
fine meadows, and is | *plentifully supplied with wood, but is remarkable principally*
for a fine breed of horses, and wood for drying, which is | *gathered here in abundance.*
The Chief Towns are, Juliers, Aix la Chappelle, Duren, Munster, Bedbur,
Wasenberg, and Lanstern.

Provenance: Desmond Coke, his sale Christie's 22 Nov. 1929, lot 1, to
Dunthorne; Harcourt Johnstone, his sale Sotheby's 12 June 1940, lot 95; J. Leslie
Wright; R. E. Hemphill, sold Christie's 22 Feb. 1966, lot 168, to Colnaghi;
acquired 1966.
Exhibitions: Leamington Spa Art Gallery and Museum; Bristol, Loan Exhibition,
1947, No. 79.
Bibliography: Baskett and Snelgrove, No. 48; Desmond Coke, *Confessions of an*
Incurable Collector (London, 1928), facing p. 122, Pl. 26; Hayes, p. 19; Basil S.
Long, 'Rowlandson Drawings in the Desmond Coke Collection,' *Connoisseur*,
79 (Dec. 1927), 204, Fig. 1, 210; Oppé, p. 14, Pl. 33.

Rowlandson made several tours to the Continent during the 1790s, at least one
of them in the company of the banker Matthew Michell, his friend and patron.
Henry Angelo tells us that 'On this tour, Rowlandson made many topographi-
cal drawings, in general, views of cities and towns; amongst others, the High-
street at Antwerp, and the Stadthouse at Amsterdam, with crowds of figures,
grouped with great spirit, though his characters were caricatures.'[1]

The present drawing derives from a journey to Holland and Germany
apparently made in 1791.[2] Its size and elaborateness suggest that it may have
been worked up especially for Michell, who assembled the finest contemporary
collection of his Continental scenes.[3] A clue to the way Rowlandson went about
peopling the open spaces of large compositions like this one may lie in the view
paintings of Canaletto, of whose work he must have seen some examples. The
geometric patterns of light and shadow on the buildings form an interesting
contrast to the elegant embellishments of the architecture. See comments under
No. 30.

1. *Reminiscences of Henry Angelo* (London, 1828–30), I, 239. The view of the Place
 de Mer at Antwerp is dated 1794 (repr. Hayes, p. 155, Pl. 91); along with the
 drawing of the Stadhuis and two other scenes at Amsterdam, it was etched and
 then published by Rudolph Ackermann in 1797—the beginning of Rowlandson's
 long association with that enterprising publisher.
2. A drawing of a coach and post-house at Cologne (about thirty miles east of
 Juliers, now called Jülich), signed and dated 1791, is in the Art Institute of
 Chicago, Clarence Buckingham Collection. Views of Düsseldorf (repr. Hayes,
 p. 18, Fig. 5) and The Hague, both dated 1791, have also survived. See No. 32
 above.
3. Angelo, *Reminiscences*, I, 237.

34. *The Singers. Ca. 1790–95.*

Pen and watercolor over pencil, on wove paper, 5½ × 4¾ in. (139 × 119 mm).
Provenance: E. Parsons and Sons; S. Girtin; Tom Girtin; John Baskett;
acquired 1970.
Exhibitions: Cambridge, Fitzwilliam Museum, Drawings by the Early English
Watercolourists, 1920, No. 46; London, Arts Council of Great Britain,
Humorous Art, 1949–50, No. 3; Sheffield, Graves Art Gallery, Early Water-colours
from the Collection of Thomas Girtin, Jnr., 1953, No. 91; London, Royal
Academy, The Girtin Collections, 1962, No. 101; New Haven, Yale Center for
British Art, The Pursuit of Happiness, 1977, No. 71.
Bibliography: Baskett and Snelgrove, No. 247; Sutton, pp. 282–83, Fig. 17.

Despite the reinforcement provided by dark areas of wash, the line is thin and
loose and does little to suggest contour (notice especially the principal singer's
forearms). The attractive coloring helps to compensate for the flatness of the
forms. The presentation is satirical, but stops short of being caricature. The
question of whether the singers are performing in an opera or a concert, as has
been variously conjectured, seems beside the point. No specific occasion is ap-
parently represented, and the heads do not seem to be those of identifiable sing-
ers, though Rowlandson did make a number of drawings of musical and
theatrical personalities.[1]

> 1. For example, the dancer Madame Théodore in *The Prospect Before Us* (see below,
> No. 39), and the opera singer Brigitta Banti in a drawing owned by W. S. Lewis,
> Farmington, Connecticut.

35. *Smuggling Out. 1792.*

Pen and watercolor over pencil, on wove paper, 10¾ × 8 in. (274 × 203 mm).
Signed and dated in ink, lower left: *Rowlandson. 1792*
Etched by H. J. Schütz and published by Rudolph Ackermann 8 Aug. 1798 as
Smuggling Out or Starting for Gretna Green (Grego, II, 407); reissued as before
8 Aug. 1810 (Grego, II, 190).[1]
Provenance: Agnew; acquired 1965.
Exhibitions: London, Whitechapel Art Gallery, 1965, No. 25.
Bibliography: Baskett and Snelgrove, No. 169; Hayes, pp. 53, 156–57, Pl. 92;
Sutton, pp. 278–79, Fig. 3.

The elopement begins with the young officer helping his pretty inamorata to
escape the confines of a boarding school. In making her descent from the bal-
cony, she provides him with a revealing display of her charms. A post chaise
stands waiting for the journey to Gretna Green, famous for its runaway mar-
riages.

This scene of amorous adventure, which would have served very well as
an illustration for a novel, epitomizes Rowlandson's humor and high spirits.
The clean, tight line and the bright coloring make it a particularly decorative
example of his work from the early 1790s. A companion drawing, showing a

trio of undergraduates hauling up a young woman into their rooms, was etched and published with the title *Smuggling In or a College Trick*.[2]

1. A later copy of the etching (not by Rowlandson), in the reverse direction, is reproduced in Gert Schiff, *The Amorous Illustrations of Thomas Rowlandson* ([New York], Cythera Press, 1969), Pl. 45.
2. Grego, II, 190. Impressions of both prints as first published in 1798 are in the Metropolitan Museum of Art.

36. *Distress. Ca. 1790–95.* PLATE XXI

Pen and watercolor over pencil, on wove paper (missing right-hand area of sail replaced), 12¼ × 17⅛ in. (311 × 434 mm).
Engraved and published by Thomas Palser, Surrey side, Westminster Bridge, ?1799 as *Distress* (Grego, I, 372–74 [repr.]).
Provenance: Dr. T. C. Girtin; G. W. Girtin; Tom Girtin; John Baskett; acquired 1970.
Exhibitions: Cambridge, Fitzwilliam Museum, Drawings by the Early English Watercolourists, 1920, No. 46.
Bibliography: Baskett and Snelgrove, No. 275; Gully, pp. 31, 271, Fig. 29; F. G. Klingender, *Hogarth and English Caricature* (London and New York, 1944), pp. 22–23, Fig. 40; Oppé, p. 18, Pl. 45.

The genesis of *Distress* is complicated and uncertain. A large drawing by Rowlandson, signed and dated 1798, was sold at auction in 1912 and was listed in a dealer's catalogue three years later as '"Distress" or Captain Englefield's Miraculous Escape from the Loss of the Centaur.'[1] The present whereabouts of this drawing is not known, but it seems very likely that the subject was the same as that of a print, published with the title *Distress*, which almost certainly was engraved from the drawing exhibited here.[2] Two other versions of the subject are known: one in the Harry Elkins Widener Collection at Harvard;[3] the other, inscribed in Rowlandson's hand 'ROWLANDSON 1796', in the Albert H. Wiggin Collection, Boston Public Library. The Widener version, which is not in the manner of a 'finished' work, appears to be a preliminary study for the Mellon drawing, although in a few details it is closer to the Wiggin version. The Mellon drawing seems clearly to be earlier (perhaps by several years) than the Wiggin version.[4] The evidence as it now stands thus suggests that the design for *Distress* was begun in the early or mid 1790s with a preliminary study (Widener), from which a finished drawing (Mellon) was executed soon afterwards; a repetition (Wiggin) was made later (in 1796, if Rowlandson's date is trustworthy), possibly from the preliminary study still in Rowlandson's possession; another repetition (missing), apparently on a larger scale, followed in 1798.

The *Centaur*, captained by John Nicholson Inglefield, was one of a large fleet of men-of-war returning to England from Jamaica in September 1782. The ship sank following a furious storm off the Banks of Newfoundland, twelve crew members, including Captain Inglefield, escaping in the pinnace before she went down. 'The tale of those who survived,' writes the naval historian William

Laird Clowes, 'is one of the most piteous records of human agony—mental and physical.'⁵ After enduring extreme hardship for sixteen days, during which one of the men died, they reached the Azores. At some later time, Rowlandson would doubtless have read or heard accounts of their survival. In his remarkable drawing, the faces of the men express individually, and with powerful realism, the terrors and misery of their situation. Rowlandson seems to aspire to the kind of 'psychological' drama that history painters of the period tried to represent in their scenes of battles and other calamitous events.

Distress has been suggested as a possible source for Gericault's *Raft of the Medusa* and Delacroix's *Shipwreck of Don Juan* and *Christ on the Lake of Gene-zareth*.⁶ But these later artists need not have turned to Rowlandson for their inspiration. The genre had been already established by pictures such as James Northcote's *The·Loss of the Halsewell, East Indiaman, on the 6th of January, 1786*, which was exhibited at the Royal Academy later that year.

1. Sold Christie's 12 Feb. 1912 (Property of a Gentleman), lot 104; offered for sale by M. Knoedler and Co., Catalogue of an Exhibition of Water Colors by Thomas Rowlandson, 1–15 March 1915, No. 64. In the Christie sale catalogue the size of the drawing is given as 18 by 30 inches.

2. The engraving is reproduced by Grego (I, 373), who assigns a conjectural publication date of 1799. He states (I, 25) that the engraving was done 'from a large picture.' I have been unable to locate an impression; the conjectural date may well be erroneous.

3. Repr. Richard M. Baum, 'A Rowlandson Chronology,' *Art Bulletin*, 20 (Sept. 1938), 245, Fig. 6.

4. All three drawings are of approximately the same size, in pen (red and brown ink) and watercolor over pencil, on wove paper. Rowlandson may have begun to use red ink in the early 1790s.

5. *The Royal Navy* (London, 1897–1903), IV, 88. A detailed narrative of their survival is given in Isaac Schomberg, *The Naval Chronology*, new edition (London, 1815), II, 101–03.

6. Baum, op. cit., p. 244; F. D. Klingender, *Hogarth and English Caricature* (London and New York, 1944), p. 23.

37. *The Connoisseurs. Ca. 1790–95.* PLATE XXII

Pen and watercolor over pencil, on wove paper, 9 × 12⅛ in. (228 × 309 mm). Inscribed in ink in a later hand on mount below drawing: *The Connoisseurs.*

Provenance: Louis Deglatigny (Lugt 1768a); C. R. Rudolph; Colnaghi; acquired 1963.

Exhibitions: London, P. and D. Colnaghi and Co., and New Haven, Yale University Art Gallery, English Drawings and Watercolors from the Collection of Mr. and Mrs. Paul Mellon, 1964/65, No. 26.

Bibliography: Baskett and Snelgrove, No. 194; Paulson, pp. 84, [106], Fig. 48; Paulson, 'The Artist, the Beautiful Girl, and the Crowd: The Case of Thomas Rowlandson,' *Georgia Review*, 31 (Spring 1977), 136, [156], Fig. 17; Yale Center for British Art, *Selected Paintings, Books & Drawings* (New Haven, 1977), p. 62 (repr.).

Elderly connoisseurs admiring a picture of a pretty girl (or the real thing) are the subject of many Rowlandson drawings from the 1790s onwards.[1] The distinction between connoisseurship and voyeurism—evaluating and ogling—is often treated in a deliberately ambiguous way. Here the theme is elaborated ironically: the painting on the easel is 'Susannah and the Elders,' a scene representing the very activity that the connoisseurs are engaged in. Susannah and the Elders seems to have been Rowlandson's favorite biblical story. The 1828 sale catalogue of his art collection mentions an engraving of 'Susannah and the Elders' by Earlom after Rembrandt, as well as two different engravings of the same by Vorsterman, and there were doubtless others not listed.[2]

This drawing is interesting technically as an early example of Rowlandson's use of red ink (vermilion mixed with brown) to enrich his penwork. Notice also the great variations in the thickness of line, especially on the coat of the connoisseur whose back is turned. A related, later drawing of similar design, but with a mythological painting (the fall of Phaeton) on the easel, is in the Huntington Art Gallery.[3]

1. Several of the drawings or engravings are discussed in Paulson, pp. 83–85.
2. Sotheby's, 23–26 June 1828, lots 47 and 247.
3. Wark, p. 60, No. 117. Cf. *Connoisseurs*, engraved and published in 1799 (Grego, I, 364, 366).

38. *A Worn-out Débauché. Ca. 1790–95.* PLATE V

Pen and watercolor over pencil, on laid paper, 11⅞ × 7⅞ in. (302 × 201 mm).
Inscribed in pencil in Rowlandson's hand, lower right: *A Worn out Debauchée—*
Provenance: Lady Dorothy Nevill; T. E. Lowinsky (Lugt 2420a); Justin Lowinsky; acquired 1963.
Exhibitions: Paris, Musée des Arts décoratifs, Caricatures et mœurs anglaises 1750–1850, 1938, No. 102; New York, Pierpont Morgan Library, and London, Royal Academy, English Drawings and Watercolors 1550–1850 in the Collection of Mr. and Mrs. Paul Mellon, 1972/73, No. 70.
Bibliography: Baskett and Snelgrove, No. 162; Ralph Nevill, 'Thomas Rowlandson,' *Connoisseur*, 2 (Jan. 1902), 45, 47 (repr.); Sutton, pp. 284–85, Fig. 19; Cornelis Veth, *Comic Art in England* (London, 1930), Pl. XXIII.

For sheer elegance of line and subtlety of tint, this is perhaps as fine a drawing on a small scale as Rowlandson ever produced. The contours are deftly defined with the brush, and the flexible penwork brilliantly expresses the superannuated character of the rake as he steps along with his 'dolly' in tow. His face is a caricature, yet it appears to be a perfectly natural aspect of his thin, angular profile. The drawing has close affinities, in terms of style, coloring, and figure types, with *Mrs. Siddons Rehearsing* in the Huntington Art Gallery.[1]

When *A Worn-out Débauché* was reproduced for the first time in 1902,[2] the rake was identified as 'Old Q'—the sobriquet of the fourth Duke of Queens-

berry (1725–1810). A celebrated gambler, philanderer, and figure at Court, Queensberry had turned seventy when he was described in these verses:

> And there, insatiate yet with folly's sport,
> That polish'd sin-worn fragment of the court,
> The shade of Q—nsb'ry should with Cl-rm-nt meet,
> Ogling and hobbling down St. James's street.[3]

It seems not unlikely that Rowlandson introduced the débauché in his drawing as a satirical portrait of 'Old Q' wearing his star as Knight of the Thistle. He is the subject of a smaller drawing by Rowlandson (5½ × 7 inches) in the collection of Augustus P. Loring, Prides Crossing, Massachusetts.

1. See 'Rowlandson's "Mrs. Siddons Rehearsing"' in Robert R. Wark, *Ten British Pictures 1740–1840* (San Marino, 1971), pp. 67–77 (repr. in color, Fig. 48).
2. See the article cited above in the bibliography.
3. Thomas James Mathias, *The Imperial Epistle from Kien Long . . . to George the Third . . . in the Year 1794* (London, [?1795]), p. 16.

39. *Female Dancer with a Tambourine. Ca. 1790–95.* PLATE XXIII

Pen and watercolor over pencil, on wove paper, 11⅝ × 8¾ in. (296 × 221 mm).
Provenance: Louis Deglatigny (Lugt 1768a), his sale Sotheby's 11 May 1938, lot 114; T. E. Lowinsky (Lugt 2420a); Justin Lowinsky; acquired 1963.
Exhibitions: Aldeburgh, Legion Hall, 1964, No. 38; London, P. and D. Colnaghi and Co., and New Haven, Yale University Art Gallery, English Drawings and Watercolors from the Collection of Mr. and Mrs. Paul Mellon, 1964/65, No. 28.
Bibliography: Baskett and Snelgrove, No. 244; Paulson, pp. 81, [105], Fig. 45.

This theatrical scene is typically Rowlandsonian in its concentration on the pretty girl being ogled from below by elderly men, who lean forward to get a closer view. The central figure is stylistically similar to that of the girl in the preceding drawing. A sufficiently close resemblance, in attitude and dress, exists between this dancer and Madame Théodore in Rowlandson's *The Prospect Before Us* (No. 2)[1] to suggest an identification for her.

1. The drawing, in a private collection, is reproduced in Falk, facing p. 108, and in the exhibition catalogue by Geoffrey Ashton and Iain Mackintosh, *The Georgian Playhouse: Actors, Artists, Audiences and Architecture 1730–1830* (London: Arts Council of Great Britain, 1975), No. 266a. For the etching, published 13 Jan. 1791, see Grego, I, 285–87 (repr.); *B.M. Satires*, No. 8008.

40. *Would You Please to Have Another Cup of Tea? Ca. 1790–95.*

Pen and watercolor over pencil, on laid paper, 5⅞ × 9 in. (150 × 230 mm); contemporary mount.
Inscribed in ink in Rowlandson's hand across bottom: *Would you please to have another Cup of Tea—*
Verso: pencil sketch of a man with his hand resting against his cheek.

Provenance: Colnaghi; acquired 1965.
Exhibitions: London, P. and D. Colnaghi and Co., Exhibition of English Drawings and Watercolours, 1965, No. 30.
Bibliography: Baskett and Snelgrove, No. 225.

The gentle satire in this scene from everyday life emerges not from any incident or mishap, but simply from Rowlandson's keen observation of social gesture and attitude. All the women are ladies of fashion, dressed in the latest modes, and Rowlandson is less interested here in what they do than in how they do it. This attractively composed drawing, in Rowlandson's rapid, loose style of the early 1790s, uses red ink and wash that is almost monochrome. Notice the pentimento pencil line above the tea tray, indicating Rowlandson's original idea for one of the figures.

41. *Interior of a Dressing Room. Ca. 1790–95.*

Pen and watercolor over pencil, on laid paper (two joined sheets), 5 × 8¼ in. (127 × 211 mm).
Provenance: Frank T. Sabin, 1948 (No. 1 in catalogue); Manning Galleries; acquired 1969.
Bibliography: Baskett and Snelgrove, No. 258; Bury, p. 80, Pl. 11.

This intimate view of theatrical life behind the scenes recalls Rowlandson's portrait sketch of John Bannister in his dressing room (see above, No. 3). It has been pointed out that the central figure in the drawing resembles Bannister, but there is no other evidence for this identification. After carefully arranging his composition from a low angle of vision, and executing the principal figures in some detail, Rowlandson seems to have put the drawing aside, though not before applying colored wash to the background and the middle ground in a rather heavy, uneven manner. The actress's hairstyle is a creation worthy of Fuseli.

42. *Travelling in France. Ca. 1790–95.* PLATE VIII

Pen and watercolor over pencil, on laid paper, 11¼ × 17½ in. (287 × 445 mm).
Verso: color splashes.
Provenance: Charles Russell, his sale Sotheby's 30 Nov. 1960, lot 84, to Colnaghi; acquired 1960.
Exhibitions: Washington, National Gallery of Art, An Exhibition of English Drawings and Water Colors from the Collection of Mr. and Mrs. Paul Mellon, 1962, No. 68.
Bibliography: Baskett and Snelgrove, No. 153.

The scene is the courtyard of a French post inn during the departure of a lumbering basketwork *diligence*. The subject is a favorite one with Rowlandson, recalling his travels to France in the last years of the *ancien régime*.[1] As the *diligence* moves off, a postilion changes the horses on a curricle standing in front of the inn. An elaborately framed sign on the inn reads, LION D'ARGEANT | ICI

ON DONNE BONNE | A MANGER PAR | J. MAIGRE, TRAITEUR. At the extreme left, two men (one of them, probably Rowlandson himself, sketching the scene) observe the departure.

Rowlandson began the design with a preliminary sketch,[2] probably made on the spot, but he ended up nevertheless with a composition that seems awkward and overcrowded. The medley of shapes and surfaces calls for a simpler arrangement. In any event, Rowlandson gives us a faithful and detailed picture of the country, right down to the enormous jackboots worn by the postilions and the wooden *sabots* worn by the countryfolk. Notice that to English eyes, all Frenchmen appeared *maigre*.

The thin, sharp line used on many of the figures, as well as the naturalistic treatment of the foliage, suggests a date in the 1790s for this drawing, although it may have been done a few years earlier.

1. For another drawing of a French *diligence* in the Mellon Collection, see Baskett and Snelgrove, No. 152 (etched by Rowlandson and published by Thomas Tegg in 1810 [Grego, II, 189]).
2. Exhibited by Spink and Son Ltd., English Watercolour Drawings, 1975, No. 35.

43–52. *Scenes at Bath.*

The following ten drawings are related to each other by their subject matter—life and society at Bath—and are accordingly exhibited together. As the drawings themselves, and their connection with the aquatints published as *Comforts of Bath*, have been a source of considerable confusion, the evidence concerning them is discussed here in a preliminary note to the individual catalogue entries.

On 6 January 1798 S. W. Fores in Piccadilly published a series of twelve plates etched and presumably aquatinted by Rowlandson, entitled *Comforts of Bath*.[1] The drawings from which the plates were etched are not known to have survived as a complete set. It is extremely difficult, if not impossible, to identify from existing drawings those which served as the actual designs, because Rowlandson made many repetitions and versions with variations.

A set of nine drawings of scenes at Bath—five of them versions of designs etched for *Comforts of Bath*—was acquired by the well-known contemporary collector Sir James Winter Lake (ca. 1745–1807), 3d Bt., and remained in the possession of the Lake family until 1946. The drawings were contained in a volume that also included a manuscript 'Description chiefly taken from Mr. Anstey's New Bath Guide,' the doggerel verses of which were signed 'J. W. L.' Matthew Bramble (spelled 'Mathew' on the old mounts) and his sister Tabitha—both characters in Smollett's epistolary novel *The Expedition of Humphry Clinker*—figured in the manuscript 'Description,' and the volume as a whole was given the title 'Mathew Bramble's Trip to Bath.'[2]

Christopher Anstey's *The New Bath Guide: or, Memoirs of the B—n—d Family*, a witty satire in verse on Bath society, first appeared in 1766; its popularity led to many later editions, some of them illustrated with plates, including one published the year before *Comforts of Bath*. *Humphry Clinker*, which contains a famous episode recording the visit of Matthew Bramble and his family entourage to Bath,[3] was first published in 1771. While it is certain that Rowlandson was familiar with both these works, no direct connection exists between them and *Comforts of Bath*. In a general way, they may have suggested to Rowlandson several of the subjects treated in *Comforts of Bath*, but there is no evidence that the series of aquatints was intended to illustrate (in the strict sense of the word) either the poem or the novel.

The confusion which has grown up around the supposed connection is perhaps due chiefly to two circumstances. The first is that Rowlandson did produce designs for *Humphry Clinker* that were specifically commissioned to illustrate various editions of the novel.[4] None of these designs, however, corresponds to a plate in *Comforts of Bath*. The second circumstance is that in 1857 Robert Walker, a publisher in Harley Street, Bath, managed to acquire the original, well-preserved copperplates of *Comforts of Bath* and issued one hundred sets of new impressions, which were quickly sold. The following year he published another edition with appropriate quotations (slightly altered for the purpose) from Anstey's *New Bath Guide* printed below the plates, and a title page and 'Prefatory Remarks' explaining what he had done.[5] As if this were not misleading enough, Joseph Grego followed Walker by including the extracts from Anstey alongside the reproductions of the plates in his *Rowlandson the Caricaturist*. It may be further noted that *Comforts of Bath* as originally issued has been included in such authoritative bibliographical works as R. V. Tooley's *English Books with Coloured Plates*, even though the plates were not accompanied by a printed text.

The twelve designs which were etched in 1798 may have come from a larger number of drawings, all of which satirized life at Bath. As mentioned earlier, only five of the nine drawings from the Lake volume are versions of designs that were etched. The other four do not specifically illustrate 'Mathew Bramble's Trip to Bath' (a title supplied by Lake, not by Rowlandson) any more than *Comforts of Bath* illustrates *Humphry Clinker* or *The New Bath Guide*. On the other hand, they do seem to belong to a larger group of Bath scenes executed by Rowlandson. It is impossible to say with certainty when the nine Lake drawings were made, since none of them is dated and we do not know exactly when Lake purchased them. On stylistic grounds alone, they appear to have been done between 1790 and 1800, though probably not all at the same time or all before the publication of *Comforts of Bath* in 1798.

It remains to be said that eight of the nine drawings from the Lake volume are now in the Mellon Collection; the ninth, which was a version of No. 47, was sold with the others at Christie's in 1967 but was not acquired by Mr. Mellon.

Two of the ten drawings exhibited here were never part of the Lake volume. The heading *Scenes at Bath* has been assigned to the ten drawings for the purposes of this exhibition; it is not the title of a published work. The order of the drawings follows, whenever possible, the sequence of the plates in *Comforts of Bath*.

1. Abbey, *Scenery*, No. 40; Grego, I, 333–49; Tooley, No. 408; *B.M. Satires*, No. 9321.
2. Malcolm C. Salaman, *British Book Illustration Yesterday and To-day* (London, 1923), pp. 12–13; Christie's auction catalogue, *Fine English Drawings and Watercolours*, 14 March 1967, p. 28.
3. A few passages from this episode in the novel are quoted in the catalogue entries below.
4. The editions are as follows:
 (1) Smollett's *Miscellaneous Works*, 6 vols. (Edinburgh: J. and J. Fairbairn, 1790), vol. VI: one plate designed by Rowlandson and engraved by James Kirkwood.
 (2) *Humphry Clinker*, 2 vols. (London: H. D. Symonds and T. Kay, 1793): ten plates designed by Rowlandson and engraved by Charles Grignion.
 (3) *Humphry Clinker*, 2 vols. (London: Longman and Co., 1805): same plates as in (2), reissued.
 (4) Smollett's *Miscellaneous Works*, 5 vols. (Edinburgh: C. Elliot, 1809), vol. V: same plates as in (2) and (3), reissued.
 See T. C. Duncan Eaves, 'Graphic Illustrations of the Principal English Novels of the Eighteenth Century,' Ph.D. Dissertation, Harvard University, 1944, pp. 561–62, 570–75; Grego, I, 320; Edward C. J. Wolf, *Rowlandson and his Illustrations of Eighteenth Century English Literature* (Copenhagen, 1945), pp. 115–21.
5. A set of *Comforts of Bath* as reissued in 1857 with Walker's additional imprint is in the Print Room of the British Museum. The British Library has a copy of the 'book' published in 1858. Walker's 'Prefatory Remarks' are quoted in Wolf, op. cit., pp. 165–66.

43. *Scenes at Bath: The Arrival. Ca. 1790–95.*

Pen and watercolor over pencil, on laid paper, 4⅝ × 7⅜ in. (117 × 189 mm); contemporary mount.

Provenance: Sir James Winter Lake, Bt.; in the possession of the Lake family until 1946; Bernard Penrose, sold Christie's 14 March 1967, lot 112, to Colnaghi; acquired 1967.

Bibliography: Baskett and Snelgrove, No. 304.

The scene is probably Gay Street, one of the three streets entering the Circus, which appears in the background. The Circus was designed by John Wood the elder and built in 1754–67. Matthew Bramble in Smollett's *Humphry Clinker* refers to it as 'a pretty bauble, contrived for shew . . . like Vespasian's amphitheatre turned outside in.' (Smollett himself lived in Gay Street from 1766 to 1768.)

'Bath is to me a new world,' writes Bramble's niece Lydia Melford in *Humphry Clinker*. 'All is gayety, good-humour, and diversion. The eye is con-

tinually entertained with the splendour of dress and equipage; and the ear with the sounds of coaches, chaises, chairs, and other carriages. *The merry bells ring round*, from morn till night. Then we are welcomed by the city-waits in our lodgings; we have musick in the Pump-room every morning, cotillons every fore-noon in the rooms, balls twice a week, and concerts every other night, besides private assemblies and parties without number.'[1]

See the preliminary note to *Scenes at Bath*. This scene is not one of the subjects in *Comforts of Bath*.

1. *The Expedition of Humphry Clinker* (London, 1771), I, 75–76.

44. *Scenes at Bath: The Concert. Ca. 1795–1800.*

Pen and watercolor over pencil, on wove paper, 4¾ × 7⅜ in. (121 × 187 mm); contemporary mount.

Provenance: Sir James Winter Lake, Bt.; in the possession of the Lake family until 1946; Bernard Penrose, sold Christie's 14 March 1967, lot 111, to Colnaghi; acquired 1967.

Bibliography: Baskett and Snelgrove, No. 297; Malcolm C. Salaman, *British Book Illustration Yesterday and To-day* (London, 1923), pp. 12–13, 45; Sutton, pp. 281, 283, Fig. 16.

See the preliminary note to *Scenes at Bath*. The same subject appears as Plate 2 in *Comforts of Bath*, but the present drawing differs from the aquatint in so many details that it seems not likely to have served as the actual design for it. Another version, closer to the aquatint, is in the William A. Farnsworth Library and Art Museum, Rockland, Maine.

According to the manuscript 'Description' in the volume that formerly contained the drawing, the singer is Madame Mara. Gertrud Elisabeth Mara (1749–1833) was a celebrated German soprano who performed in England from 1784 to 1802.

45. *Scenes at Bath: The Music Master. Ca. 1790–95.*

Pen and watercolor over pencil, on laid paper, 4¾ × 7⅜ in. (120 × 188 mm); contemporary mount.

Provenance: Sir James Winter Lake, Bt.; in the possession of the Lake family until 1946; Bernard Penrose, sold Christie's 14 March 1967, lot 115, to Colnaghi; acquired 1967.

Bibliography: Baskett and Snelgrove, No. 305; Hayes, pp. 57, 59, Fig. 60.

See the preliminary note to *Scenes at Bath*. This scene is not one of the subjects in *Comforts of Bath*. Unlike most of the other drawings acquired by Sir James Winter Lake, this one is on laid paper; it was possibly made a few years earlier than the others. There is a later version of the subject in the collection of N. M. Fleishman, Vancouver, British Columbia.[1] Rowlandson used the basic composition for another drawing in the Mellon Collection.[2]

The situation represented in this drawing is one of the most frequently encountered in all of Rowlandson's *oeuvre*. His theme is simply that of youth (an attractive boy and girl, amorously inclined) contrasted with age (a much older spouse, parent, or guardian, ugly or infirm). The contrast sometimes takes the form of cuckoldry, as seems to be the case here, and it almost always involves age being fooled or outwitted by youth.[3]

1. Repr. Hayes, p. 59, Fig. 61.
2. Baskett and Snelgrove, No. 216.
3. This 'romantic triangle' is discussed at length in Paulson, pp. 71–79.

46. *Scenes at Bath: The Pump Room. Ca. 1795–1800.*

Pen and watercolor over pencil, on wove paper, 4¾ × 7⅜ in. (120 × 189 mm); contemporary mount.

Provenance: Sir James Winter Lake, Bt.; in the possession of the Lake family until 1946; Bernard Penrose, sold Christie's 14 March 1967, lot 113, to Colnaghi; acquired 1967.

Bibliography: Baskett and Snelgrove, No. 298; Oppé, p. 16, Pl. 47.

See the preliminary note to *Scenes at Bath*. The same subject appears as Plate 3 in *Comforts of Bath*, but the present drawing differs from the aquatint in numerous details and almost certainly did not serve as the actual design for it. A version closer to the aquatint (present whereabouts unknown) was reproduced by Frank Jewett Mather in his article 'Some Drawings by Thomas Rowlandson' published in 1912,[1] and there is another version in the collection of Philip Pinsof, Highland Park, Illinois.

The Pump Room of Rowlandson's day was built between 1791 and 1795 from designs by Thomas Baldwin and John Palmer. In Smollett's *Humphry Clinker*, Lydia Melford tells of going to drink the waters:

> At eight in the morning, we go in dishabille to the Pump-room; which is crowded like a Welsh fair; and there you see the highest quality, and the lowest trades folks, jostling each other, without ceremony, hail-fellow well-met. The noise of the musick playing in the gallery, the heat and flavour of such a crowd, and the hum and buz of their conversation, gave me the head-ach and vertigo the first day. . . . I content myself with drinking about half a pint of the water every morning.
>
> The pumper, with his wife and servant, attend within a bar; and the glasses, of different sizes, stand ranged in order before them, so you have nothing to do but to point at that which you chuse, and it is filled immediately, hot and sparkling from the pump.[2]

The niche in the wall beyond the bar contains the famous statue of 'Beau' Nash, the Master of Ceremonies at Bath for over fifty years.

1. *Print-Collector's Quarterly*, 2 (Dec. 1912), 395. The size of this drawing is
 5 × 7½ inches.
2. *The Expedition of Humphry Clinker* (London, 1771), I, 76–78.

47. *Scenes at Bath: The Bath. Ca. 1795–1800.*

Pen and watercolor over pencil, on wove paper, 4¼ × 7⅛ in. (108 × 181 mm).
Provenance: Maas Gallery; acquired 1964.
Exhibitions: New Haven, Yale Center for British Art, The Pursuit of Happiness,
1977, No. 14.
Bibliography: Baskett and Snelgrove, No. 299.

See the preliminary note to *Scenes at Bath*. The same subject appears as Plate 7
in *Comforts of Bath*, but the present drawing differs from the aquatint in numer-
ous details: for example, the tower-like structure in the center is missing in the
aquatint. A drawing very similar to this one, from the collection of Sir James
Winter Lake and his descendants, was sold at Christie's on 14 March 1967
(Property of Bernard Penrose), lot 114,[1] and there is another version (with the
tower) in the William A. Farnsworth Library and Art Museum.

In the later eighteenth century, when Bath was the most fashionable spa in
England, there were several public and private baths in use. They were sup-
plied daily with fresh water from the hot springs by a system of sluices and
drains. The hours appointed for bathing were before breakfast, between six and
nine o'clock. Lydia Melford in Smollett's *Humphry Clinker* describes the morn-
ing ritual:

> Right under the Pump-room windows is the King's Bath; a huge
> cistern, where you see the patients go up to their necks in hot water.
> The ladies wear jackets and petticoats of brown linen, with chip hats,
> in which they fix their handkerchifs to wipe the sweat from their faces;
> but, truly, whether it is owing to the steam that surrounds them, or the
> heat of the water, or the nature of the dress, or to all these causes
> together, they look so flushed, and so frightful, that I always turn my
> eyes another way.[2]

1. Reproduced in the sale catalogue; present whereabouts untraced.
2. *The Expedition of Humphry Clinker* (London, 1771), I, 77.

48. *Scenes at Bath: Gouty Gourmands at Dinner. Ca. 1798–1800.*

Pen and watercolor over pencil, on wove paper, 5⅛ × 7⅞ in. (129 × 200 mm).
Provenance: Sir Bruce Ingram (Lugt 1405a); Charles Sawyer; acquired 1965.
Bibliography: Baskett and Snelgrove, No. 300; F. Gordon Roe, 'Drawings by
Rowlandson: Captain Bruce S. Ingram's Collection,' *Connoisseur*, 118 (Dec. 1946),
91 (repr.).

See the preliminary note to *Scenes at Bath*. The same subject appears as Plate 9
in *Comforts of Bath*. The present drawing is very similar to the aquatint; it may

have served as the actual design, although it has more the appearance of being a copy after the print. The gouty man in the Bath chair at left also appears in Plate 4 of *Comforts of Bath*, making purchases at a fish-stall for his dinner, as well as in other plates in the series.

49. *Scenes at Bath: Private Practice Previous to the Ball. Ca. 1790–95.*

Pen and watercolor over pencil, on laid paper, 5 × 7⅜ in. (126 × 186 mm); contemporary mount.

Provenance: Sir James Winter Lake, Bt.; in the possession of the Lake family until 1946; Bernard Penrose, sold Christie's 14 March 1967, lot 116, to Colnaghi; acquired 1967.

Bibliography: Baskett and Snelgrove, No. 306.

See the preliminary note to *Scenes at Bath*. This scene is not one of the subjects in *Comforts of Bath*. As in the case of *The Music Master* (above, No. 45), the drawing is on laid paper and was possibly made a few years earlier than the other drawings from the collection of Sir James Winter Lake and his descendants.

50. *Scenes at Bath: The Ball. Ca. 1795–1800.*

Pen and watercolor over pencil, on wove paper, 4⅞ × 7⅜ in. (125 × 189 mm); contemporary mount.

Provenance: Sir James Winter Lake, Bt.; in the possession of the Lake family until 1946; Bernard Penrose, sold Christie's 14 March 1967, lot 117, to Colnaghi; acquired 1967.

Bibliography: Baskett and Snelgrove, No. 301; Sutton, pp. 281–82, Fig. 12.

See the preliminary note to *Scenes at Bath*. The same subject appears as Plate 10 in *Comforts of Bath*, but the present drawing differs from the aquatint in numerous details; the aquatint is more crowded with figures. A version closer to the aquatint (particularly the figures in the orchestra) is in the Victoria Art Gallery, Bath,[1] and there are other versions in the Auckland City Art Gallery[2] and in the William A. Farnsworth Library and Art Museum.

The scene is the ballroom of the New (or Upper) Assembly Rooms, built in 1769–71 from designs by John Wood the younger. Lydia Melford in Smollett's *Humphry Clinker* once again provides a commentary:

> After all, the great scenes of entertainment at Bath, are the two public rooms; where the company meet alternately every evening—They are spacious, lofty, and, when lighted up, appear very striking. They are generally crowded with well-dressed people, who drink tea in separate parties, play at cards, walk, or sit and chat together, just as they are disposed. Twice a-week there is a ball; the expence of which is defrayed by a voluntary subscription among the gentlemen; and every subscriber has three tickets.[3]

1. Repr. [Denys Sutton], 'Realms of Enjoyment,' *Apollo*, 98 (Nov. 1973), 333, Fig. 8.
2. Repr. (Pl. II) in the *Supplement* (1975) to *A Collection of Drawings by Thomas Rowlandson 1757–1827* (Auckland: City Art Gallery, 1958).
3. *The Expedition of Humphry Clinker* (London, 1771), I, 81.

51. *Scenes at Bath: The Breakfast. Ca. 1795–1800.*

Pen and watercolor over pencil, on wove paper, 4¾ × 7½ in. (121 × 192 mm); contemporary mount.

Provenance: Sir James Winter Lake, Bt.; in the possession of the Lake family until 1946; Bernard Penrose, sold Christie's 14 March 1967, lot 118, to Colnaghi; acquired 1967.

Bibliography: Baskett and Snelgrove, No. 302.

See the preliminary note to *Scenes at Bath*. The same subject appears as Plate 11 in *Comforts of Bath*, but the present drawing differs from the aquatint in numerous details: for example, the male figure in the foreground welcoming his guests is replaced in the aquatint by a fat, gouty man seated in a Bath chair. Another version of this subject was shown at the Grolier Club exhibition in November 1916.[1]

Public breakfasts at the Assembly Rooms were a common feature of social life at Bath. Some breakfasts were private parties at which people of fashion entertained their friends and held morning concerts, while others were open to any of 'the company' at Bath who cared to attend.

1. No. 8 in the large-paper edition of the exhibition catalogue; present whereabouts unknown.

52. *Scenes at Bath: Overturn on the Circus Hill. Ca. 1795–1800.*

PLATE XXIV

Pen and watercolor over pencil, on wove paper, 4⅞ × 7⅜ in. (123 × 187 mm); contemporary mount.

Verso: color splashes.

Provenance: Sir James Winter Lake, Bt.; in the possession of the Lake family until 1946; Bernard Penrose, sold Christie's 14 March 1967, lot 119, to Colnaghi; acquired 1967.

Bibliography: Baskett and Snelgrove, No. 303.

See the preliminary note to *Scenes at Bath*. A related subject appears as Plate 12 in *Comforts of Bath*, but the present drawing differs in so many respects (primarily the figures) from the aquatint that the two cannot properly be considered as versions of the same composition. A drawing closely resembling this one is in the Victoria Art Gallery, Bath. The William A. Farnsworth Library and Art Museum has a weaker version of this subject, and also a drawing whose composition is the same as that of the aquatint.

The scene is apparently the steep hill just below Lansdown Crescent (designed by John Palmer and built 1789–91), to the north of the Circus. A similar

subject, showing lame and crippled persons descending the hill on crutches and in Bath chairs, was designed by Rowlandson, etched, and published in 1810 with the title *Bath Races.*[1]

1. Grego, II, 194; *B.M. Satires*, No. 11640.

53. *Laborers at Rest. Ca. 1790–95.*

Pen and watercolor over pencil, on laid paper, 5½ × 8¼ in. (139 × 210 mm); contemporary mount.
Inscribed in pencil, possibly in Rowlandson's hand, on mount below drawing: *Labourers at Rest*
Provenance: Gilbert Davis (Lugt 757a); Colnaghi; acquired 1961.
Exhibitions: London, Whitechapel Art Gallery, 1953, No. 77; Washington, National Gallery of Art, An Exhibition of English Drawings and Water Colors from the Collection of Mr. and Mrs. Paul Mellon, 1962, No. 67; V.M.F.A., 1963, No. 416.
Bibliography: Baskett and Snelgrove, No. 82.

Subdued tones of blue, brown, and gray enhance the quiet mood of this simply but gracefully composed scene. Rowlandson has sketched the figures rapidly, giving strong reinforcement to some of the contours using both pen and brush. The loose, naturalistic treatment of the foliage recalls that in *Two Greyhounds Lying under a Tree* (No. 26 above). The sleeping dog on the left not only adds a picturesque note, but serves to anchor the figure group within the composition. Although the drawing may have been done from life, it was possibly influenced by genre scenes of Nicolaes Berchem (1620–83), a Dutch forerunner of the Rococo whose etchings were collected by Rowlandson.

54. *River Landscape with a Waterfall. Ca. 1795–1800.*

Pen and watercolor over pencil, on wove paper, 5¾ × 8⅜ in. (145 × 214 mm).
Provenance: Desmond Coke, his sale Sotheby's 21 July 1931, lot 59; Martin Hardie; Colnaghi; acquired 1961.
Exhibitions: Reading Museum and Art Gallery, 1962, No. 31; V.M.F.A., 1963, No. 418.
Bibliography: Baskett and Snelgrove, No. 61.

Examples of pure landscape by Rowlandson are relatively uncommon before the mid 1790s. This imagined scene, probably dating from that time, could have been dictated by the compositional formulae of William Gilpin: it is a pretty but conventional essay in the Picturesque. A strong sense of depth is achieved by the heavy, dark penwork on the rocks in the foreground, with bright sunlight playing over the river bank and the hills in the distance. The starkly outlined tree on the left is an obvious *repoussoir* framing the background. The nervous, mannered handling of the branches and foliage hints at Rowlandson's exaggerated rococo landscape style in other drawings of the 1790s such as *The Picnic* (No. 68 below).

55. *Embarkation of Lord Moira's Troops at Southampton, 20 June 1794 (Preliminary Study). 1794.*

Pen and gray wash over pencil, on laid paper, 8½ × 11⅛ in. (217 × 282 mm).
Inscribed in pencil in a later hand, upper right: *June 20th after Ld Hows Action*
[lower right] *Embarcation at Southampton*
Inscribed in pencil in a different hand on the verso: *Embarcation at Southampton | June 20th | after Lord How's action*
Provenance: Louis Deglatigny (Lugt 1768a), his sale Sotheby's 11 May 1938, lot 111; Iolo A. Williams; Colnaghi; acquired 1964.
Bibliography: Baskett and Snelgrove, No. 288.

This is a preliminary sketch for the drawing that follows, offering a rare opportunity to follow the progress of a composition at first hand. Though one might expect an on-the-spot sketch to be worked up later into a drawing on a larger scale, here Rowlandson has done just the opposite: the monochrome study (probably a verso page from a sketchbook) comprises only the left half of the scene, yet it is even larger than the finished drawing. It is not known whether the right-hand portion of the study has survived.

The sketch has been quickly executed, but Rowlandson must have planned the overall composition beforehand with some care. The trees, the buildings, and the mass of figures on the left are successfully integrated and balanced against the fleet of men-of-war anchored offshore on the right; only minor shifts in the placement of objects occur in moving from the sketch to the finished drawing. The sketch contains virtually all of the realistic detail found in the drawing—including even the man who is relieving himself next to the wall of the cottage in the foreground—and manages to project a stronger feeling of immediacy and activity.

The occasion is identified in the following catalogue entry.

56. *Embarkation of Lord Moira's Troops at Southampton, 20 June 1794. Ca. 1794.*

Pen and watercolor over pencil, on wove paper, 4¾ × 12 in. (120 × 305 mm); contemporary mount.
Provenance: Brigadier C. Huxley; Agnew; acquired 1962.
Bibliography: Baskett and Snelgrove, No. 289.

See comments under No. 55. Following Lord Howe's victory over the French fleet on the 'Glorious First of June,' 1794, Rowlandson joined his friend Henry Angelo at Portsmouth to watch the landing of the French prisoners. Later they visited the prisoners, some of them wounded and dying, in Forton prison (see above, No. 18). 'The next day,' Angelo writes,

> having seen quite enough, I returned to town. Rowlandson went to
> Southampton, where he made a number of sketches of Lord Moira's

embarkation for La Vendée. I saw them afterwards, and was delighted, for it appeared he had taken more pains than usual, and he must have pourtrayed them well, from having been on the spot himself at the time. The shipping, and the various boats filled with soldiers, were so accurately delineated, that I have often since regretted that I did not at that time purchase them. Mr. Fores, of Piccadilly, who has by him many of the very finest drawings, . . . fortunately purchased them.[1]

The present drawing is probably one of those seen by Angelo, after it had been worked up from the sketch made on the spot (No. 55). His comment about Rowlandson's taking 'more pains than usual' is borne out by the fine detail and meticulous (unfaded) coloring in this panoramic view. But as Austin Dobson was the first to point out, Angelo has confused Lord Moira's departure for Ostend on 20 June 1794 with his expedition to La Vendée of the previous year. The scene represents Moira's embarkation from Southampton, with reinforcements numbering several thousand men, to join the Duke of York's army in Flanders.[2]

1. *Reminiscences of Henry Angelo* (London, 1828–30), II, 294.
2. Dobson, *A Paladin of Philanthropy and Other Papers* (London, 1899), pp. 76–77. For details of the embarkation, see J. W. Fortescue, *A History of the British Army* (London, 1899–1930), IV, 281–82.

57. *French Prisoners on Parole at Bodmin, Cornwall. 1795.*

Pen and watercolor over pencil, on wove paper, 9⅜ × 15⅛ in. (237 × 384 mm); contemporary mount.
Inscribed in ink, probably in Rowlandson's hand, on mount below drawing:
FRENCH PRISONERS | ON PAROLE. | AT BODMIN CORNWALL. | 1795.
Inscribed in ink in a contemporary hand on verso of mount: *My Dear Rowlandson | I shall be at home and alone, if you will favour me with a call I shall be happy | CN* [in pencil in Rowlandson's hand] *Dear Bess | Am Obliged to dine out shall not be able to call on you | before ten O Clock*
Provenance: Arthur Russell Johnson, sold Christie's 13 July 1965, lot 151, to Colnaghi; acquired 1965.
Bibliography: Baskett and Snelgrove, No. 15; H. L. Douch, *Old Cornish Inns and their Place in the Social History of the County* (Truro, 1966), p. 81, Pl. I.

Rowlandson's friendship with the banker Matthew Michell led to many visits at Hengar House, Michell's country estate near Bodmin in Cornwall. From the mid 1790s until Michell's death in 1817, these convivial excursions provided Rowlandson with opportunities to sketch the picturesque Cornish countryside. Among the numerous drawings he made were those engraved and published in 1812 as *Etchings of Landscapes from Scenes in Cornwall.*[1]

This drawing and the following one are apparently a pair, both scenes of the market place at Bodmin, executed in the same style and from a similar viewpoint. Rowlandson seems to have admired the quaint old houses and inns, with

their tiled roofs and rough-hewn wooden pillars outside the entrances. In the Wiggin Collection, Boston Public Library, there is a drawing which shows a larger area of the market place,[2] and several versions of the *Arrival of the Stage Coach at Bodmin* (the companion, No. 58) are known.

British victories over the French fleet in 1794 and following years resulted in large numbers of prisoners being held in the southwest of England. Here a group of prisoners 'on parole' is shown mingling freely with the townsfolk in front of the Lion Inn at Bodmin. The street bustles with activity. Through an open window above, a young couple is seen embracing—a typically Rowlandsonian aside.

Though strong blues and vermilion highlight some of the figures, neutral tones of gray and tan prevail. The gray wash which sweeps across the lower left corner is a compositional device used to reinforce the other diagonals. Notice that thin, short, broken lines are more in evidence in this drawing than in most earlier works by Rowlandson.

1. A set of the sixteen plates, as well as a drawing of one of the engraved subjects (Baskett and Snelgrove, No. 36), is in the Mellon Collection. Fourteen of the plates are reproduced in Grego, II, 240–46.
2. Repr. Arthur W. Heintzelman, *The Watercolor Drawings of Thomas Rowlandson* (New York, 1947), p. 81; Falk, facing p. 196; Bury, Pl. 47.

58. *Arrival of the Stage Coach at Bodmin, Cornwall. 1795.*

Pen and watercolor over pencil, on wove paper, 9¼ × 15 in. (234 × 381 mm); contemporary mount.
Provenance: Arthur Russell Johnson, sold Christie's 13 July 1965, lot 152, to Colnaghi; acquired 1965.
Exhibitions: New Haven, Yale Center for British Art, The Pursuit of Happiness, 1977, No. 9.
Bibliography: Baskett and Snelgrove, No. 14; H. L. Douch, *Old Cornish Inns and their Place in the Social History of the County* (Truro, 1966), p. 82, Pl. II.

See comments under No. 57. A stage coach has arrived at the Sun Inn at Bodmin. One of the alighting passengers, a bearded Jew, is detained by the coachman, who forcefully demands payment of the fare. The incident is amusingly parodied in the set-to between a dog and a pig. The townsfolk carry on their affairs, oblivious to the commotion in the foreground.

Rowlandson executed at least five versions of this subject. A pen-and-wash sketch in the Wiggin Collection, Boston Public Library,[1] appears to be the earliest version and is possibly a preliminary study for the large (14⅜ × 21⅛ inches), brightly colored drawing in the Royal Collection at Windsor.[2] Another version, in brown ink and wash, probably later than the Wiggin sketch, is in the collection of Augustus P. Loring, Prides Crossing, Massachusetts. A drawing similar to the present one was exhibited by Frank T. Sabin in

1933; it came from the collections of William Esdaile and the Marquess of Lincolnshire.[3]

The lack of balance and overcrowding in the Mellon drawing were avoided in the earlier Windsor version by enlarging the scope of the scene, so that the coach does not overpower the left side of the composition.

1. Repr. Arthur W. Heintzelman, *The Watercolor Drawings of Thomas Rowlandson* (New York, 1947), p. 73.
2. A. P. Oppé, *English Drawings, Stuart and Georgian Periods . . . at Windsor Castle* (London, 1950), p. 87, No. 529; repr. Falk, facing p. 32.
3. No. 2 in the catalogue by V. P. Sabin (repr.).

59. *Richmond Market Place, Yorkshire. Ca. 1795–1800.*

Pen and watercolor over pencil, on wove paper, 8¾ × 12⅝ in. (223 × 320 mm).
Provenance: Frank T. Sabin, 1933 (No. 58 in catalogue); sold Sotheby's 24 Nov. 1965, lot 52, to Colnaghi; acquired 1965.
Bibliography: Baskett and Snelgrove, No. 35.

Rowlandson has characteristically subordinated the topographical interest of this view—Trinity Church, a monumental stone drinking fountain, and the square tower of the Castle keep—to the lively figure groups crowding the large market place. Architectural details are glossed over, the perspective left uncertain. Even the figures have been added in a hasty and imprecise manner using short, coarse penstrokes. Yet these seeming deficiencies in no way detract from the overall integrity of the composition and the lovely effects of cloud and shadow throughout the scene.

Another, or possibly the same, version of this subject was exhibited at the Grolier Club in November 1916.[1] A much later (but more carefully executed) repetition, signed and dated 1818, was sold at Christie's 22 March 1966, lot 103, to Charlton.[2]

1. No. 39 in the large-paper edition of the exhibition catalogue.
2. Not further traced. The same drawing was exhibited by Frank T. Sabin in 1948 and is No. 32 in the catalogue (repr.).

60. *Caernarvon Castle, North Wales. 1797.*

Pen and watercolor over pencil, on wove paper, 5½ × 16⅛ in. (140 × 409 mm).
Inscribed in ink in Rowlandson's hand, lower left: *Carnarvon Castle North Wales*
Etched, aquatinted by John Hill, and published by W. Wigstead as Pl. [6]
(dated 2 Nov. 1799) for Henry Wigstead's *Remarks on a Tour to North and South Wales, in the Year 1797*, 1800 (Abbey, *Scenery*, No. 516; Grego, II, 20).
Provenance: John Mitchell and Son; acquired 1962.
Bibliography: Baskett and Snelgrove, No. 41.

Some of Rowlandson's most beautiful drawings of pure landscape derive from a tour to Wales made on horseback in company with Henry Wigstead. Twenty-

two drawings from the journey (several of them by Wigstead) were later etched by Rowlandson and others as illustrations for Wigstead's *Remarks on a Tour to North and South Wales, in the Year 1797*, published in 1800. In his Introduction to the book Wigstead writes:

> The romantic and picturesque scenery of North and South Wales, having within these few years been considered highly noticeable and attractive, I was induced to visit this Principality with my friend Mr. Rowlandson, whose abilities as an artist need no eulogium from me. We left London in August 1797, highly expectant of gratification: nor were our fullest hopes in the least frustrated.[1]

The Sir John Williams Collection in the National Library of Wales contains forty-eight drawings by Rowlandson from the Welsh tour.[2] Though they cannot match the brilliance and variety of the drawings from Rowlandson's tour to the Isle of Wight in 1784 (see No. 8 above), they form the only other large group of scenes relating to a specific excursion. Many of the Welsh drawings are elaborate, panoramic views in watercolor, carefully worked up from sketches made on the spot. Two such drawings (both exhibited) are in the Mellon Collection, along with two smaller Welsh subjects.[3]

In this sweeping view of Caernarvon, Rowlandson is obviously less interested in the topography of the Castle and its environs than in the qualities which render the setting picturesque. The ships on the sea, the women and children in the foreground, and the large tree at the extreme left are more than simply compositional elements, even though they do function in that way. Notice that Rowlandson has drawn the horizon as a gently swelling curve. Prevailing tones of blue and gray give the scene an atmospheric freshness.

1. *Remarks on a Tour to North and South Wales, in the Year* 1797 (London, 1800). pp. [v]–vi.
2. The fullest discussion of the drawings is in David Bell's Introduction to the exhibition catalogue *Tro Trwy Gymru . . . : A Tour through Wales, Drawings by Thomas Rowlandson from the Sir John Williams Collection in the National Library of Wales, Aberystwyth* (Cardiff, 1947). See also Gully, pp. 105–10.
3. The smaller drawings are *Caernarvon Castle, Entrance to a Tower* and *Falls on the River Conway, North Wales* (Baskett and Snelgrove, Nos. 42, 43).

61. *Entrance to Festiniog, North Wales. 1797.* PLATE XXVI

Pen and watercolor over pencil, on wove paper, 5⅝ × 16⅜ in. (143 × 415 mm).
Inscribed in ink in Rowlandson's hand, lower left: *entrance to Festiniog*
Etched, aquatinted by John Hill, and published by W. Wigstead as Pl. [10] (dated 1 Sept. 1799) for Henry Wigstead's *Remarks on a Tour to North and South Wales, in the Year 1797*, 1800 (Abbey, *Scenery*, No. 516; Grego, II, 20).
Provenance: Dr. John Percy (Lugt 1504, on verso); Frank T. Sabin; acquired 1964.
Bibliography: Baskett and Snelgrove, No. 44; Hayes, pp. 158–59, Pl. 94.

See comments under No. 60. This is one of Rowlandson's most evocative and

dynamic panoramas from his tour of Wales in 1797: a rococo *tour de force*. Hills and valleys surge and undulate, the road winds its way across them, and the entire landscape appears to be gently in motion. Here is an instance in which Rowlandson's natural inclination towards curving, billowing forms must have been particularly gratified by the organic flow of the terrain.

Festiniog lies in the valley between the rivers Dwyryd and Cynfael, about sixteen miles southwest of Llanrwst. Rising steeply on the left in this scene is Mount Snowdon, the highest peak in Wales.

62. *A Burial at Carisbrooke, Isle of Wight. Ca. 1797–1800.*

PLATE XXVII

Pen and watercolor over pencil, on wove paper (two joined sheets),
5⅜ × 17⅝ in. (136 × 447 mm).
Provenance: Sir John Crampton, his sale Christie's 16 April 1923, lot 93, to
Meatyard; Desmond Coke, his sale Sotheby's 21 July 1931, lot 61; T. E. Lowinsky
(Lugt 2420a); Justin Lowinsky; acquired 1963.
Bibliography: Baskett and Snelgrove, No. 20.

As is evident from the number and stylistic variety of his surviving drawings of the Isle of Wight, Rowlandson made several visits there at different periods. The drawings from the tour in a post chaise in 1784 (see above, No. 8) form by far the largest group documenting a particular visit. The Mellon Collection contains six views of the Isle of Wight, each of them on two leaves of a sketchbook joined together. The three that are exhibited here (Nos. 62–64) appear to have been made in the late 1790s and probably derive from the same excursion.[1]

In this scene of a burial at Carisbrooke, Rowlandson uses the pen only on the figures and trees in the foreground, allowing somber shades of wash to suggest an atmosphere appropriate to the occasion. Yet the topographical interest is so great that the burial itself seems incidental. The delineation of the church is accomplished by light and shadow, except for delicate pencil lines visible underneath the gray wash. This effect, though uncharacteristic of Rowlandson, is noteworthy as showing that he did not always employ the pen before applying watercolor.[2] Carisbrooke Castle is seen impressionistically in the distance. The large tree on the left almost overbalances the right side of the composition.

1. The three drawings are of very nearly the same size and were formerly in the collection of Sir John Crampton. A drawing of Cowes, Isle of Wight, also from the Crampton Collection (Baskett and Snelgrove, No. 23), doubtless belongs with these three. The two other views in the Mellon Collection (Baskett and Snelgrove, Nos. 37, 40) were possibly (but less certainly) done at this time.
2. Cf. *West Cowes, Launching a Cutter* in the Huntington Collection (Wark, pp. 57–58, No. 100). This scene on the Isle of Wight is rendered in a similar style, and many of the buildings are executed in watercolor over pencil without pen reinforcement.

63. *Newport High Street, Isle of Wight. Ca. 1797–1800.*

Pen and watercolor over pencil, on wove paper (two joined sheets), 5¼ × 18⅜ in. (134 × 466 mm).
Inscribed in pencil in a later hand, upper left: *Newport High Street*
Provenance: Sir John Crampton, his sale Christie's 16 April 1923, lot 86, to W. Sabin; Frank T. Sabin, 1933 (No. 46 in catalogue); Sir Bruce Ingram (Lugt 1405a, on verso), his sale (Part I) Sotheby's 21 Oct. 1964, lot 137, to Colnaghi; acquired 1964.
Exhibitions: Reading Museum and Art Gallery, 1962, No. 11.
Bibliography: Baskett and Snelgrove, No. 32; Falk, facing p. 189 (repr.).

See comments under No. 62. This broad perspective of the High Street on market day projects Newport's importance as the capital and trading center of the Isle of Wight. Activity is everywhere as small clusters of figures are distributed throughout the composition. The costumes provide the only touches of bright color. In his elaborate crowd scenes of the 1780s, such as *The Prize Fight* (No. 14 above), Rowlandson used bright tints on only a few figures, creating a mosaic-like pattern of diffused color. Though the figure groups here are broken up rather than massed together, the same general principle obtains. The buildings at the far end of the street are not unfinished: they have been softly defined by shadow, without any penwork, so that they recede into the distance.

64. *Mr. Drummond's Cottage, East Cowes, Isle of Wight. Ca. 1797–1800.*

Pen and watercolor over pencil, on wove paper (two joined sheets), 5⅜ × 18¼ in. (136 × 464 mm).
Inscribed in pencil in Rowlandson's hand, upper right: *Mr Drummonds cottage*
[in pencil in a later hand, lower right] *East Cowes*
Inscribed in pencil in a different hand on the verso: *East Cowes*
Provenance: Sir John Crampton, his sale Christie's 16 April 1923, lot 93, to Meatyard; Desmond Coke, his sale Sotheby's 21 July 1931, lot 62; T. E. Lowinsky (Lugt 2420a); Justin Lowinsky; acquired 1963.
Bibliography: Baskett and Snelgrove, No. 22.

See comments under No. 62. The view is taken from the east bank of the river Medina, not far from the estuary with the Solent. Groups of figures pursue the leisurely occupations of a summer holiday. An easy, relaxed atmosphere is enhanced by Rowlandson's delicate and economical use of color. The sky is left untouched. The cottage on high ground overlooking the river adds a note of unexpected elegance to the scene.

65. *The South Gate, Exeter. Ca. 1795–1800.* PLATE XXV

Pen and gray wash, on wove paper, 5 × 7⅝ in. (127 × 193 mm).

46

Provenance: Colnaghi; acquired 1965.
Exhibitions: London, P. and D. Colnaghi and Co., English Drawings and Watercolours, 1965, No. 67.
Bibliography: Baskett and Snelgrove, No. 26.

Such a slight and quickly executed drawing as this one poses a difficult problem in connoisseurship. A larger, more finished version of the subject, formerly in the Gilbert Davis Collection,[1] clearly dates from a later period. It has none of the boldness and energy of this sketch, yet is easily recognized as being Rowlandson's work. Here the scene is recorded in a kind of notational shorthand that retains the essential fluency of his line, but lacks the earmarks of any specific period in Rowlandson's stylistic development. The great freedom in the handling of architectural details suggests that the sketch was done no earlier than the mid 1790s, and the coarse but vigorous method of indicating figures points to a date closer to 1800 or perhaps some years later. These conclusions must be regarded, however, as extremely tentative.

1. Repr. Falk, facing p. 180; present location unknown.

66. *Norwich Market Place. Ca. 1795–1800.*

Pen and gray wash, on wove paper, 5⅜ × 6⅞ in. (138 × 175 mm).
Inscribed in ink in Rowlandson's hand, lower right: *Norwich*
Verso: drawing (pen and gray wash) by Rowlandson of two men drinking and smoking pipes by a fireside, with a woman carrying a tray of food through a doorway in the background; inscribed in pencil in a later hand, lower right: (?) *Rithes*
Provenance: Walter Schatzki; acquired 1962.
Bibliography: Baskett and Snelgrove, No. 33.

A much larger (10½ × 15¾ in.), panoramic view of Norwich Market Place, formerly in the collection of Roy M. Hyslop,[1] was probably executed around 1800 or slightly later. If, as seems possible, the present sketch served as a preliminary study for the central portion of that drawing, a similar date for it can be posited. The same patterns of light and shadow appear in the two works, and the figure groups barely suggested here are elaborated in the finished view. See comments under No. 65, a rapid study that has much in common with this sketch.

1. Repr. Falk, facing p. 197; present location unknown.

67. *Harvesters Setting Out. Ca. 1795–1800.*

Pen and watercolor over pencil, on wove paper, 9 × 14⅞ in. (230 × 378 mm).
Provenance: Agnew; acquired 1972.
Exhibitions: London, Thos. Agnew and Sons, 1972, No. 21.
Bibliography: Baskett and Snelgrove, No. 78.

During the later 1790s Rowlandson's coloring underwent a gradual change, as

warm tones of orange, yellowish green, and brown began to replace the brighter, cooler blues and vermilion found in many of his earlier works. His penwork became enriched by the use of red and brown ink instead of, or in addition to, India ink. Some watercolors from this transitional period[1] display a limited, almost monochromatic range of tint which is reminiscent of landscapes being done at the time by Edward Dayes. The present drawing, which to some extent characterizes the change taking place, is apparently a repetition of the drawing in the Museum of Fine Arts, Boston, John T. Spaulding Collection. That drawing is more highly colored and finished, with the figures outlined fairly strongly in black ink,[2] whereas here the penwork tends to be thin and spidery. Rowlandson has not bothered to put in the background on the left. The tree on the left framing the figures is a *repoussoir* of the kind favored by painters of classical landscape.

1. For example, *Caernarvon Castle, North Wales* (No. 60 above).
2. Cf. *Landscape with Cows Being Driven through a Stream* in the Ashmolean Museum, Oxford (repr. in color in Hayes, p. 169, Pl. 104).

68. *The Picnic. 1798.*

Pen and watercolor over pencil, on wove paper, 11 × 16⅛ in. (278 × 419 mm); contemporary mount.
Signed and dated in ink, lower right: *Rowlandson 1798*
Verso: pencil sketch of a landscape with a building on the right.
Provenance: George, 5th Duke of Gordon; Elizabeth, Duchess of Gordon; The Brodie of Brodie; Agnew; acquired 1962.
Exhibitions: V.M.F.A., 1963, No. 429; London, P. and D. Colnaghi and Co., and New Haven, Yale University Art Gallery, English Drawings and Watercolors from the collection of Mr. and Mrs. Paul Mellon, 1964/65, No. 27; New York, Pierpont Morgan Library, and London, Royal Academy, English Drawings and Watercolors 1550–1850 in the Collection of Mr. and Mrs. Paul Mellon, 1972/73, No. 73.
Bibliography: Baskett and Snelgrove, No. 53; Paulson, pp. 32, [97], Fig. 28.

The exaggerated, mannered landscapes which particularly distinguish Rowlandson as a late exponent of the Rococo were done for the most part between 1795 and 1805. Two Gainsboroughesque scenes that serve to document the style are *Fording a Stream,* dated 1795, in an English private collection,[1] and *A Country Scene with Peasants at a Cottage Door*, dated 1805, in the Wiggin Collection, Boston Public Library.[2] Other examples that may be mentioned are *Landscape with Figures and Snake*, in the Metropolitan Museum of Art,[3] and *The Woodcutter's Picnic*, in the Mellon Collection.[4]

The characteristics of the style are strongly exhibited in the present drawing. The trees completely dominate the composition, twisting and turning like the tentacles of some strange monster. Gnarled trunks and branches are outlined in short, curving penstrokes, and a vigorous looping technique is used for the foliage. The evolution of this manner has never been adequately explained, but

one may guess that the influence of Canaletto on Rowlandson was stronger than that of Gainsborough. In Canaletto's drawing of *Old Walton Bridge* (1755; in the Mellon Collection[5]), there is a prominently featured tree which is not unlike those in *The Picnic*. Other examples may be seen in the engravings after Canaletto's views of Vauxhall Gardens, with which Rowlandson was doubtless familiar.[6] The poses of the figures in *The Picnic* (especially the rollicking couple on the right) resemble the shapes of the trees in such a way as to suggest a mysterious interplay between the human and the inanimate worlds.

1. Repr. Hayes, p. 168, Pl. 103.
2. Repr. ibid., p. 179, Pl. 114.
3. Repr. Ronald Paulson, 'The Artist, the Beautiful Girl, and the Crowd: The Case of Thomas Rowlandson,' *Georgia Review*, 31 (Spring 1977), [150], Fig. 11.
4. Baskett and Snelgrove, No. 83; Falk, facing p. 204 (repr.). Another version of this subject, signed and dated 1803 (ex coll. Augustus Walker), is reproduced in Walter Shaw Sparrow, 'Rowlandson and Howitt—Painters of Sport,' *International Studio*, 97 (Dec. 1930), 64.
5. Repr. Christopher White, *English Landscape* 1630–1850 (New Haven, 1977), Pl. LII (No. 11).
6. Repr. W. G. Constable, *Canaletto*, 2nd ed., rev. J. G. Links (Oxford, 1976), I, Pls. 139, 140, 183 (Nos. 748a, b, c, d).

69. *The Woolpack Inn at Hungerford, Berks. 1796.* PLATE IX

Pen and watercolor over pencil, on wove paper, 8 × 11⅛ in. (203 × 281 mm). Signed and dated in ink, lower right: *Rowlandson 1796*
Inscribed in ink in Rowlandson's hand, lower left: *The Woolpack at Hungerford. Berks*

Provenance: Harry Thornber; Dyson Perrins; sold Sotheby's 24 Feb. 1960 (Property of Mrs. C. W. Dyson Perrins), lot 54, to R. J. Bailey; Spink; acquired 1962.
Exhibitions: London, Royal Institute of Painters in Water Colours, The English Humourists in Art, 1889, No. 76; London, 39 Grosvenor Square, British Country Life, 1937, No. 504; V.M.F.A., 1963, No. 427.
Bibliography: Baskett and Snelgrove, No. 29; Selwyn Brinton, 'The Davenham Collection: English Eighteenth-Century Caricaturists—Thomas Rowlandson,' *Connoisseur*, 42 (July 1915), 131 (repr.); T. W. Earp, 'Rowlandson,' *Drawing and Design*, New Series, 1 (Nov. 1926), 171 (repr.); Oppé, p. 13, Pl. 51.

Though the trees are less exaggerated here than in the preceding drawing, they must undergo contortions in order to bend and stretch across the top of the scene, thus forming a frame. The composition involves a series of strong verticals, anchored in place by the road. The range of warm, autumnal tones is more typical of Rowlandson's landscapes after 1800. In commenting severely on the 'disproportions' in this drawing, Paul Oppé has suggested that it may have been done later than the date Rowlandson put on it.[1]

1. Oppé, p. 13.

70. *Stag at Bay—Scene near Taplow, Berks. Ca. 1795–1801.*

Pen and watercolor over pencil, on wove paper, 16¼ × 20⅝ in. (415 × 525 mm).
Etched and published by Rudolph Ackermann 1801 as *Stag at Bay | Scene near Taplow, Berks.*
Provenance: Gloucester Collection; acquired 1956.
Bibliography: Baskett and Snelgrove, No. 111.

The diversity of Rowlandson's subject matter is such that he is rarely thought of as a sporting artist, but in fact he produced many drawings of fox hunts, horse races, and coaching scenes throughout his career.[1] Some of these works were specifically commissioned (see above, No. 13). This large hunting scene is one in a series of four etched and published by Rudolph Ackermann in 1801. The other three subjects are entitled *Going Out in the Morning | Scene in Windsor Forest; Fox Chase | Scene near Maidenhead Thicket;* and *Return from the Chase | Scene at Eaton.*[2] Here the drama of the chase is concentrated in the immediate foreground, and the landscape becomes the dominant aspect of the composition. With the requirements of the etcher clearly in mind, Rowlandson has used a strong, crisp outline in red ink on the figures and animals.

1. See Walter Shaw Sparrow, *British Sporting Artists from Barlow to Herring* (London, 1922), pp. 145–63; idem, 'Rowlandson and Howitt—Painters of Sport,' *International Studio,* 97 (Dec. 1930), 61–64, 108; Frank Siltzer, *The Story of British Sporting Prints* (London, 1925), pp. 237–38.
2. The drawing of the last subject is in the Royal Collection (repr. Hayes, p. 51, Fig. 48); the etching is reproduced in Falk, facing p. 160. A complete set of the four prints is in the Mellon Collection.

71. *The Canterbury-Dover Fly Descending a Steep Hill. Ca. 1795–1800.*

Pen and watercolor over pencil, on wove paper, 11⅝ × 18 in. (295 × 458 mm).
Falsely signed in ink, lower left: *Rowlandson*
Provenance: Mrs. Gilbert Miller, sold Sotheby's 7 July 1965, lot 49, to Colnaghi; acquired 1965.
Bibliography: Baskett and Snelgrove, No. 142.

The Canterbury-Dover Fly (a fast passenger coach operating between London and Dover) is said to be passing Vanbrugh Castle, the house which the architect and dramatist Sir John Vanbrugh built for himself (1717–26) on Maze Hill at Greenwich. The identification is probably mistaken; although Rowlandson was in the habit of taking liberties with topography, the building in the drawing bears no resemblance at all to the fanciful brick 'castle,' with its crenellations and round turrets. On the other hand, the setting could indeed be Greenwich Park, with the Thames curving around the Isle of Dogs in the background.[1]

This drawing and the following two have in common a somberness of coloring (blue-gray, tan, brown, olive green) that reflects the gradual change

taking place in Rowlandson's palette during the later 1790s. See comments under No. 67.

1. Cf. John Robert Cozens's view of the Thames from Greenwich Park, ca. 1791, in the Mellon Collection; repr. Christopher White, *English Landscape 1630–1850* (New Haven, 1977), Pl. LXXXIX (No. 77).

72. *Landing at Greenwich. Ca. 1795–1800.* PLATE XXVIII

Pen and watercolor over pencil, on laid paper, 11⅛ × 18⅜ in. (283 × 466 mm).
Provenance: Agnew; acquired 1967.
Bibliography: Baskett and Snelgrove, No. 5.

This view of the Thames at low tide shows the arrival of a ferryboat at Greenwich stairs, next to the Salutation Tavern, with the Royal Hospital for Seamen (since 1873 the Royal Naval College) in the background. According to his friend Henry Angelo, Rowlandson

was frequently making his sketches at Greenwich, his favourite resort, both for shipping and scenes relative to the assemblage of sailors. . . . Our excursions were generally some time before dinner; when standing near him we were amused, whilst his pencil was engaged delineating the various objects, ships passing, and sketching the different characters collected, that excited his attention, which, when finished, were not unworthy the genius of a second Hogarth.[1]

The composition develops from two strong diagonals that intersect on the extreme right. The lower diagonal takes form in the procession of figures, many of which are rapidly sketched and outlined in red ink. This is earliest of three known versions of the subject. The drawing in the Victoria and Albert Museum[2] has bright coloring and finer topographical detail, with the figures somewhat more elaborately grouped. Another, formerly in the collection of Sir Bruce Ingram,[3] more closely resembles the Victoria and Albert drawing and is perhaps an intermediate version. A similar view of Greenwich was exhibited by Frank T. Sabin in 1933.[4]

1. *Angelo's Pic Nic; or, Table Talk* (London, 1834), pp. 144–45.
2. Ex coll. Desmond Coke; repr. Osbert Sitwell, *Famous Water-colour Painters VI—Thomas Rowlandson* (London, 1929), Pl. II; A. P. Oppé, 'Rowlandson, the Surprising,' *Studio*, 124 (Nov. 1942), 152.
3. Repr. Falk, facing p. 189; F. Gordon Roe, 'Drawings by Rowlandson: Captain Bruce S. Ingram's Collection,' *Connoisseur*, 118 (Dec. 1946), 86, Fig. IV.
4. No. 25 in the catalogue by V. P. Sabin (repr.).

73. *A Military Escapade. Ca. 1794–1800.* PLATE XXIX

Pen and watercolor over pencil, on wove paper watermarked 1794, 15¼ × 10⅞ in. (387 × 275 mm).
Verso: color splashes.

Provenance: Sir Bruce Ingram, his sale (Part II) Sotheby's 9 Dec. 1964, lot 349, to Charles J. Sawyer; acquired 1965.
Exhibitions: London, P. and D. Colnaghi and Co., 1952, No. 80.
Bibliography: Baskett and Snelgrove, No. 294; Hayes, pp. 164–65, Pl. 100.

This drawing possibly illustrates an episode from a contemporary novel, but the source has not been identified. The escape is presented in a theatrical and romantic manner, with a full moon breaking through the clouds to illuminate the scene just as the young prisoner makes his descent from the castle tower. Though the surroundings are rendered in a perfunctory way, the pyramid of soldiers has been skillfully managed so as to express the tension and balance of their formation as it receives the weight of the prisoner. A similar subject entitled *Escape of French Prisoners* is in the Cleveland Museum of Art, Leonard G. Hanna, Jr., Bequest.

74. *Review of the Light Horse Volunteers on Wimbledon Common, 5 July 1798. 1798.* PLATE XXX

Pen and watercolor over pencil, on wove paper, 9¾ × 16¼ in. (249 × 414 mm).
Falsely signed in ink, lower left: *Rowlandson*

Provenance: Desmond Coke, his sale Christie's 22 Nov. 1929, lot 9, to Maggs; L. G. Duke (D.2682), from Spink, 1952; Colnaghi; acquired 1961.
Bibliography: Baskett and Snelgrove, No. 285; Hayes, pp. 36–37, Fig. 26; Basil S. Long, 'More Drawings by Rowlandson in the Desmond Coke Collection,' *Connoisseur,* 80 (Feb. 1928), 72–73, Fig. VIII.

The occasion recorded in this drawing was described in the *London Chronicle* of 5–7 July 1798: 'Yesterday [5 July] the corps of City Light Horse Volunteers, commanded by Lieut. Col. Herries, were honored with a Royal review on Wimbledon Common. They paraded early on Clapham Common, and about eight o'clock came on the ground.' The King arrived, reviewed the troops, and 'took his station at the Royal camp colour . . . when the Colonel delivered into his hands effective returns of the men then under arms; viz. 347 horse, and 154 foot;—total, 501.' The troops then executed a series of elaborate formations and maneuvres, ending at half after ten. 'The day proved exceedingly unfavourable; for, just as the King took his post, a heavy rain began to descend, which continued with little intermission throughout the review . . . however, nothing was wanting that martial gallantry and discipline could achieve The ground was lined with an immense concourse of Nobility and Gentry in carriages, &c. who were highly gratified with the whole of this interesting national spectacle.'[1]

The Light Horse Volunteers of London and Westminster were patrons of Henry Angelo's fencing academy, and Angelo may have commissioned his friend Rowlandson to produce a print of the review in their honor. The present sketch is a preliminary study for the design that was etched by Rowlandson and published by Angelo less than two weeks after the event.[2] Comparison of the

sketch with the finished drawing (in the Wiggin Collection, Boston Public Library[3]) reveals a good deal about Rowlandson's habits of composition. In delineating the crowd of spectators, he has taken care to strengthen the two diagonals slanting downwards towards the center. The left and right sides are joined together by a conspicuous group in the foreground (a typically Rowlandsonian incident in which a horse is rearing at a gig), and the diagonals are repeated in the formation of the troops on the parade ground. But as often happens when Rowlandson labors at elaborating and integrating the various elements, some of the vigor and spontaneity of his on-the-spot sketch is missing in the finished work.

1. *London Chronicle*, No. 6139, 5–7 July 1798, *sub* 6 July.
2. Grego, I, 349; *B.M. Satires*, No. 9238. The aquatint is dated 18 July 1798. For Angelo's connection with the Light Horse Volunteers, see *Angelo's Pic Nic; or, Table Talk* (London, 1834), p. 349.
3. Repr. Hayes, p. 36, Fig. 27.

75. *A Horse Sale at Hopkins's Repository, Barbican. Ca. 1798–1800.*
Pen and watercolor over pencil, on wove paper watermarked 1798, 10½ × 15⅝ in. (267 × 396 mm); contemporary mount.
Provenance: Gilbert Davis (Lugt 757a); Sir Eldred Hitchcock, sold Sotheby's 24 Feb. 1960, lot 18, to Colnaghi; acquired 1960.
Exhibitions: London, Whitechapel Art Gallery, 1953, No. 95; Washington, National Gallery of Art, *An Exhibition of English Drawings and Water Colors from the Collection of Mr. and Mrs. Paul Mellon*, 1962, No. 65; V.M.F.A., 1963, No. 428; Victoria, Canada, Art Gallery of Greater Victoria, *British Watercolour Drawings in the Collection of Mr. and Mrs. Paul Mellon*, 1971, No. 33; New York, Pierpont Morgan Library, and London, Royal Academy, *English Drawings and Watercolors 1550–1850 in the Collection of Mr. and Mrs. Paul Mellon*, 1972/73, No. 72.
Bibliography: Baskett and Snelgrove, No. 140; Gully, p. 424, Fig. 201; G. E. Mingay, *Georgian London* (London, 1975), p. 107 (repr.).

This composition incorporates a number of features commonly associated with Rowlandson. The figures (slightly caricatured) are arranged in a frieze-like pattern diagonally across the foreground; the horse being auctioned draws the attention to the center. Two sporting types on the extreme right, boldly outlined in vermilion ink, act as a none too subtle *repoussoir*. The background has not been managed with complete success, although the buildings are nicely highlighted in monochrome and offer an interesting contrast of architectural styles. The Mellon Collection contains an outline drawing of the figures only (slightly varied) which may have been intended for an etching.[1] A similar scene of a horse sale, from the collection of G. N. Bruton, is signed and dated 1785.[2]

1. Baskett and Snelgrove, No. 141.
2. Repr. Falk, facing p. 132.

76. *The Pier at Amsterdam. 1801.*

Pen and watercolor over pencil, on wove paper, 10 × 11½ in. (253 × 291 mm). Signed and dated in ink (probably by Rowlandson, possibly inked over by another hand), lower left: *Rowlandson 1801*

Provenance: Colnaghi; acquired 1961.
Exhibitions: V.M.F.A., 1963, No. 431.
Bibliography: Baskett and Snelgrove, No. 274.

The earliest version of the subject, in the Birmingham City Museum and Art Gallery, J. Leslie Wright Collection, was executed on the spot at Amsterdam in 1792.[1] That drawing is vigorously sketched, with dark wash and India ink used extensively to suggest mass and contour. Rowlandson has somewhat varied the proportions in the present version, which was done in 1801 (if the date on the drawing can be trusted) or perhaps a few years earlier. The boat in the center has been made smaller, and the pier higher, in relation to each other; the boats to the left and right have been positioned closer to the center boat. These changes were presumably made in an effort to balance and unify the composition, but the result is not necessarily more successful. Interestingly enough, the Mellon Collection contains a considerably later repetition of this subject[2] in which Rowlandson has returned to the proportions of his original composition.

1. Repr. Hayes, p. 153, Pl. 89.
2. Baskett and Snelgrove, No. 273. The drawing is undated, but the style is clearly that of a later period.

77. *The Gaming Table. 1801.*

Pen and watercolor over pencil, on wove paper, 5⅞ × 9½ in. (150 × 241 mm). Signed and dated in ink, lower left: *Rowlandson 1801*

Provenance: J. E. Huxtable and Mrs. Pope; Colnaghi; acquired 1963.
Exhibitions: New Haven, Yale Center for British Art, The Pursuit of Happiness, 1977, No. 119.
Bibliography: Baskett and Snelgrove, No. 239; Sutton, p. 280, Fig. 9.

Throughout his life Rowlandson was hopelessly addicted to gambling. According to one of his intimates, he was

> known in London at many of the fashionable gaming houses, [and] alternately won and lost without emotion, till at length he was minus

several thousand pounds. . . . It was said to his honour, however, that he always played with the feelings of a gentleman, and his word passed current, even when with an empty purse. He . . . frequently played throughout a night and the next day; and . . . once, such was his infatuation for the dice, he continued at the gaming table nearly thirty-six hours, with the intervention only of the time for refreshment, which was supplied by a cold collation.[1]

It is not surprising, therefore, that Rowlandson should have made numerous drawings that show people in high or low life gathered around a gaming table. The drawings must frequently have embodied his own experience.

The gaming table itself determines the basic design, a vortical composition which may perhaps be said to echo Hogarth's famous gambling scene in *A Rake's Progress*. Among the most accomplished examples from Rowlandson's *oeuvre* are *A Gaming Table at Devonshire House* (dated 1791), in the Metropolitan Museum of Art,[2] and *A Club Subscription Room* (1792), in the Victoria and Albert Museum.[3] In terms of draughtsmanship or subtlety of arrangement, the present drawing is hardly comparable to those works, but it effectively sums up the moment of suspense before the dice are rolled. All of the men, whether participants or spectators, are transfixed by the young sharper who holds the dice-box.

From a technical standpoint, the drawing is of interest as demonstrating Rowlandson's increasing reliance on the brush to model the forms and indicate contour. Washes are applied locally, sometimes (as on the faces) on top of each other, creating a textured surface of color that is characteristic of many drawings made after 1800.

1. 'Rowlandson,' in *The London Literary Gazette*, No. 536, 28 April 1827, p. 268. The writer is probably John Thomas Smith.
2. Repr. Falk, facing p. 84; Hayes, p. 151, Pl. 87.
3. Repr. Falk, facing p. 77; Hayes p. 160, Pl. 95. Another version, signed and dated 1791, is in the collection of Philip Pinsof, Highland Park, Illinois.

78. *The Register Office. Ca. 1800–05.* PLATE XII

Pen and watercolor over pencil, on wove paper, 9¼ × 12⅞ in. (235 × 353 mm).

Provenance: Louis Deglatigny (Lugt 1768a); Paul Prouté et ses fils, 1964 (catalogue 'Colmar,' No. 63); Colnaghi; acquired 1968.

Bibliography: Baskett and Snelgrove, No. 202.

Register offices were first set up in the 1750s to provide an employment service for domestic servants. The offices charged a fee for listing the qualifications of job applicants or advertising vacancies. Prospective employers could consult the lists and inspect the applicants in person on 'show days.' But the buying and selling of places quickly led to abuses. Unscrupulous managers advertised places that did not exist and collected fees for placing unsuspecting servants in them;

character references of any description were manufactured for a price. These practices became sufficiently widespread to be satirized in a two-act farce by Joseph Reed entitled *The Register Office*, which enjoyed popularity on the London stage for many years after 1761.

In this scene inside a register office on 'show day,' Rowlandson develops the contrasts between youth and age, beauty and ugliness, illusion and reality. On the left, a fat, coarse-featured matron warms to a handsome young male servant, who appears to be embarrassed by her interest. On the right, a lecherous old man, with the seasoned eye of a connoisseur, admires a pretty girl through a quizzing glass;[1] a middle-aged woman, seated to her left, eyes him cynically. In the background, an older female servant who wishes to register pays her fee to an oversolicitous clerk, while an elderly man standing in the doorway quizzes a comely young maidservant. The two dogs cavorting in the center are Rowlandson's satirical comment on the reality of the situation: in judging the 'qualifications' of servants, these employers clearly do not have domestic experience uppermost in mind. It is entirely characteristic of Rowlandson that the satire does not concern itself with social injustice. On the contrary, the goings-on are presented simply as a lively aspect of *la comédie humaine.*

An earlier version of this subject, signed and dated 180[3?], is in the Huntington Collection;[2] it differs chiefly in the coloring of the figures and in the more extensive use of written notices on the walls of the office.

1. A very similar old man quizzing a pretty girl (attended by an ugly bawd) appears in a drawing, signed and dated 17[98?], in the Fitzwilliam Museum, Cambridge; repr. Paulson, p. [102], Fig. 40.
2. Wark, No. 135; repr. in color, p. 7. See ibid., pp. 6–10, for an illuminating discussion of the work, which 'involves as many forms of humor as Rowlandson is likely to combine in one drawing.' A drawing of a similar subject (11 × 8½ in.; ex coll. Desmond Coke), given the title *Hiring a Servant: Ladies and Gentlemen Accommodated*, was sold at Christie's 22 June 1962 (Property of a Lady), lot 46, to Patter; not further traced.

79. *Actresses' Dressing Room at Drury Lane. Ca. 1800–05.*

Pen and watercolor, on laid paper, 7⅜ × 6 in. (187 × 153 mm).
Inscribed in ink in Rowlandson's hand, lower center: *Actresses Dressing Room at Drury Lane*
Provenance: L. G. Duke (D.52), from Crook, 1931; Colnaghi; acquired 1961.
Bibliography: Baskett and Snelgrove, No. 246; Sutton, pp. 282, 284, Fig. 20.

Being a close friend of the actor John Bannister (see above, No. 3), Rowlandson must have attended many performances at Drury Lane Theatre and have been frequently admitted backstage. This broadly sketched view of the actresses' dressing room has the unstudied appearance of being taken from life, despite the intimacy of the activities. Rowlandson works directly and rapidly with the pen to capture the urgency of preparations between scenes, in striking contrast

to the unhurried atmosphere of his earlier *Interior of a Dressing Room* (No. 41 above). Possibly at a later time he added the pastel shades of wash and enriched the penwork here and there with vermilion ink.

80. *A Maiden Aunt Smelling Fire. 1804.*

Pen and watercolor over pencil, on wove paper, 11⅜ × 8½ in. (288 × 216 mm); contemporary mount.
Signed and dated in ink, lower left: *Rowlandson 1804*
Etched by Rowlandson in the reverse direction and published by him 1 May 1806 as *A Maiden Aunt Smelling Fire* (Grego II, 58–59).
Provenance: Henry S. Reitlinger (Lugt 2274a); Davis Galleries; acquired 1967.
Exhibitions: New York, Davis Galleries, Thomas Rowlandson, 1967, No. 24.
Bibliography: Baskett and Snelgrove, No. 218.

Around the turn of the century Rowlandson's work took on a new aspect as he began to produce subjects like *A Maiden Aunt Smelling Fire.* These drawings use upright compositions in which the figures are drawn on a much larger scale than before, so that they dominate the picture space. Outlines are simplified; spatial proportions are altered in a way that reduces the sense of depth. Subject matter as well as style becomes distinctly less subtle and more given to crude caricature. The difference in the character of line between drawings and etchings is no longer so pronounced.

A Maiden Aunt Smelling Fire combines bedroom farce with the grotesque. The humor in the title is perhaps Rowlandson's best stroke. Otherwise, the scene is one of obvious contrast between the shrivelled-up ugliness of the aunt (imitated by her cat) and the bountiful charms of her niece, who is alertly assisting her lover to escape from her apartment. The contrast is weakened in the print. There the breasts of both women are covered up, and the young man's shirttail falls below his posterior. A handbill lying at the foot of the stairs proclaims that 'Old Maids are doomed to lead Apes in Hell.' See comments under No. 100.

81. *The Launching of H. M. S. 'Hibernia' at Devonport, 17 November 1804. Ca. 1804.*

Pen and watercolor over pencil, on wove paper, 9¾ × 15¼ in. (249 × 387 mm). Verso: color splashes.
Provenance: Desmond Coke, his sale Christie's 22 Nov. 1929, lot 12, to Francis Edwards; Sir Bruce Ingram (Lugt 1405a, on verso), his sale (Part I) Sotheby's 21 Oct. 1964, lot 142, to Colnaghi; acquired 1964.
Bibliography: Baskett and Snelgrove, No. 269; Falk, facing p. 172 (repr.; incorrectly identified as the 'Launch of H.M.S. *Nelson*, 1805').

The *Hibernia*, a man-of-war which saw long and distinguished service as a flagship, was launched at Devonport on 17 Nov. 1804 under the direction of Joseph

Tucker. The London *Times* reported that at about two o'clock on the 17th

> the people began to crowd towards the Dock-yard in immense
> numbers; and by three o'clock . . . the harbour of Hamoaze, in the
> vicinity of the Dock-yard, was covered with boats, and the hills were
> lined by spectators, the whole amounting to many thousands. Every
> necessary preparation being made . . . about a quarter before five o'clock,
> the *Hibernia*, of 120 guns, in the most majestic style, glided off her
> slip into the sea. The whole was effected without the smallest accident.
> . . . the *Hibernia* is considered as fine a ship as ever was seen: she
> measures 2499 tons, and is pierced for 132 guns.[1]

Rowlandson must have visited Devonport to record the event in this
drawing, which is ambitiously conceived but not altogether successful as a com-
position. The imposing mass of the ship is insufficiently balanced by the three
other men-of-war anchored in the harbor at left. One might have expected the
scene to be carefully worked up, but handling of details is for the most part cur-
sory and impatient. The limited range of color may in fact be intended to reflect
the rainy weather that occurred during much of the day.

> 1. *The Times*, No. 6184, 21 Nov. 1804, *sub* Ship News, Plymouth, Nov. 18.

82. *The Gardener's Offering. Ca. 1803–05.*

Pen and watercolor over pencil, on wove paper watermarked 1803, 10⅞ × 14⅞ in.
(276 × 378 mm).
Verso: pencil sketch of a man and a woman conversing.
Provenance: Unrecorded.
Bibliography: Baskett and Snelgrove, No. 163.

Commenting on an earlier version of this subject, now in the collection of
Brinsley Ford, London,[1] Paul Oppé observes that 'the humour is expressed
with a delicacy which recalls Jane Austen instead of Smollett.' He suggests that
this subtle 'moment' in Rowlandson's development came about 'under the re-
straining influence of Empire taste.'[2] The style is distinguished by refinement of
line and elegance of proportion—a late embodiment of the neoclassical ideal.
The large and elaborate *Boodle's Club Fête to George III at Ranelagh, 1802,* in
the Fogg Art Museum at Harvard,[3] is perhaps Rowlandson's most sustained
essay in the style.

In the present instance the neoclassical element is apparent in the attenu-
ated form of the female figure. The coloring is fresh and more varied than one
expects to find in drawings made after 1800, although one must acknowledge
Rowlandson's ability to work in more than one manner at the same period.
What might otherwise have become a scene of unalloyed sentiment is turned
to comedy by the young lady's dog and the man watching intently from his

perch on a ladder at the extreme left. The gardener pleading on his knees is also the subject of *A Scene from 'Love in a Village,'* a drawing in the British Museum[4] which, though dated 1800, may have been done some years earlier.

1. Repr. Hayes, p. 178, Pl. 113; Oppé, Pl. 61 (both in color).
2. Oppé, p. 19.
3. Repr. Falk, facing p. 52.
4. Repr. in color in Hayes, p. 175, Pl. 111; Oppé, Pl. 60.

83. *The Waggoner's Rest. Ca. 1800–05.*

Pen and watercolor over pencil, on wove paper, 5⅞ × 9¼ in. (150 × 236 mm); contemporary mount.
Inscribed in pencil, possibly in Rowlandson's hand, on mount below drawing: *The Waggoner's Rest*
Provenance: Gilbert Davis; John Baskett; acquired 1970.
Exhibitions: London, John Baskett Ltd., Exhibition of Drawings and Prints by Thomas Rowlandson, 1969, No. 14.
Bibliography: Baskett and Snelgrove, No. 74.

Although Rowlandson occasionally imitated the manner of contemporary artists, he did not assimilate the ideas of Girtin, Turner, and the English romantic school of watercolor painting. He was not unaware of these developments, but apparently chose to ignore them in his own work. The present drawing offers an interesting analogy to works by William Payne (fl. 1776–1830) and other minor exponents of the school who sought after romantic effects of light and atmosphere. The beauty and charm of the scene derives not from the line, which is particularly thick and loose, but from the subtle variations in tones of blue and gray wash that register the shadows at dusk.

84. *A Chop House. Ca. 1800–05.*

Pen and watercolor over pencil, on wove paper, indented for transfer, 4⅜ × 6⅝ in. (111 × 170 mm).
Verso: money sums.
Provenance: Sabin Galleries; acquired 1964.
Bibliography: Baskett and Snelgrove, No. 199.

George Cruikshank is said to have remarked that the most profitable work of his career, and of Rowlandson's and Gillray's as well, had been 'the washing of other people's dirty linen.' By this, we are told, he meant 'putting on to copper the crude designs of fashionable amateurs.' 'Such jobs were quickly executed, and liberally paid for; and the artists regarded them . . . as "so much fat,"—a sort of Canaan in the wilderness.'[1]

Rowlandson's collaborations with amateurs began in the 1780s, when he etched prints from the sketches or suggestions of his friend Henry Wigstead.[2] From the 1790s onwards, he was fairly regularly employed in such work with

Henry William Bunbury, George Moutard Woodward, John Nixon, and others. These amateurs had limited abilities as draughtsmen, but they were clever inventors of comic and burlesque scenes. Their influence on Rowlandson was that of pushing him further in the direction of broad humor and caricature.

The present drawing is a hastily executed copy after Bunbury's well-known design engraved and published in 1781 as *A Chop-House*.[3] The drawing is indented for transfer, preliminary to etching. In this instance Rowlandson follows Bunbury closely, though in other cases he takes liberties with details and makes new additions, always impressing his own style on Bunbury's original.[4] The seated figure on the right is reputed to be Dr. Johnson.

1. William Bates, *George Cruikshank: The Artist, the Humourist, and the Man*, 2nd ed. (Birmingham, 1879), p. 83.
2. See comments under No. 20.
3. *B.M. Satires*, No. 5922. The engraver and publisher of the print was William Dickinson.
4. Rowlandson's prints after Bunbury are discussed in J. C. Riely, 'Horace Walpole and "the Second Hogarth,"' *Eighteenth-Century Studies*, 9 (Fall 1975), 42–44.

85. *A Funeral Procession. Ca. 1805–10.* PLATE XXXI

Pen and watercolor over pencil, on wove paper, 7⅞ × 11 in. (200 × 280 mm).

Provenance: Dyson Perrins; sold Sotheby's 24 Feb. 1960 (Property of Mrs. C. W. Dyson Perrins), lot 61, to P. J. Nash; sold Sotheby's 20 March 1963 (Various Properties), lot 40, to Colnaghi; acquired 1963.
Exhibitions: London, P. and D. Colnaghi and Co., and New Haven, Yale University Art Gallery, English Drawings and Watercolors from the Collection of Mr. and Mrs. Paul Mellon, 1964/65, No. 29.
Bibliography: Baskett and Snelgrove, No. 190; Oppé, Pl. 57.

The exact location of this view has not been identified, but it is doubtless taken from high ground above the Thames, with London church spires and the dome of St. Paul's in the distance. A funeral cortège makes its way slowly towards a large mansion overlooking the river; people have gathered to watch the procession and they bow their heads in respect as it passes. The rococo character of the drawing is embodied in the serpentine line of the procession, continued by the road leading to the mansion and contrasting with the sloping curve of the riverbank. The penwork in vermilion ink tends to be rapid and superficial, but the figures acquire sufficient weight when overlaid with dark wash. By subtle modulation of color and tone, Rowlandson creates a surprisingly strong impression of depth. The penwork suggests a date in the first decade of the nineteenth century.

86. *A Crowded Race Meeting. Ca. 1805–10.*

Pen and watercolor, on wove paper, 5⅞ × 9½ in. (148 × 240 mm).

Provenance: Charles Russell; Agnew; acquired 1961.
Exhibitions: Washington, National Gallery of Art, An Exhibition of English
Drawings and Water Colors from the Collection of Mr. and Mrs. Paul Mellon,
1962, No. 60.
Bibliography: Baskett and Snelgrove, No. 122.

In addition to copying and engraving designs by other artists, Rowlandson was
in the habit of repeating many of his own works. This was accomplished by
various means, most often by straightforward copying or occasionally by
tracing. In later years he sometimes resorted to the more mechanical process of
counterproofing, a method described in 1869 by Wyatt Papworth:

> Rowlandson would call in the Strand, ask for paper, vermilion, a
> brush, water, a saucer, and a reed; then, making of the reed such a pen
> as he liked, he drew the outline of a subject (generally taking care to
> reverse the arms of his figures), and hand[ed] the paper to Mr. [Rudolph]
> Ackermann to be treated as if it were a copper-plate. This was taken to
> the press, where some well-damped paper was laid upon the sketch,
> and the two were subjected to a pressure that turned them out as a
> right and left outline. The operation would be performed with other
> pieces of damp paper in succession, until the original would not part
> with vermilion enough to indicate an outline; then that original became
> useless, and Rowlandson proceeded to reline the replicas, and to tint
> them according to the fancy of the moment.[1]

The essential accuracy of this account is borne out by numerous surviving
drawings that began as counterproofs, of which the present work is an example.
The evidence can be seen in the faint sucked-out lines, side by side with rein-
forcing lines, on the female figure in the center holding a basket (?) in her arms.
The Museum of Art, Rhode Island School of Design, has another version of
this subject that could conceivably be the original from which this drawing was
'pulled': it is of the same size but in the reverse direction.[2]

1. W[yatt] P[apworth], 'Thomas Rowlandson, Artist,' *Notes and Queries*, 4th Series,
 4 (31 July 1869), 89. Wyatt Papworth was the son of John Buonarotti Papworth,
 who contributed verses to *Poetical Sketches of Scarborough* (London: Rudolph
 Ackermann, 1813); Rowlandson etched the twenty-one plates in the work.
2. Repr. [Malcolm Cormack *et al.*], *Selection II: British Watercolors and Drawings
 from the Museum's Collection* (Providence, 1972), No. 30.

87. *The Annual Race for Doggett's Coat and Badge. Ca. 1805–10.*

Pen and watercolor over pencil, on wove paper, 5⅝ × 9¼ in. (144 × 234 mm).
Provenance: Sir Theodore Cook; Desmond Coke, his sale Christie's 22 Nov. 1929,
lot 47, to Francis Edwards; Sir Clive Burn; Agnew; acquired 1962.
Exhibitions: V.M.F.A., 1963, No. 430.
Bibliography: Baskett and Snelgrove, No. 116; Theodore Andrea Cook and Guy
Nickalls, *Thomas Doggett, Deceased* (London, 1908), facing p. 40 (repr.); Sutton,
pp. 282, 285, Fig. 23.

Rowlandson's friend John Thomas Smith describes the race instituted by the actor Thomas Doggett (?1670–1721) to mark the accession of the House of Hanover:

> In 1715, the year after George the First came to the throne, Doggett, to quicken the industry and raise a laudable emulation in our young men of the Thames, whereby they not only may acquire a knowledge of the river, but a skill in managing the oar with dexterity, gave an orange-coloured coat and silver badge, on which was sculptured the Hanoverian Horse, to the successful candidate of six young watermen just out of their apprenticeship, to be rowed for on the 1st of August, when the current was strongest against them, starting from the "Old Swan," London Bridge, to the "Swan," at Chelsea. On the 1st of August 1722, the year after Doggett's death, pursuant to the tenor of his will, the prize was first rowed for, and has been given annually ever since.[1]

In the grueling race over a distance of four and a half miles, the rowers had to contend not only with each other and the strong tide, but also with the throngs of spectator boats dangerously nearby. The event was celebrated in Charles Dibdin's popular ballad opera *The Waterman; or, The First of August*, first performed in 1774 and frequently revived.

A small preliminary study for the present drawing, boldly sketched in pen and wash and inscribed by Rowlandson 'First of August. Rowing for Coat & Bad⟨ge⟩', is in the Princeton University Library, Dickson Q. Brown Collection.[2] A drawing showing the finish of the race is in the British Museum.[3]

1. John Thomas Smith, *A Book for a Rainy Day* (London, 1845), pp. 207–08.
2. Repr. O. J. Rothrock, 'Rowlandson Drawings at Princeton: Introduction and Checklist,' *Princeton Univ. Library Chronicle*, 36 (Winter 1974–75), Fig. 6, between pp. 100 and 101 (No. A54).
3. Repr. in color in T. A. Cook and Guy Nickalls, *Thomas Doggett, Deceased* (London, 1908), frontispiece; Bury, Pl. 26.

88. *Evading the Toll. Ca. 1805–10.*

Pen and watercolor over pencil, on wove paper, 6⅜ × 9⅛ in. (162 × 233 mm). Falsely signed in ink, lower left: *T. Rowlandson*

Provenance: Colnaghi; acquired 1964.
Bibliography: Baskett and Snelgrove, No. 131.

Evading the Toll treats an incident from everyday life with the broad comic appeal most often associated with Rowlandson. The action is caught precisely at the moment the crime is being committed; as the humor is largely dependent on the reaction of the toll-keeper and his wife, their gestures of anger and surprise are recorded simultaneously. The original version of the subject, in the Wiggin Collection, Boston Public Library, has rapid, vigorous penwork over very free

pencil outlines. This repetition shows greater attention to detail, but it remains a typical example of Rowlandson's facile, unlabored production.

89. *Outside the Greengrocer's and Baker's Shops. Ca. 1805–10.*

Pen and watercolor over pencil, on wove paper, 10⅝ × 8⅜ in. (271 × 213 mm). Verso: color splashes.
Provenance: Frank T. Sabin; acquired 1974.
Bibliography: Baskett and Snelgrove, No. 164.

Rowlandson designed and etched a series of fifty-four plates entitled *Characteristic Sketches of the Lower Orders*, published in 1820 as a supplement to Samuel Leigh's *New Picture of London*.[1] The Advertisement to the volume praises the 'truth and genuine feeling in his delineations of human character': 'The great variety of countenance, expression, and situation, evince an active and lively feeling, which he has so happily infused into the drawings as to divest them of that broad caricature which is too conspicuous in the works of those artists who have followed his manner.'[2]

The present drawing, though much larger than the plates in *Characteristic Sketches* and dating from a decade or more earlier, is a genre scene in the same vein. A very similar figure of a baker appears in one of the plates and is so identified. The well-dressed representative of a higher order is added here for contrast. However great Rowlandson's genius for 'expression' and 'situation,' he could be careless of basic anatomy: notice particularly the awkwardness of the young buck's right leg and the baker's right upper arm. There is another version of this subject in the Metropolitan Museum of Art.

1. Grego, II, 366–67; Grolier, No. 44; Tooley, No. 424.
2. *Rowlandson's Characteristic Sketches of the Lower Orders* (London, 1820), pp. iii–iv.

90. *Harvesters Resting in a Cornfield. Ca. 1805–10.*

Pen and watercolor over pencil, on wove paper, 8⅛ × 11⅛ in. (205 × 284 mm).
Provenance: C. F. Huth; C. R. Carter, sold Sotheby's 19 Nov. 1970, lot 125, to John Baskett; acquired 1970.
Bibliography: Baskett and Snelgrove, No. 84.

The penwork in this drawing is somewhat freer and more relaxed than in many of Rowlandson's pastorals. Muted tones of olive green and tan, warmed by vermilion ink, give the picturesque composition a late summer glow appropriate to harvest home. The familiar Rowlandsonian counterpoint between human and natural forms is provided by the sprightly group of harvesters, who have been very naturally introduced into the foreground. A similar subject, given the title *The Harvest Field*, was formerly in the collection of Desmond Coke.[1]

1. Repr. Basil S. Long, 'More Drawings by Rowlandson in the Desmond Coke Collection,' *Connoisseur*, 80 (Feb. 1928), 69, Fig. IV.

91. *Angry Scene in a Street. Ca. 1805–10.*

> Pen and watercolor over pencil, on wove paper, 5¾ × 9⅜ in. (146 × 238 mm).
> *Provenance:* T. E. Lowinsky (Lugt 2420a); Justin Lowinsky; acquired 1963.
> *Bibliography:* Baskett and Snelgrove, No. 187; Sutton, p. 281, Fig. 11.

Rowlandson left behind him so many drawings of people in low life that it is often supposed he came from that world. In fact he was born into the prosperous middle class, and he remained in it throughout his life. It was the social milieu he knew best and was most successful at representing. When he turned to low life for his subjects, as he did often enough, his inclination was to exaggerate what he saw—even though low life by its very nature is an exaggerated, or extreme, kind of existence. The tendency is apparent in the present drawing, a violent, boisterous street scene in which everything seems to be happening at once. Women are shouting and gesticulating, laughing and quarrelling, standing in doorways and hanging out of windows, stealing and being stolen from. This is the rough-and-tumble world of the bawdy house, only more so—and to Rowlandson it is all a great deal of fun. He caricatures the figures at will and sets up a strong rhythm of waving limbs and fluttering draperies (notice the string of wash hung across the street). The action of the scene is amusingly summed up by the sign on the bawdy house at right. 'NO THOROUGHFARE' might very well serve as the title of the drawing.

92. *A Group of Five Bulls about to Fight. Ca. 1810.*

> Pen and pinkish gray wash over pencil, on wove paper, 5¾ × 8¾ in. (145 × 223 mm).
> *Provenance:* L. G. Duke (D.101), from M. de Beer, 1945; Colnaghi; acquired 1961.
> *Bibliography:* Baskett and Snelgrove, No. 156.

This monochrome study of bulls possibly owes something to Sawrey Gilpin or Gainsborough, both of whom were represented in Rowlandson's *Imitations of Modern Drawings*,[1] but the arrangement is doubtless his own invention. With assured, economical use of the pen and brush, Rowlandson brilliantly demonstrates his mastery of animal form and movement.

> 1. See comments under No. 28.

93. *Quakers' Meeting. Ca. 1810.*

> Pen and watercolor over pencil, on wove paper, 8⅛ × 11 in. (208 × 280 mm).
> Inscribed in ink in Rowlandson's hand, lower right: *Quakers Meeting*
> *Provenance:* Sold Christie's 22 June 1962, lot 39, to Colnaghi; acquired 1962.
> Bibliography: Baskett and Snelgrove, No. 232.

Rowlandson collaborated with the architect Augustus Charles Pugin (father of the Gothic designer A. W. N. Pugin) to produce *The Microcosm of London*, one of the greatest of English color-plate books. The two were employed by Ru-

dolph Ackermann to make 104 aquatint views of places in the city, thus provid-
ing a visual record of its appearance and activities. The subjects included public
buildings and government offices, schools, legal and financial institutions, out-
door markets and fairs, theatres, houses of worship, and the like.

Pugin was responsible for delineating the architectural part of the subjects,
and Rowlandson supplied the figures. In the Introduction to the completed
work, Ackermann pointed out that in earlier engraved views of architecture,

> the buildings and figures have almost invariably been designed by the
> same artists. In consequence of this, the figures have been generally
> neglected, or are of a very inferior cast, and totally unconnected with
> the other part of the print. . . . To remove these glaring incongruities
> from this publication, a strict attention has been paid . . . to the general
> air and peculiar carriage, habits, &c. of such characters as are likely to
> make up the majority in particular places.[1]

Ackermann had astutely foreseen the happy results of combining the talents of
Rowlandson and Pugin.

A unique extra-illustrated copy of the *Microcosm*, once belonging to
Pugin himself and now in the Art Institute of Chicago, Charles Deering Collec-
tion, contains original sketches, finished designs, and proof impressions of the
aquatints, fully documenting the genesis of the work.[2] For each subject, one or
both draughtsmen made preliminary studies on the spot and reached an agree-
ment as to the viewpoint. Pugin then executed a detailed perspective drawing in
pencil, of the same size as the etching. This drawing, sometimes bearing a curt
directive from Pugin, was turned over to Rowlandson, who put in the figures.
After they had settled any remaining artistic differences, the completed design
was transferred in reverse to the copperplate, doubtless by means of a pencil
tracing. Pugin as well as Rowlandson seems to have taken part in the etching of
the plate, which was subsequently aquatinted by any one of several skilled prac-
titioners employed by Ackermann. Proof impressions were taken and inspected.
Finally, prints were produced in quantity and colored by hand according to a
model provided by the artists.

The *Microcosm* was issued to subscribers in twenty-six monthly parts
(four plates to a part) between 1808 and 1810. In the latter year Ackermann pub-
lished the collected numbers in three volumes.[3] The author of the descriptive
letterpress accompanying the plates in the first two volumes is said to be W. H.
Pyne; William Combe, who wrote the verses for the three *Tours of Doctor
Syntax* (see below, No. 94), was responsible for the text in the third volume.

The present drawing is entirely Rowlandson's work and appears to be a
copy after the aquatint that is the last plate (No. 64) in the second volume of the
Microcosm.[4] A similar watercolor drawing by him, said to be a study for the
etching but probably another copy after the print, is in the Art Institute of
Chicago, Gift of Mrs. James Ward Thorne.[5]

1. *The Microcosm of London (or London in Miniature)* (London, 1808–10), I, ii–iii.
2. The copy is described in detail in Carl O. Schniewind, 'A Unique Copy of *The Microcosm of London* Acquired for the Charles Deering Collection,' *Bulletin of the Art Institute of Chicago*, 34 (Sept.–Oct. 1940), 77–78. It was formerly owned by Desmond Coke, who discusses it in *Confessions of an Incurable Collector* (London, 1928), pp. 107–10. See also Carl Zigrosser, '"The Microcosm of London,"' *Print Collector's Quarterly*, 24 (April 1937), 145–72, where some examples of the unique material are reproduced. A set of etching proofs before aquatinting is in the Museum of Fine Arts, Boston, W. G. Russell Allen Bequest.
3. Abbey, *Scenery*, No. 212; Grego, II, 125–28; Grolier, No. 16; Tooley, No. 7.
4. The plate was aquatinted by J. C. Stadler and originally appeared in the sixteenth monthly part, dated 1 April 1809. Rowlandson's and Pugin's design for the plate is preserved in the unique copy of the *Microcosm* mentioned above.
5. Repr. Schniewind, op. cit., p. 78; ex coll. Desmond Coke.

94. *Doctor Syntax Copying the Wit of the Window. 1809.*
PLATE XXXII

Pen and watercolor over pencil, on wove paper, 5½ × 8⅛ in. (139 × 208 mm). Inscribed in ink in Rowlandson's hand across bottom: *Amuses himself at an Inn with reading the Poetry on the Windows—*
Verso: tracing in pencil of the principal outlines; money sums.
Etched by Rowlandson and published by Rudolph Ackermann as Pl. 10 for the *Poetical Magazine*, No. 5, 1 Sept. 1809 (Abbey, *Life*, No. 214; Grego, II, 177; Grolier, No. 18; Tooley, No. 421; *B.M. Satires*, No. 11512); retouched (and, for the fourth edition, newly etched) by Rowlandson and published by Ackermann as Pl. 6 for *The Tour of Doctor Syntax, In Search of the Picturesque*, 1 May 1812 (Grego, II, 247; Grolier, No. 20; Tooley, No. 427).
Provenance: John Fleming; acquired 1966.
Bibliography: Baskett and Snelgrove, No. 309; Gully, pp. 77–78, 340, Fig. 108 (the aquatint in the *Poetical Magazine*).

During the nineteenth century, Rowlandson was best known for his aquatint illustrations to the three *Tours of Doctor Syntax*, a collaboration with the hack writer William Combe. John Bannister, the actor (see above, No. 3), is said to have provided 'hints' for the work, which began as a humorous satire on the 'picturesque' tours of the English countryside described by William Gilpin.[1] The first series appeared in Ackermann's *Poetical Magazine* (1809–11), with the title *The Schoolmaster's Tour*, and was published in book form in 1812 as *The Tour of Doctor Syntax, In Search of the Picturesque*. Immediately popular, it went into nine editions over the next seven years. The second *Tour* (*In Search of Consolation*) followed in 1820, the third (*In Search of a Wife*) in 1820–21; there were numerous imitations and parodies.

In the Advertisement to the first *Tour*, Combe explained the peculiar circumstances of the collaboration:

An Etching or a Drawing was . . . sent to me every month, and I composed a certain proportion of pages in verse, in which, of course, the subject of the design was included. . . . When the first print was sent to me, I did not know what would be the subject of the second; and in this manner, in a great measure, the Artist continued designing, and I continued writing, every month for two years, 'till a work, containing near ten thousand Lines was produced: the Artist and the Writer having no personal communication with, or knowledge of each other.

Ackermann, the publisher, apparently served as intermediary between the two.[2]

This drawing is probably Rowlandson's original design for the aquatint, which illustrates an episode in the first *Tour* in which Syntax appears as the inspired but absent-minded poet:

> But as he copied quite delighted,
> All that the Muse had thus indited,
> A hungry dog, and prone to steal,
> Ran off with half his breakfast meal;
> While Dolly, ent'ring with a kettle,
> Was follow'd by a man of mettle,
> Who swore he'd have the promis'd kiss,
> And, as he seiz'd the melting bliss,
> From the hot ill-pois'd kettle's spout,
> The boiling stream came pouring out,
> And drove the Doctor from the Muse,
> By quickly filling both his shoes.[3]

There is a repetition of this subject in the collection of Philip Hofer, Cambridge, Massachusetts.

1. John Adolphus, *Memoirs of John Bannister, Comedian* (London, 1839), I, 290–91. See also Ephraim Hardcastle [W. H. Pyne], *Somerset House Gazette* (London, 1824), II, 222. It should be noted that Syntax-like figures appear in Rowlandson drawings of several years earlier. The elderly cleric with antiquarian pursuits was a stock character in late eighteenth-century literature.
2. For a critical discussion of the Syntax series, see Harlan W. Hamilton, *Doctor Syntax: A Silhouette of William Combe, Esq.* (London, 1969), pp. 243–61.
3. *The Tour of Doctor Syntax, In Search of the Picturesque* (London, 1812), p. 32.

95. *The Doctor Is So Severely Bruised that Cupping Is Judged Necessary. Ca. 1809–11.*

Pen and watercolor over pencil, on wove paper, 5½ × 8⅜ in. (141 × 213 mm). Inscribed in pencil in Rowlandson's hand, upper right: *The Doctor is so severely bruised that Cupping | is judged necessary*

Provenance: W. Eastland, sold Sotheby's 20 Nov. 1969, lot 126, to John Baskett; acquired 1969.

Bibliography: Baskett and Snelgrove, No. 324; Gully, pp. 209 (No. 73 in Catalogue, erroneously listed as in the Witt Collection, Courtauld Institute of Art), 347, Fig. 115.

See comments under No. 94. Rowlandson executed a number of designs for the *Tours of Doctor Syntax* that were never etched. The present drawing is possibly related to an episode in the first *Tour* in which Syntax becomes ill while staying at an inn: 'His limbs were all besieg'd with pain.' The landlord summons a local doctor, who decides to bleed the suffering patient.[1] Syntax is shown here undergoing the operation of cupping; blood is drawn out by scarifying the skin and applying heated glass cups. The design was not used for the book.

The penwork is loose and in some areas (especially the figures in the center) rather disjointed, though less so than in some of Rowlandson's later drawings. The watercolor washes have been applied with little variation in tone, so that the forms tend to remain flat and unlifelike.

1. *The Tour of Doctor Syntax, In Search of the Picturesque* (London, 1812), pp. 76–77.

96. *Venus Crowned by Cupids. Ca. 1810–15.*

Pen and watercolor over pencil, on wove paper, 5⅝ × 8¾ in. (144 × 221 mm).

Provenance: Desmond Coke, his sale Christie's 22 Nov. 1929, lot 52, to Rimell; Charles Slatkin Inc. Galleries; acquired 1971.

Bibliography: Baskett and Snelgrove, No. 340.

Rowlandson's affinities with eighteenth-century French art have often been remarked upon. He visited France on several occasions and is said to have received formal training at Paris during his early student days,[1] although documentary evidence of this training is lacking. His familiarity with the work of certain French artists is at all events beyond question; the sale catalogue of his art collection indicates that he owned well over three hundred engravings of the 'French School,' including 'fancy subjects' and *fêtes champêtres* after Fragonard, Watteau, and Boucher.[2] These artists, among others, he copied or imitated with some frequency; his experience of them appears to have encouraged his instinctive preference for the curving form and the flowing line. Though influences are often impossible to prove one way or the other, critics have observed resemblances to Rowlandson in earlier works by Gabriel de Saint-Aubin and Moreau le Jeune, and in contemporary or later works by Debucourt, Horace Vernet, and Constantin Guys.

Venus Crowned by Cupids is a close copy after the engraving of a drawing (in the reverse direction) by Boucher, signed and dated 1754.[3] At various times during mid-career, Rowlandson made studies of nudes, chiefly after the Italian masters, which were often adapted for compositions of his own.[4] Many of the subjects were mythological, involving groups of nymphs and satyrs or the

Roman deities. This drawing, with its smooth, rounded contours and fresh pastel tints, is a particularly attractive example of the type.

1. See *The London Literary Gazette*, No. 536, 28 April 1827, p. 267; *Reminiscences of Henry Angelo* (London, 1828–30), I, 236–37; II, 325.
2. Sotheby's sale catalogue, 23–26 June 1828, lots 237–46.
3. The drawing was sold at Sotheby's 10 June 1959 (Property of Mrs. Hubert Chanler), lot 2 (repr.), to Engell Gallery; not further traced.
4. See, for example, the sheet of nude studies after Giulio Romano, Carlo Maratti, Boucher, and others in the Whitworth Art Gallery, Manchester; repr. Hayes, p. 57, Fig. 57. Cf. other examples in the Huntington Collection, repr. Wark, Nos. 366, 369–74.

97. *A Summer Idyll. Ca. 1810–15.*

Pen and watercolor over pencil, on wove paper, 8½ × 10⅞ in. (215 × 278 mm). Inscribed in pencil in a later hand on the verso: *The College Green.*
Provenance: Mrs. Gilbert Miller, sold Sotheby's 19 March 1970, lot 27, to John Baskett; acquired 1970.
Bibliography: Baskett and Snelgrove, No. 54; Frank Davis, 'Porcelain in its own Right,' *Country Life*, 148 (16 July 1970), 168, Fig. 2.

The influence of Watteau and Lancret is strongly felt in this charming pastoral scene, a stylized vision of the modern Arcadia. Rowlandson is following the French manner of *fêtes champêtres,* and he retains their elegance and grace within the context of an English landscape. The composition is superbly contrived so that the small pyramid of figures in the foreground gains prominence from the strong verticals of the Gothic chapel above and beyond it. Luxuriant foliage surrounds the figures and emphasizes the lyrical mood of their *déjeuner sur l'herbe.* See comments under No. 96.

98. *A Stag Hunt in the Park of a Country House. Ca. 1810–15.*

Pen and watercolor over pencil, on wove paper, 11 × 17 in. (279 × 431 mm).
Provenance: Miss B. K. Abbot, sold Sotheby's 19 Nov. 1970, lot 168, to John Baskett; acquired 1970.
Bibliography: Baskett and Snelgrove, No. 112.

See comments under No. 70. This hunting scene, like many others produced by Rowlandson during his long career, is as much a landscape as a sporting picture. Such drawings must have sold well for him to have produced as many as he did. The scenes could be varied according to his own fancy or the wishes of a patron, for they were rarely, if ever, taken from nature. In this respect Rowlandson differs from his brother-in-law, the watercolorist Samuel Howitt, whose sporting subjects, if not always done from life, were based on first-hand experience.[1] The colors in this drawing—mostly olive greens and browns, except on the figures—are typical of Rowlandson's later landscapes, though there is evidence (along

the edges) of considerable fading. The outlines in brown and vermilion ink on the figures tend to be thin and wiry.

1. See Walter Shaw Sparrow, 'Rowlandson and Howitt—Painters of Sport,' *International Studio*, 97 (Dec. 1930), 61–64, 108. Many of Howitt's early watercolors of the 1780s and '90s—landscapes as well as sporting scenes—are stylistically similar to those of Rowlandson at the same period. The telling difference usually lies in the figures, which Howitt draws rather more stiffly and precisely. Cf. Baskett and Snelgrove, No. 108, a drawing that is given to Rowlandson but which seems more likely to be Howitt's work.

99. *The Ivory Coast, West Africa. Ca. 1810–15.*

Pen and watercolor over pencil, on wove paper, 14¾ × 21½ in. (374 × 547 mm).
Provenance: Dr. John Percy; Randall Davies, his sale Sotheby's 12 Feb. 1947, lot 350; Maas Gallery; acquired 1964.
Exhibitions: Paris, Musée des Arts décoratifs, Caricatures et mœurs anglaises 1750–1850, 1938, No. 88.
Bibliography: Baskett and Snelgrove, No. 47.

Rowlandson never travelled farther away from England than Italy, and consequently he had no first-hand knowledge of the Ivory Coast. He may have read, however, any of several English accounts of voyages to the western coast of Africa published in London between 1800 and 1820. Some of these books, such as Joseph Corry's *Observations upon the Windward Coast of Africa* and Francis Spilsbury's *Account of a Voyage to the Western Coast of Africa* (both published in 1807), were illustrated with engraved views of local scenery from sketches made on the spot by the authors. The views show not only the terrain of the country, but also the natives engaged in their activities.

A direct source for Rowlandson's drawing of the Ivory Coast has not been found; it may well be a *pastiche* based on various views in the African travel books. Scenes of this kind are an exotic and rarely encountered oddity in Rowlandson's *oeuvre*. His choice of subject may have been generally influenced by the beautiful engraved views of South Pacific islands, after drawings by William Hodges, in Cook's *Voyage towards the South Pole, and round the World* (London, 1777), or by the large colored aquatints in Samuel Daniell's *African Scenery and Animals* (London, 1804–05).[1] A small (8¾ × 7⅜ in.), apparently related drawing, inscribed by Rowlandson 'A Negro Boy of the River Gaboon on the Coast of Africa Receiving punishment for stealing Chickens,' is in the Princeton University Library, Dickson Q. Brown Collection.[2]

1. These and many other works are discussed in Bernard Smith's well-illustrated study *European Vision and the South Pacific 1768–1850* (Oxford, 1960).
2. See O. J. Rothrock, 'Rowlandson Drawings at Princeton: Introduction and Checklist,' *Princeton Univ. Library Chronicle*, 36 (Winter 1974–75), 103, No. A38. That drawing is probably of an earlier date.

100. *How to Vault in the Saddle. 1813.*

Pen and watercolor over pencil, on wove paper watermarked 1809, indented for
transfer, 10¾ × 8⅝ in. (273 × 219 mm); contemporary mount.
Falsely signed in ink, lower left: *Rowlandson.*
Inscribed in ink in Rowlandson's hand, lower right: H O W T O V A U L T I N
T H E S A D D L E.
Etched in the reverse direction by Rowlandson and published by Thomas Tegg
30 Dec. 1813 with the title *How to Vault in the Saddle. | or A New Invented
Patent Crane. for the Accomodation of Rheumatic Rump'd Rectors,* (Grego, II, 265).
Provenance: William Wright, sold Christie's 15 May 1899, lot 53; Dr. Kiczales;
acquired 1972.
Bibliography: Baskett and Snelgrove, No. 128.

At the time that Rowlandson was being employed by Rudolph Ackermann on
Doctor Syntax, he was also turning out a steady stream of popular caricatures
which were quickly etched and published by Thomas Tegg in Cheapside,
'Price One Shilling Coloured.' Because these prints are often grotesque in sub-
ject matter and crudely executed, they have frequently been dismissed as exam-
ples of Rowlandson's degeneration into hackwork. Yet Paul Oppé was surely
right in pointing out that

> The cheap caricatures are not to be set aside as mere "pot-boilers."
> They have their roots in Rowlandson's very centre. He had a real
> taste for the ugly in itself, whether he used it to produce a shudder or
> a grin. Some of his most finished work from the earlier date is to be
> found in heads of hideous old men, evidently not drawn from Nature
> but with every feature of malice, grossness and vice, and every line
> left by years of evil living dwelt upon, tenderly and without over-
> emphasis. They are not caricatures, but images [of] obsessions. He
> never gave to his portraits or other ideal heads a fraction of the care
> which he gave to these.[1]

Rowlandson's association with Tegg dates from the time of *The Caricature
Magazine, or Hudibrastic Mirror,* which Tegg began to issue serially, with as-
sistance from the amateur artist G. M. Woodward, in 1807. Rowlandson was a
prolific contributor to the magazine, and over the next dozen years or so Tegg
published a vast number of cheap prints after his designs, of which the present
drawing is a fairly typical example.[2] Rowlandson's 'taste for the ugly' is ex-
pressed in the exaggerated features of the fat, gouty divine who is being hoisted
into his saddle by two smiling servant girls. In the print, he is shown carrying
in his pocket a discourse on the text 'He that humbleth himself shall be exalted.'

1. Oppé, p. 20. For 'finished work from the earlier date' he doubtless has in mind a
 drawing such as *A Worn-out Débauché* (No. 38 above).
2. The two impressions of the print that I have seen (in the William B. Osgood Field
 Collection at Harvard and in the Clements C. Fry Collection, Yale Medical

Library) both lack the publication line, but the numbering at the top is evidence of Tegg's proprietorship. The print is signed in the plate 'Rowlandson Del. 1813' (i.e., the date of his original design, exhibited here).

101. *An Artist's Studio. 1814.*

Pen and watercolor over pencil, on wove paper watermarked 1809, 10½ × 8½ in. (267 × 215 mm).
Signed and dated in ink, lower left: *Rowlandson 1814*
Provenance: Mrs. J. E. Hawkins; sold Christie's 22 June 1962 (Property of a Lady), lot 44, to Colnaghi; acquired 1962.
Bibliography: Baskett and Snelgrove, No. 196.

This is another upright design, less fanciful than the preceding one, but exhibiting much the same type of coarse, close-up caricature often found in Rowlandson prints published by Tegg. An etching of this subject has not come to light, although one may well have been executed. The small, crowded interior, filled with the artist's clutter and debris, is a scene with Hogarthian overtones recalling the more elaborate composition of Rowlandson's *The Chamber of Genius*, etched and published in 1812.[1] Here the grotesque humor derives from the voyeuristic concentration of the artist and his patron (both oblivious to their surroundings) on the painting before them—a ludicrous portrayal of a bearded old swain drawing to him a voluptuous maid. This is a crudely simplified variation on the theme Rowlandson brilliantly expressed two decades earlier in *The Connoisseurs* (No. 37 above).

1. Grego, II, 227–28; *B.M. Satires*, No. 11962. The original drawing is in the Royal Collection; repr. Falk, facing p. 45; Hayes, Pl. 133; Oppé, Pl. 85.

102. *A Book Auction. Ca. 1810–15.*

Pen and watercolor over pencil, on wove paper, 6 × 9¾ in. (153 × 249 mm).
Verso: faint pencil sketch of a soldier and other male figures.
Provenance: Colnaghi; acquired 1962.
Exhibitions: New Haven, Yale Center for British Art, The Pursuit of Happiness, 1977, No. 49.
Bibliography: Baskett and Snelgrove, No. 192; Sutton, pp. 279–81, Fig. 7.

In the course of forming a substantial collection of prints and illustrated books, Rowlandson must have become a familiar figure in the London auction rooms. According to W. H. Pyne, he was in the habit of attending Greenwood's candlelight auctions in company with his friends John Bannister and Matthew Michell, and John Thomas Smith informs us that he 'frequently made drawings of Hutchins and his print-auctions.'[1] The two chief auction firms then, as today, were Christie's and Sotheby's, both founded in the mid eighteenth century. Christie's saleroom is one of the subjects included in *The Microcosm of London* (see above, No. 93), and a preliminary sketch by Rowlandson for this

subject is in the British Museum. The present drawing is said to represent a book sale at Sotheby's, though it is not certain that the identification is correct. A very similar, perhaps slightly earlier, version of this subject is owned by Sotheby's, London,[2] and there is another version in the Brooklyn Museum.

1. Ephraim Hardcastle [W. H. Pyne], *Somerset House Gazette* (London, 1824), II, 360; John Thomas Smith, *A Book for a Rainy Day* (London, 1845), p. 104.
2. Repr. A. P. Oppé, 'Rowlandson, the Surprising,' *Studio*, 124 (Nov. 1942), 156.

103. *Death and the Débauché. Ca. 1814–16.* PLATE XXXIII

Pen and watercolor over pencil, on wove paper, 5¼ × 8⅝ in. (135 × 218 mm).
Inscribed in ink in Rowlandson's hand, lower center: *Death and the Debauchéé—*
Provenance: Hamill and Barker; acquired 1958.
Bibliography: Baskett and Snelgrove, No. 329; Robert R. Wark, *Rowlandson's Drawings for The English Dance of Death* (San Marino, 1966), p. 178, No. 98 (repr.).

Although Rowlandson was to produce hundreds of drawings over the following decade, *The English Dance of Death* was his last major undertaking. The enormous popularity of the first *Tour of Doctor Syntax* (see above, No. 94) encouraged Ackermann, the publisher, to promote another collaboration between Rowlandson and William Combe. In this project the two men followed a procedure much the same as before. Rowlandson executed one or two designs at a time; they were then delivered to Combe, who composed the accompanying verses. The two men presumably did not meet, but there is evidence of some communication between them.[1] Seventy-two designs, not including the title page and frontispiece, were etched (apparently not by Rowlandson) and aquatinted. They were first issued in twenty-four monthly parts (three plates to a part) between 1814 and 1816, and in the latter year were published in two volumes.[2]

The English Dance of Death had nothing like the popular success of *Doctor Syntax*, but artistically it was a much more inventive and sophisticated achievement. Ackermann was responsible for proposing the subject, which has its pictorial origins in late medieval scenes of Death (depicted as a skeleton or corpse) leading his human victims in a macabre 'dance.' Holbein's celebrated treatment of the theme (published in 1538) is generally regarded as its culmination. But Rowlandson did not much concern himself with traditional representations of the theme, which emphasize the universality of Death visiting men in all walks of life. Instead, he used the idea primarily as a vehicle for creating an extremely ingenious and lively variety of tragicomic episodes. Except in the broadest sense, his situations involving Death have little moral or didactic content.[3]

In addition to the designs that were etched and published, Rowlandson executed a fair number of related subjects that were not included in the series. Some of these may have been offered as alternative designs which Combe, for

one reason or another, decided not to use. Others were probably produced for Rowlandson's own diversion. Moreover, he repeated many of the engraved subjects,[4] sometimes copying them in a slightly smaller size (possibly to serve as models for etching) or making counterproofs. In 1966 Robert Wark had located 180 Rowlandson drawings concerned with the Dance of Death, representing 96 different subjects, and others have since come to light.

The present drawing is an example of an unpublished design. Death, bearing his dart in one hand and an hourglass in the other, appears in the doorway of a garret and surprises an old debauchee in his bed. His mistress, who sits fully clothed at the foot of the bed, crouches forward to shield herself from Death's approach. Rowlandson's line is thin and flexible in character, with few reinforced passages.

1. On the verso of a drawing in the Huntington Collection, there is an inscription in Combe's hand suggesting changes that were adopted in the print. See Robert R. Wark, *Rowlandson's Drawings for The English Dance of Death* (San Marino, 1966), pp. 6–7.
2. Abbey, *Life*, No. 263; Grego, II, 317–55; Grolier, No. 32; Tooley, No. 411; *B.M. Satires*, Nos. 12411–37, 12656–91.
3. The fullest discussions of *The English Dance of Death* and the nature of Rowlandson's achievement are in Wark, op. cit., pp. 3–27, and in Paulson, pp. 93–96, 113–16. Paulson is mainly concerned with exploring the 'meaning' in the work.
4. The following drawing, No. 104, is an example of a repetition.

104. *Death Turned Pilot. Ca. 1815–16.*

Pen and watercolor over pencil, on wove paper, 5¾ × 9⅜ in. (146 × 237 mm).
Provenance: Alan G. Thomas; acquired 1959.
Bibliography: Baskett and Snelgrove, No. 326; Robert R. Wark, *Rowlandson's Drawings for The English Dance of Death* (San Marino, 1966), pp. 160–61, No. 45(c).

See comments under No. 103. This subject was etched and published in the fifteenth monthly part (dated 1 June 1815) of *The English Dance of Death*, and forms the ninth plate in the second volume of the collected work.[1] The couplet appearing below the aquatint reads:

> The fatal Pilot grasps the Helm,
> And steers the Crew to Pluto's Realm.

Five versions of the subject, including the present one, are known. The Mellon version, executed chiefly in vermilion ink and watercolor, is clearly a repetition, whereas that in the Huntington Collection is squared off in pencil and may well be the original design. There are two versions in the New York Public Library, one in the Spencer Collection and the other (slightly smaller, possibly a copy by a later hand) in the Arents Collection. The fifth version was sold at the

American Art Association on 6 January 1937 (Fitz Eugene Dixon Sale), lot 139, and has not been further traced.[2]

A much more elaborate treatment of crew members struggling for survival in a lifeboat following shipwreck appears in *Distress* (No. 36 above).

1. Grego, II, 344; *B.M. Satires*, No. 12673.
2. Details of size and medium of all the versions except that in the Arents Collection are given in Robert R. Wark, *Rowlandson's Drawings for The English Dance of Death* (San Marino, 1966), pp. 160–61, No. 45; the Huntington version is reproduced, Pl. 45.

105. *Mr. Michell's Picture Gallery, Grove House, Enfield, 1817.* 1817.

Pen and watercolor over pencil, on wove paper, 5⅞ × 9⅜ in. (150 × 239 mm).
Falsely signed in ink, lower right: *Rowlandson*
Inscribed in ink in Rowlandson's hand, lower left: *Mr Michells Picture Gallery Grove House Enfield 1817.*
Provenance: Mrs. J. E. Hawkins; sold Christie's 22 June 1962 (Property of a Lady), lot 55 (with another drawing), to Colnaghi; acquired 1962.
Exhibitions: New Haven, Yale Center for British Art, The Pursuit of Happiness, 1977, No. 89.
Bibliography: Baskett and Snelgrove, No. 226.

In *Wine and Walnuts* W. H. Pyne includes an amusing account of a meeting between two of Rowlandson's jovial comrades, Matthew Michell and Caleb Whitefoord:

> "Well, Sirs, Master Caleb was on his way up the hill in the Adelphi, to his post at the Society of Arts, and who should he stumble upon at the corner of James Street, just turning round from Rowlandson's, but Master Mitchell, the quondam banker, of old Hodsoll's house. He had, as usual, been foraging among the multitudinous sketches of that original artist, and held a port-folio under his arm; and as he was preparing to step into his chariot, Caleb accosted him—'Well, worthy Sir, what more choice bits—more graphic whimsies, to add to the collection at Enfield, hey? Well, how fares it with our old friend Rolly?' (a familiar term by which the artist is known to his ancient cronies.)
>
> "'Why yes, Mister Caleb Whiteford, I go collecting on, though I begin to think I have enough already, for I have some hundreds of his spirited works; but somehow there is a sort of fascination in these matters. . . .'"[1]

Michell kept most of his collection of pictures at Grove House, Enfield, a few miles north of London, where Rowlandson was a frequent visitor.

This drawing provides a highly detailed and apparently accurate view of the gallery at Grove House, but except for the artist at the easel on the right, all the figures, including the housekeeper, are greatly caricatured. The exaggerated profiles of the three visitors recall the manner of Thomas Patch (1725–82), the expatriate English painter whose caricature conversation pieces of grand tourists in Italy had a significant influence on the development of English comic art.

There is another version of this subject in the Detroit Institute of Arts.[2] Two other views by Rowlandson of Michell's gallery at Grove House are known, one in the Mellon Collection[3] and the other, dated 1816 and misidentified as the British Institution, in the Wiggin Collection, Boston Public Library.

1. *Wine and Walnuts; or, After Dinner Chit-Chat* (London, 1823), II, 323–24.
2. Repr. David Keppel, 'Rowlandson,' *Art Quarterly*, 12 (1949), 79, Fig. 4. In this version the artist's head is turned the other way, and the man standing beside him is replaced by two women.
3. Baskett and Snelgrove, No. 227.

106. *Viewing at the Royal Academy. Ca. 1815.*

Pen and watercolor over pencil, on wove paper, 5¾ × 9½ in. (147 × 240 mm).
Provenance: F. Meatyard; Thomas Girtin; Tom Girtin; John Baskett; acquired 1970.
Exhibitions: London, Spring Gardens, Humorous Art, 1925; London, Arts Council of Great Britain, Humorous Art, 1949/50, No. 1; Sheffield, Graves Art Gallery, The Collection of Thomas Girtin, Jnr., 1953, No. 90; London, Royal Academy, The Girtin Collection, 1962, No. 102.
Bibliography: Baskett and Snelgrove, No. 10; Randall Davies, introd., *Caricature of To-day* (London, 1928), Pl. 5.

The scene is presumably the annual exhibition at 'new' Somerset House, Strand, the home of the Royal Academy between 1780 and 1836. Pictures are hung from floor to ceiling, taking up all available wallspace, a feature that is fully documented in J. H. Ramberg's well-known view of the 1787 exhibition.[1] As in the preceding drawing of a private art gallery, Rowlandson has allowed himself complete freedom to exaggerate the faces and figures of the visitors for comic effect. The background pattern of squares and rectangles gives particular emphasis to the billowing curves of their bellies and posteriors. The theme had been similarly treated in Gillray's *A Peep at Christie's*,[2] a satirical print of 1796 that Rowlandson almost seems to be imitating on a larger scale. As in many drawings from late in Rowlandson's career, colored washes are brushed over one another to model the forms, in addition to, or in place of, reinforcement with pen and vermilion ink.

1. The engraving of Ramberg's view by Pietro Martini is reproduced in William T. Whitley, *Artists and their Friends in England 1700–1799* (London, 1928), II, facing p. 78, and in Sidney C. Hutchison, *The History of the Royal Academy 1768–1968* (London, 1968), Pl. 15. 'Exhibition Room, Somerset House' is one of the subjects in *The Microcosm of London* (see above, No. 93).
2. *B.M. Satires*, No. 8888.

107. *Newbury Market Place, Berkshire. Ca. 1815–20.*

Pen and watercolor over pencil, on wove paper, 10 × 15⅞ in. (254 × 403 mm).
Inscribed in ink in Rowlandson's hand, lower left: NEWBERY BERKSHIRE
Provenance: Henry Jephson; Sir John Crampton; sold Christie's 28 June 1963
(Property of a Gentleman), lot 37, to Colnaghi; acquired 1963.
Exhibitions: London, Royal Institute of Painters in Water Colours, The English
Humourists in Art, 1889, No. 113.
Bibliography: Baskett and Snelgrove, No. 31.

This crowd scene is from the outset less ambitious than many of Rowlandson's
earlier compositions.[1] He has not bothered to mass the figures into carefully
balanced, interrelated groups; instead, they are lumped together in a rather care-
free fashion across the middle ground, with groups in the left and right fore-
ground serving as *repoussoirs*. There is little attempt at characterization, the
faces tending to be small and highly generalized. But the scene is strongly uni-
fied by the object of the crowd's attention, the man in the pillory of the Old
Guildhall.

The penwork on the figures may be compared with that in *The Road to
Fairlop Fair*, dated 1818, in the Victoria and Albert Museum,[2] of which there is
a preliminary sketch, dated 1815, in the Birmingham City Museum and Art Gal-
lery, and another finished version dated 1816.[3] Short, curving strokes are used;
the resulting outlines (except where vermilion is used for reinforcement) are
thin, wiry, and sometimes broken. Broad areas of pale gray wash are overlaid
with local tints of orange, yellow, and olive green.

1. It is not impossible, however, that this is a repetition of an earlier drawing.
2. Repr. Hayes, p. 205, Pl. 141.
3. Repr. Oppé, Pl. 89.

108. *Plymouth Dock. 1817.*

Pen and watercolor over pencil, on laid paper, 6⅞ × 11¾ in. (174 × 297 mm).
Signed and dated in ink, lower right: *Rowlandson 1817.*
Inscribed in ink in Rowlandson's hand, lower left: PLYMOUTH DOCK
Provenance: Colnaghi; acquired 1961.
Bibliography: Baskett and Snelgrove, No. 34.

Plymouth Dock follows a familiar compositional formula—a strong receding
diagonal, with buildings at either side serving as *repoussoirs*. The figure groups
are neatly disposed across the foreground. Scenery is rendered in the stylistic
idiom of Rowlandson's later drawings, although the penwork tends to be weak
and unincisive. Despite the carelessness in the delineation of certain figures,
there appears to be no reason to question the authorship or the genuineness of
the date next to the signature.

109. *The Vicar of Wakefield. 1817.*

Pen and watercolor over pencil, on wove paper, 6½ × 4⅝ in. (164 × 117 mm).
Falsely signed in ink, lower left: *T. Rowlandson*
Verso: tracing in pencil of the principal outlines.
Etched and published by Rudolph Ackermann as the frontispiece for Oliver
Goldsmith's *The Vicar of Wakefield*, 1 May 1817 (Grego, II, 356; Grolier, No. 40;
Tooley, No. 436); reissued by Ackermann in 1823.
Provenance: The Marquess of Sligo; Bronson Winthrop, his sale Parke Bernet
12 March 1945, lot 388; Selima Nahas; acquired 1974.
Bibliography: Baskett and Snelgrove, No. 333.

Rowlandson's illustrations to novels by Fielding, Smollett, and Sterne are today relatively unknown, the editions in which they appeared having become extremely rare. Most of the plates were uncolored line etchings executed in the 1790s, sometimes from designs by other artists such as G. M. Woodward or Richard Newton.[1] His illustrations to Goldsmith's *The Vicar of Wakefield* have enjoyed a much wider circulation. They were commissioned by Rudolph Ackermann, and the twenty-four plates for the edition of the *Vicar* published in 1817 and reissued in 1823 are hand-colored aquatints after Rowlandson's own designs. Fourteen of the original designs are in the Mellon Collection.[2] The designs for the frontispiece and for the well-known episode of 'the family picture' are exhibited.

Rowlandson has depicted the Vicar ('a character eminently calculated to inculcate benevolence, humanity, patience in sufferings, and reliance on Providence') as a youthful, plump, rather self-satisfied man in clerical dress, accompanied by his modishly dressed daughters, Olivia and Sophia. One of the daughters bestows a penny on a family of beggars, who are ugly but apparently not starving. This drawing and the following one show Rowlandson's tendency as a book illustrator to follow closely the incident described by the novelist, but to give comic exaggeration to human features and gestures.

1. For a brief but perceptive analysis of Rowlandson's achievement as a book illustrator, see Ronald Paulson, 'The Tradition of Comic Illustration from Hogarth to Cruikshank,' *Princeton Univ. Library Chronicle*, 35 (Autumn-Winter 1973–74), 51–55.
2. Baskett and Snelgrove, No. 333. Full, if largely uncritical, discussions of all the plates are provided in T. C. Duncan Eaves, 'Graphic Illustrations of the Principal English Novels of the Eighteenth Century,' Ph.D. Dissertation, Harvard University, 1944, pp. 274–76, 695–702; Edward C. J. Wolf, *Rowlandson and his Illustrations of Eighteenth Century English Literature* (Copenhagen, 1945), pp. 95–115. Robert H. Hopkins has recently offered a highly idiosyncratic interpretation in 'Social Stratification and the Obsequious Curve: Goldsmith and Rowlandson,' *Studies in the Eighteenth Century III*, ed. R. F. Brissenden and J. C. Eade (Toronto, 1976), pp. 55–71. In the British Museum there are pen-and-ink sketches for two of the plates (Nos. 22, 24).

110. *The Vicar of Wakefield: The Family Picture. 1817.*

> Pen and watercolor over pencil, on wove paper, 4½ × 7½ in. (114 × 190 mm).
> Falsely signed in ink, lower right: *T Rowlandson*
> Verso: tracing in pencil of the principal outlines.
> Etched and published by Rudolph Ackermann as Pl. 14 for Oliver Goldsmith's
> *The Vicar of Wakefield*, 1 May 1817 (Grego, II, 357–58; Grolier, No. 40; Tooley,
> No. 436); reissued by Ackermann in 1823.
> *Provenance:* The Marquess of Sligo; Bronson Winthrop, his sale Parke Bernet,
> 12 March 1945, lot 388; Selima Nahas; acquired 1974.
> *Bibliography:* Baskett and Snelgrove, No. 333.

See comments under No. 109. The drawing illustrates the famous passage in *The Vicar of Wakefield* in which the Primrose family

> after many debates . . . came to an unanimous resolution of being
> drawn together, in one large historical family piece. This would be
> cheaper, since one frame would serve for all; and it would be
> infinitely more genteel, for all families of any taste were now drawn in
> the same manner. As we did not immediately recollect an historical
> subject to hit us, we were contented to be drawn as independent
> historical figures.[1]

Here is a notable instance in which Goldsmith's sentimental comedy gives way to a gentle form of satire, and Rowlandson seized the opportunity to make the Primrose family's grandiose scheme an amusing parody of contemporary history painting. The episode had earlier served as the inspiration for Bunbury's *A Family Piece*, a satirical print of 1781 that Rowlandson himself copied and etched.[2]

1. *The Vicar of Wakefield* (London: Rudolph Ackermann, 1817), p. 96 (chapter XVI). The aquatint after Rowlandson's design is reproduced in color in Martin Hardie, *English Coloured Books* (London, 1906), facing p. 172.
2. *B.M. Satires*, No. 5921. Rowlandson's drawing, formerly in the collection of Henry S. Reitlinger, is reproduced in Gully, p. 439, Fig. 218. His etching was published in 1811 (Grego, II, 222).

111. *Portrait of Francesco Bartolozzi. Ca. 1815.* PLATE XXXIV

> Pen and watercolor over pencil, on wove paper, 10¼ × 8⅛ in. (260 × 207 mm);
> contemporary mount.
> Inscribed in pencil in Rowlandson's hand, lower left: *Fran. Bartolozzi*
> *Provenance:* T. E. Lowinsky (Lugt 2420a); Sir Eldred Hitchcock, sold Sotheby's
> 24 Feb. 1960, lot 9, to Maddison; sold Sotheby's 26 March 1975, lot 277, to
> Baskett and Day; acquired 1975.
> *Bibliography:* Baskett and Snelgrove, No. 259; Falk, p. 56.

Between 1778 and 1781, after the completion of his formal training, Rowlandson exhibited five small portraits at the Royal Academy. These were among his

very first public exhibits, but none of them can be positively identified today. During the 1780s he continued to make portrait drawings, including numerous whole-length studies of fashionable young women (see above, Nos. 23, 24). Two of his finest portraits from this period were of men: a masterful half length of George IV when Prince of Wales,[1] and the well-known full length of George Morland now in the British Museum.[2] Over the course of a long career, however, he seems to have produced relatively few serious portraits, and in later years he was more apt to make copies from prints.[3]

Rowlandson was doubtless well acquainted with Francesco Bartolozzi (1727–1815), but there is no assurance that this seemingly faithful likeness was taken from life. In 1802, after nearly forty years as a prolific artist and engraver in England, Bartolozzi left the country to become director of the academy of art in Lisbon. Rowlandson's portrait of him appears to have been executed some years after that date, and probably around the time when Rowlandson was becoming engrossed in the study of physiognomy and comparative anatomy (see below, No. 114). The technical interest of the drawing lies in the precise hatching around the eyes and in the use of parallel lines in addition to colored wash for modelling of facial contours.

1. Formerly in the collection of J. Leslie Wright; repr. Falk, facing p. 21.
2. Repr. Hayes, Pl. 38 (in color); Oppé, Pl. 20.
3. See A. P. Oppé, *English Drawings, Stuart and Georgian Periods . . . at Windsor Castle* (London, 1950), p. 88, Nos. 543, 544; Falk, facing p. 16.

112. *Portrait of George Michael Moser. Ca. 1815.*

Pen over traces of pencil, on wove paper, 5¾ × 5½ in. (145 × 140 mm).
Inscribed in ink, probably in Rowlandson's hand, across bottom: *R. Moser RA Keeper of the Royal Academy*
Provenance: G. W. Girtin; Thomas Girtin; Tom Girtin; John Baskett; acquired 1970.
Bibliography: Baskett and Snelgrove, No. 265.

George Michael Moser (1706–83), a Swiss who established himself in London as a gold chaser, enameller, and medallist, was appointed Keeper of the Royal Academy on its founding in 1768. Henry Angelo records in his *Reminiscences* that when Rowlandson was a student in the Academy drawing school, he

> once gave great offence, by carrying a pea-shooter into the life academy, and, whilst old Moser was adjusting the female model, and had just directed her contour, Rowlandson let fly a pea, which making her start, she threw herself entirely out of position, and interrupted the gravity of the study for the whole evening. For this offence, Master Rowlandson went near to getting himself expelled.[1]

81

This portrait of Moser is executed in the *caricatura* style of Pier Leone Ghezzi (see below, No. 113), whose influence on Rowlandson is particularly noticeable in drawings done about 1778–80. For several reasons, however, it seems more probable that this drawing was made long after Moser's death in 1783. The line does not exhibit the degree of variation in thickness found in most of the early drawings. Moreover, Rowlandson did not begin to use vermilion ink until the 1790s. Perhaps more revealing than these technical aspects is the character of the profile itself, which suggests Rowlandson's late interest in physiognomy and comparative anatomy (see below, No. 114).[2] The British Museum possesses a very similar but slightly stiffer version of this portrait (identically inscribed, not by Rowlandson) which is quite possibly a copy or tracing by another hand.[3]

1. *Reminiscences of Henry Angelo* (London, 1828–30), I, 262. See also *Angelo's Pic Nic; or, Table Talk* (London, 1834), p. 368.
2. If the inscription is in Rowlandson's hand, the fact that Moser is given the wrong first initial may be significant; it would seem to suggest that over a period of years Rowlandson had forgotten his correct name.
3. Repr. Hayes, p. 31, Fig. 20. Grego describes (II, 427) a drawing then owned by John West, of Bayswater, as follows: 'R. Moser, R. A., Keeper of the Royal Academy. A serious portrait, boldly executed, both outline and shadows put in with a reed pen, in the manner of Mortimer. Evidently a sketch made from life when Rowlandson was an Academy student.' As the British Museum version was acquired in 1870, Grego must have seen the Mellon version or possibly an earlier drawing from which the two versions known today derive.

113. *Three Full-length Figures of Men Talking. Ca. 1815.*

PLATE XXXV

Pen, on wove paper, 9⅜ × 7⅜ in. (238 × 186 mm).

Provenance: Iolo A. Williams; Colnaghi; acquired 1964.

Bibliography: Baskett and Snelgrove, No. 167.

In this drawing the influence of Pier Leone Ghezzi (1674–1755) is readily suggested by the exaggerated profiles of the three men and by the hatching technique used to indicate contour and shadow. Ghezzi was a Roman artist who drew portraits in *caricatura* of nearly all the notable visitors to his studio.[1] Between 1736 and 1747, twenty-five caricature portraits after Ghezzi and others were etched by Arthur Pond and published in London by John Boydell. Ghezzi was among those ridiculed by Hogarth in his famous print of *Characters and Caricaturas* (1743), but his impact on English artists proved to be considerable. When Reynolds travelled to Italy in 1750, he painted a number of caricature groups in the Ghezzi manner. Thomas Patch, who studied in Rome and lived there until settling in Florence in 1755, must have seen many of Ghezzi's caricatures, for his own satirical drawings very closely resemble Ghezzi's work. In addition to painting many caricature conversation pieces for Englishmen on the

Grand Tour, Patch etched two series of his caricature drawings from the years 1765–70, and these prints also found their way to England.[2] That Rowlandson was an inheritor of the *caricatura* tradition is evident not only from very early drawings, of which *The School of Eloquence* (etched and published in 1780) is a good example,[3] but also from much later drawings such as this one and the preceding one. Here Rowlandson may even be copying a work by Ghezzi or Patch.

1. See Michel N. Benisovich, 'Ghezzi and the French Artists in Rome,' *Apollo*, 85 (May 1967), 340–47, and George Kahrl, 'Smollett as a Caricaturist,' in *Tobias Smollett: Bicentennial Essays Presented to Lewis M. Knapp*, ed. G. S. Rousseau and P.–G. Boucé (New York, 1971), esp. pp. 172–80 and Pls. VI–XVII.
2. See F. J. B. Watson, 'Thomas Patch (1725–1782): Notes on his Life, Together with a Catalogue of his Known Works,' *Walpole Society*, 28 (1939–40), 26, 44–45.
3. The drawing is in the Royal Collection; repr. Hayes, p. 69, Pl. 5; Oppé, Pl. 1.

114. *A Tub Thumper. Ca. 1817–20.*

Pen and watercolor over pencil, on wove paper watermarked 1817, 12½ × 9¼ in. (317 × 235 mm).
Signed and dated in ink, lower left: *Rowlandson 1811.*

Provenance: Colnaghi; acquired 1965.
Exhibitions: London, P. and D. Colnaghi and Co., English Drawings and Watercolours, 1965, No. 27.
Bibliography: Baskett and Snelgrove, No. 186.

Rowlandson put dates on relatively few of his drawings, and some of those dates can be proved to be inaccurate. The present drawing is a case in point. Both the signature and the date ('Rowlandson 1811.') appear to be in his hand, but the paper is clearly watermarked '1817', indicating that the drawing must have been made in or after that year. Rowlandson sometimes added dates to drawings years after they had been executed, and it is clear that his memory could mislead him. Moreover, at the request of patrons who may have considered his early works to be more valuable, he seems to have been quite willing to inscribe an earlier than actual date. As a result of these practices, Rowlandson's dates must always be weighed against the evidence of style and costume (and watermark date, if present) before they are accepted as genuine.

Two other versions of this subject are known, both weaker drawings and almost certainly repetitions: one, falsely signed and dated 1801, in the Philadelphia Museum of Art, and the other, signed and dated 1812 by Rowlandson, in the Museum of Fine Arts, Boston, John T. Spaulding Collection.[1] *Methodist Preacher* (an evangelist preaching in a tub) is one of twenty-five plates etched by Rowlandson, after designs by G. M. Woodward, for the 1808 edition of G. A. Stevens's *A Lecture on Heads*.[2] Woodward's design, though only a simple vignette, may have suggested the subject to Rowlandson.

The drawing is noteworthy as showing Rowlandson's serious interest in

physiognomy—the art of discovering character or temperament from outward appearance, especially facial features. This interest revealed itself early on in Rowlandson's career, and towards the end of his life it became an engrossing study. In 1800 he etched twenty plates (after Woodward's designs) for *Le Brun Travest[i]ed, or Caricatures of the Passions*, published by Rudolph Ackermann.[3] These prints, as the title indicates, are a burlesque in modern terms of Charles Le Brun's *Méthode pour apprendre à dessiner les passions* (1667). The popular tradition of *l'expression des passions* goes further back to Giovanni della Porta's *De Humana Physiognomonia* of 1586. Rowlandson's awareness of the tradition doubtless owes much to J. C. Lavater's essays on physiognomy, first published at Geneva in 1775–78 and later translated into English. He was also acquainted with the phrenological theories of Franz Joseph Gall.

The aspect of the subject that particularly fascinated Rowlandson was the parallel between human and animal features. Around 1820 he embarked on an extensive series of drawings, frequently repeated, comparing human heads with those of animals or gargoyle-like monsters. Several albums of these drawings, as well as numerous separate sheets, are in public and private collections. *Comparative Anatomy. Resemblances between the Countenances, of Men and Beasts* is the title he gave to a large group of drawings in the Houghton Library at Harvard (Grenville Lindall Winthrop Bequest),[4] which also has a similar album of nine drawings in the William B. Osgood Field Collection. Another album, consisting of some sixty-four studies, with the same title, is in the British Museum,[5] and there is a fourth volume of fifteen drawings in the Art Museum of Princeton University. The Huntington Collection contains several single sheets of physiognomic and anatomical studies.[6] Watermarks show that the drawings were made between 1821 and 1825.

In physiognomic theory, ugliness is sometimes interpreted as an outward manifestation of evil. It may be tempting to think that the grotesque heads (especially that of the hooded foreground figure) in *A Tub Thumper* embody Rowlandson's commentary on the moral degeneracy of society, or at least of one level of society, but he probably intended no such criticism. The physical variety of the human animal in its metamorphosis from birth to death was enough to occupy his attention.

1. Repr. Bury, Pl. 66.
2. See Grego, II, 117–19; *B.M. Satires*, No. 11179.
3. Grego, II, 1–3; Grolier, No. 56; *B.M. Satires*, Nos. 9628–32.
4. The contents of the album are summarized in Paulson, pp. 33–34. See ibid., pp. 66–70, for an analysis of Rowlandson's comparative anatomy and its implications.
5. The drawings are listed in Laurence Binyon, *Catalogue of Drawings by British Artists . . . in the British Museum* (London, 1898–1907), III, 260–63.
6. Wark, Nos. 377, 464–66.

115. *A Consultation. Ca. 1815–20.*

> Pen and watercolor over pencil, on wove paper, 10⅞ × 8¾ in. (275 × 222 mm).
> Signed in ink, possibly by Rowlandson, lower right: *Rowlandson*
> Inscribed in ink in Rowlandson's hand, lower center: A CONSULTATION.
> Engraved (with variations) and published as an illustration in W. H. Harrison's
> *The Humourist* (London: Rudolph Ackermann, 1831), p. [12], with the title *The*
> *Doctors Puzzled* (Grego, II, 380; Grolier, No. 50).
> *Provenance:* Herbert L. Carlebach; John Fleming; acquired 1966.
> *Bibliography:* Baskett and Snelgrove, No. 249.

Rowlandson's drawings and prints relating to medicine constitute a distinctive sub-genre of his work. At all periods in his career he depicted learned physicians in consultation, fashionable quacks and apothecaries, patients being operated on (with disastrous results) or confined to wheelchairs by that ubiquitous eighteenth-century ailment, the gout.[1] Rowlandson himself seems to have enjoyed robust health until his last two years, and he found it easy to mock the medical profession and its pretensions.

Another version of this subject, inscribed by Rowlandson 'a Consultation' but signed and dated 1812 probably in a later hand, is in the Clements C. Fry Collection, Yale Medical Library. That drawing uses the same kind of thick, reinforced line and strong, layered washes of color; the left background consists of a mantelpiece decorated with bric-a-brac, and the two figures in the sickroom on the right are better drawn. A pen-and-ink drawing of the three doctors (outlines only), on paper watermarked 182[5?], is in the Huntington Collection.[3] The grotesque heads belong to Rowlandson's extensive series of physiognomic studies; see comments under No. 114.

1. See above, Nos. 29, 46, 48, 52, 95.
2. See William C. Butterfield, 'The Medical Caricatures of Thomas Rowlandson,' *Journal of the American Medical Association*, 224 (2 April 1973), 113–17; Morris Saffron, 'The Doctor Dissected; Twelve Medical Caricatures by Thomas Rowlandson,' foreword to a portfolio of Rowlandson's *Medical Caricatures* (New York: Editions Medicina Rara, [1971]).
3. Wark, No. 459.

116. *Serving Punch. Ca. 1815–20.*

> Pen and watercolor over pencil, on wove paper, 9⅝ × 13⅞ in. (245 × 352 mm).
> *Provenance:* W. A. Sillence; Randall Davies, his sale Sotheby's 12 Feb. 1947,
> lot 343; Mickelson's Inc.; acquired 1962.
> *Bibliography:* Baskett and Snelgrove, No. 241; Randall Davies, introd.,
> *Caricature of To-day* (London, 1928), Pl. 4.

The caricature drawing in which human heads (usually male) are massed together, row upon row, had become a familiar type by Rowlandson's time. The

basic form was established by Hogarth in his *Four Groups of Heads* (*A Chorus of Singers*, *The Laughing Audience*, *Scholars at a Lecture*, and *The Company of Undertakers*), dating from 1732–37, and was elaborated in his well-known *Characters and Caricaturas* of 1743.[1] John Hamilton Mortimer, who strongly influenced Rowlandson's early work, provided an immediate model in his drawing of *Choir and Orchestra* (1779).[2]

Serving Punch is a late example of Rowlandson's experiments in the form, an assemblage of grotesques having an affinity with the heads in the two preceding drawings in the exhibition. Another version of the subject (present location unknown) was in the Jules S. Bache Sale at Kende Galleries, New York, on 19–21 April 1945, lot 451, and there is a stronger version, possibly the original, in the Huntington Collection.[3]

1. Repr. Ronald-Paulson, *Hogarth's Graphic Works*, rev. ed. (New Haven, 1970), II, Pls. 133, 136, 154–55, 174.
2. In the Royal Collection; repr. in the exhibition catalogue by Benedict Nicolson, *John Hamilton Mortimer ARA 1740–1779* (London, 1968), No. 98. The drawing was etched twice.
3. Wark, No. 375; repr. Paulson, p. [52], Fig. 9. These two versions have both been given the title *The Ugly Club*.

117. *An Old Coquette Outstood her Market. Ca. 1815–20.*
Pen and watercolor over pencil, on wove paper, 6⅝ × 5⅛ in. (169 × 129 mm); contemporary mount.
Inscribed in ink in Rowlandson's hand on mount below drawing: *An Old Coquette outstood her Market.*
Verso: pencil sketch of a woman; color splashes.
Provenance: Sir Bruce Ingram (Lugt 1405a, on verso of mount), his sale (Part II) Sotheby's 9 Dec. 1964, lot 344, to C. Powney; Hazlitt, Gooden and Fox Ltd.; acquired 1976.
Bibliography: Baskett and Snelgrove, No. 344.

Most of Rowlandson's grotesque single figures are male. The 'old coquette' is a rare specimen, just the opposite of the healthy, full-bodied wenches who represent his favorite female type. She also appears in a drawing entitled *Teatime* in the Harry Elkins Widener Collection at Harvard. Her emaciated features and tawdry costume tell the story of a woman who staunchly refuses to accept her age and makes a fool of herself by carrying on as if nothing had changed. The drawing was probably made not long before 1820, when Rowlandson became preoccupied with comparative anatomy. Notice the ingenious use of the dress pattern to suggest the rib cage underneath.

118. *A Sporting Cove. Ca. 1815–20.*

> Pen and watercolor over pencil, on wove paper, 7¾ × 6 in. (197 × 152 mm).
> Verso: color splashes.
> *Provenance:* E. Parsons and Sons; Thomas Girtin; Tom Girtin; John Baskett;
> acquired 1970.
> *Exhibitions:* Royal Society of Arts, Humorous Art, n.d., No. 4.
> *Bibliography:* Baskett and Snelgrove, No. 125; Sutton, pp. 282, 285, Fig. 24.

Although the 'old coquette' in the preceding drawing seems to come from Rowlandson's imagination, the 'sporting cove' is doubtless a real (if unidentified) person. This is a masterful portrait of cunning and brutality, shrewdly observed in the angle of the hat, the furrowed brow and half-shut eyes, the twisted smile. He is the sort of devious character who would have showed up regularly at the cockpit and the gambling den, armed with a trick or two to better his luck. The brilliance of the characterization is in no small part due to Rowlandson's understanding of the man's habits and haunts. In style and presentation, the portrait may be compared with that of Bob Kennett in the British Museum,[1] a drawing which probably dates from the time of Kennett's trial and execution for forgery in 1813. Here the brush is used for subtle modelling of the face; the washes lack the transparency of Rowlandson's tints in his earlier works, but the effect is calculated and assured.

> 1. Repr. Bury, Pl. 58.

119. *A Potter Going Out. Ca. 1815–20.*

> Pen and watercolor over pencil, on wove paper, 6 × 9½ in. (152 × 240 mm).
> Inscribed in ink in a later hand on label below drawing: *A Potter going out.*
> Verso: pencil sketch of a shipwreck (not by Rowlandson).
> *Provenance:* William Esdaile (Lugt 2617, monogram in ink, lower right),
> purchased at Rowlandson's sale Sotheby's 23 June 1828, lot 101 (with nine other
> drawings); Colnaghi; acquired 1964.
> *Bibliography:* Baskett and Snelgrove, No. 94.

The bright, fresh tints (light blue, pink, yellow, tan) in this Morlandesque country scene cannot be considered characteristic of Rowlandson's later drawings, but similar coloring occurs in a surprisingly large number of works executed during the final decade of his career. As a very late example, there is the drawing in the Museum of Fine Arts, Boston, entitled *Off to the Fair*, signed and dated 1822, in which the figures and buildings are tinted with pale, transparent pastel washes, and the white of the paper is used positively. Here the penwork has become relatively flaccid, uniform, inexpressive. The drawing was formerly owned by the well-known contemporary collector William Esdaile, who purchased it at Rowlandson's sale in 1828.

120. *Bodmin Moor, North Cornwall. Ca. 1825.* PLATE XXXVI

Pen and watercolor over pencil, on wove paper watermarked 1825, 11⅛ × 16⅞ in.
(284 × 429 mm).
Signed in ink, lower right: *Rowlandson*
Inscribed in ink in Rowlandson's hand, lower center: *North Cornwall*
Provenance: Henry S. Reitlinger (Lugt 2274a, on verso); A. J. Rowe; Agnew;
acquired 1969.
Exhibitions: London, Thos. Agnew and Sons, 96th Annual Exhibition of
Watercolours and Drawings, 1969, No. 23.
Bibliography: Baskett and Snelgrove, No. 16.

In 1822 a group of eighteen landscapes, mostly of scenes in Cornwall, was
etched by Rowlandson and published as *Rowlandson's Sketches from Nature.*[1]
The power and vitality of this landscape are all the more remarkable for its
having been drawn during the last two years of Rowlandson's life, when he is
said to have been seriously ill.[2] Only a handful of drawings from this time are
known to survive, and none nearly so large or ambitious as this one.[3] It would
be pleasant to think of the man seated in the cart as Rowlandson himself, look-
ing back at the Cornish countryside he had so often sketched on convivial jaunts
to Hengar House. Though the figure is not Rowlandson, the drawing is an ef-
fective summation of his landscape idioms. The curling rococo penwork en-
livens picturesque scenery that hints at the rugged grandeur of the sublime.

1. Abbey, *Scenery*, No. 33; Grego, II, 373; Tooley, No. 426. The etchings were
 aquatinted by J. C. Stadler and colored by hand.
2. The obituary in the *Gentleman's Magazine*, 97 (June 1827), 564–65, records the
 death of 'that veteran humourist, Mr. Thomas Rowlandson' 'at his apartments in
 the Adelphi, after a severe illness of two years, aged 70.' He died on 21 April 1827.
3. A study of types of laughter, on paper watermarked 1825, was formerly in the
 Gilbert Davis Collection. Two sheets, one in the album of *Comparative Anatomy*
 at Harvard (Winthrop Bequest) and the other in a similar album at Princeton, are
 watermarked 1825 (see above, No. 114). The Huntington Collection has an
 outline drawing, entitled *The Band*, on paper watermarked 1826 (Wark, No. 478).

Bibliography

This is primarily a bibliography of books, articles, and passages in books written about Rowlandson. The first section contains a list of letters and other manuscripts in Rowlandson's hand, along with some contemporary documents of biographical interest. It has seemed worthwhile also to include in this section printed sources written by those who knew, or could have known, Rowlandson personally. The works included in the second section have been selected according to their interest for Rowlandson's later reputation as an artist or for their intrinsic merit as contributions to Rowlandson scholarship.

A more comprehensive Rowlandson bibliography, which lists numerous exhibition, auction, and dealers' catalogues, is given in John Baskett and Dudley Snelgrove, *The Drawings of Thomas Rowlandson in the Paul Mellon Collection* (London, 1977).

I. *CONTEMPORARY SOURCES*

Letters and documents:

Rowlandson to James Heath, 1 March 1804. British Museum Add. MS. 29300, f. 26 (repr. Falk, facing p. 36).

Rowlandson to Henry Angelo, 18 July 1815. Collection of the late Hugh D. Auchincloss, Washington, D.C. (printed above, pp. xiii–xiv, for the first time).

Rowlandson to Mrs. Landon, 16 November 1820. Henry E. Huntington Library and Art Gallery (repr. Hayes, pp. 24–25).

Francis Rimbault's account with Rowlandson for 1822. Houghton Library, Harvard University, MS. Typ. 100.2 (repr. Hayes, p. 10).

Students' Register of the Royal Academy Schools, recording Rowlandson's admission on 6 November 1772 (see Sidney C. Hutchison, 'The Royal Academy Schools, 1768–1830,' *Walpole Society*, vol. 38 [1962], p. 138).

Royal Academy catalogues of annual exhibitions, listing Rowlandson's addresses between 1775 and 1787 (printed in Algernon Graves, *The Royal Academy of Arts* [London, 1905–06], VI, 384).

Ratebooks, recording Rowlandson's residences in the Adelphi (London County Council, *Survey of London*, vol. 18, *The Strand*, by George Gator and E. P. Wheeler [London, 1937], pp. 110, 112).

Joseph Farington, Diary, *sub* 8 June 1796 (typescript, p. 656, in the British Museum Print Room; quoted in Hayes, p. 23).

Will of Jane Rowlandson, née Chevalier (Rowlandson's aunt), died April 1789. Public Record Office Prob. 10/3112.

Will of Thomas Rowlandson, died 21 April 1827. Public Record Office Prob. 10/4946.

Printed sources (in chronological order):

European Magazine, 5 (April 1784), 248.

Morning Chronicle, 27 May 1784, 1 June 1784.

St. James's Chronicle, 17–19 May 1785.

Morning Herald, 25 Dec. 1786.

Malcolm, J[ames] P[ellier]. *An Historical Sketch of the Art of Caricaturing*. London, 1813. Pp. 114–17, 149.

Hardcastle, Ephraim [W. H. Pyne]. *Wine and Walnuts; or, After Dinner Chit-Chat*. London, 1823. II, 323–27.

―――. *Somerset House Gazette, and Literary Museum*. London, 1824. I, 410; II, 222, 347, 360.

'Biography. Rowlandson.' *London Literary Gazette and Journal of Belles Lettres, Arts, Sciences, &c.*, No. 536 (28 April 1827), pp. 267–68.

'Mr. Rowlandson' [obituary]. *Gentleman's Magazine*, 97 (June 1827), 564–65.

Sotheby's. *Catalogue of the Valuable Library of the late Burges Bryan, Esq. . . . To which Are Added the Books of Prints, &c. of the late Thomas Rowlandson, Esq.* [Catalogue of auction held 18–21 June 1828].

―――. *A Catalogue of the Valuable Collection of Prints, Drawings & Pictures of the late Distinguished Artist, Thomas Rowlandson, Esq.* [Catalogue of auction held 23–26 June 1828].

Angelo, Henry. *Reminiscences of Henry Angelo*. London, 1828–30. I, 233–40, 254, 262, 389, 410–11, 415–16; II, 1–2, 47, 100–01, 105, 209, 222–23, 253, 292–95, 324–26, 337–38, 403, 439. Reprinted, introd. Lord Howard de Walden, notes and a memoir by H. Lavers-Smith, London and Philadelphia, 1904.

―――. *Angelo's Pic Nic; or, Table Talk*. London, 1834. Pp. 144–46, 193–94, 368.

Adolphus, John. *Memoirs of John Bannister, Comedian*. London, 1839. I, 287, 289–91.

Smith, John Thomas. *A Book for a Rainy Day: or, Recollections of the Events of the last Sixty-six Years*. London, 1845. Pp. 103–04, 173. 2nd ed., London, 1845; reprinted, London, 1905.

II. *LATER SOURCES*

Baskett, John, and Dudley Snelgrove. *The Drawings of Thomas Rowlandson in the Paul Mellon Collection*. London, 1977.

Bates, William. 'Thomas Rowlandson, Artist.' *Notes and Queries*, 4th Series, 4 (2 Oct. 1869), 278–79.

Baum, Richard M. 'A Rowlandson Chronology.' *Art Bulletin*, 20 (Sept. 1938), 237–50.

Bell, David, introd. *Tro Trwy Gymru . . . : A Tour through Wales, Drawings by Thomas Rowlandson from the Sir John Williams Collection in the National Library of Wales*. Cardiff, 1947.

Binyon, Laurence. *English Water-colours*. London, 1933. 'Figure Painters: Rowlandson,' pp. 67–78.

Birnbaum, Martin. *Jacovleff and Other Artists*. New York, 1946. 'Thomas Rowlandson,' pp. 99–123.

Boston Public Library, Print Department. *A Rowlandson Letter*. Two reports, dated 5 April 1974 and 10 June 1975; compiled by Sinclair H. Hitchings and Catherine Nicholson; distributed by the Print Department.

Brinton, Selwyn. *The Eighteenth Century in English Caricature*. London, 1904. 'The Comedy of Life,' pp. 74–96.

Bury, Adrian. *Rowlandson Drawings*. London, 1949.

Buss, R. W. *English Graphic Satire and its Relation to Different Styles of Painting, Sculpture, and Engraving*. London, privately printed, 1874. 'Thomas Rowlandson,' pp. 133–37.

Butterworth, Walter. 'Thomas Rowlandson, Caricaturist and Satirist.' *Manchester Quarterly*, 39 (July 1920), 179–92.

Coke, Desmond. *Confessions of an Incurable Collector*. London, 1928. 'Rowlandson,' pp. 96–114; 'Collecting Rowlandson,' pp. 115–46; 'Museums,' pp. 153–60; *et passim*.

Davies, Randall. *Chats on Old English Drawings*. London, 1923. Pp. 89–93, 164–67.

Davis, Frank. 'A Rowlandson Sketch-Book.' *Illustrated London News*, 193 (20 Aug. 1938), 338.

———. 'Rowlandson the Poet.' *Illustrated London News*, 191 (27 Nov. 1937), 960.

———. 'Wigstead—Thomas Rowlandson's Artist Friend.' *Illustrated London News*, 189 (12 Sept. 1936), 452.

Davis, Gilbert, introd. *Watercolours & Drawings by Thomas Rowlandson*. London: Arts Council of Great Britain, 1950. [Catalogue of a travelling exhibition of drawings from the Gilbert Davis Collection].

Demus, Otto. 'Eine Rembrandt-Travestie von Thomas Rowlandson.' *Phoebus*, 2 (1948–49), 80–81.

D[obson], A[ustin]. 'Rowlandson, Thomas.' *Dictionary of National Biography*, ed. Leslie Stephen and Sidney Lee. Reissue, London, 1908–09. XVIII, 357–59.

Doin, Jeanne. 'Thomas Rowlandson.' *Gazette des Beaux-Arts*, 4ᵉ période, 1 (March 1909), 287–96; (April 1909), 376–84.

Earp, Thomas Wade. 'Rowlandson.' *Drawing and Design*, New Series, 1 (Nov. 1926), 167–73.

Falk, Bernard. *Thomas Rowlandson: His Life and Art, A Documentary Record*. London, [1949].

Finberg, A. J. *The English Water Colour Painters*. London, [1906]. 'Rowlandson & Blake,' pp. 114–21.

Fraxi, Pisanus [Henry Spencer Ashbee]. *Bibliography of Prohibited Books*. London, 1877–85. Reprinted, New York, 1962. II, xlix–li, 346–98.

George, Mary Dorothy. *Catalogue of Political and Personal Satires . . . in . . . the British Museum*. V–IX. London, 1935–49.

———. *Hogarth to Cruikshank: Social Change in Graphic Satire*. London and New York, 1967. Pp. 13, 17, 28, *et passim*.

Gibbs, A. H. *Rowlandson's Oxford*. London, 1911.

Gibson, Frank. 'The Landscape Element in Rowlandson's Art.' *International Studio*, 65 (Oct. 1918), 111–17.

Goncourt, Edmond and Jules de. *L'Art du dix-huitième siècle*. Paris, 1873–74. II, 255.

Grego, Joseph. 'Our Graphic Humorists—Thomas Rowlandson.' *Magazine of Art*, New Series, 26 (Feb. 1902), 166–69; (March 1902), 210–14.

G[rego], J[oseph]. 'Rowlandson's Tour in a Post Chaise 1782.' *The Graphic Summer Number*, 1891 [vol. 43].

Grego, Joseph. *Rowlandson the Caricaturist*. 2 vols. London, 1880.

Grolier Club. *Catalogue of Books Illustrated by Thomas Rowlandson Exhibited at the Grolier Club, November 2 to November 23 [1916]*. New York, 1916. [Limited large-paper edition includes a list of original drawings exhibited.]

Gully, Anthony Lacy. 'Thomas Rowlandson's *Doctor Syntax*.' Ph.D. Dissertation, Stanford University, 1972.

Hamilton, Harlan W. *Doctor Syntax: A Silhouette of William Combe, Esq*. London, 1969. Pp. 243–61.

Hardie, Martin. *English Coloured Books*. London, 1906. 'Thomas Rowlandson,' pp. 159–76; 'Appendix III, Coloured Books with Plates by Rowlandson,' pp. 315–18.

———. 'The Tours of Dr. Syntax: Rowlandson's Unpublished Illustrations.' *Connoisseur*, 18 (Aug. 1907), 214–19.

———. *Water-colour Painting in Britain*. London, 1966–68. 'Thomas Rowlandson and Other Figure and Animal Painters,' I, 205–19.

Hartmann, Idis Birgit. *Thomas Rowlandson—Stilphasen in seinen Landschaftsdarstellungen* [Doctoral dissertation, University of Tübingen]. Tübingen, privately printed, 1971.

Hayes, John. *A Catalogue of the Watercolour Drawings by Thomas Rowlandson in the London Museum*. London, 1960.

———. *Rowlandson Watercolours and Drawings*. London, 1972.

Heintzelman, Arthur W. *The Watercolor Drawings of Thomas Rowlandson from the Albert H. Wiggin Collection in the Boston Public Library*. New York, 1947.

Huysmans, J.–K. *Certains*. Paris, 1889. Pp. 85–88.

———. *L'Art moderne*. Paris, 1883. 'Le Salon officiel de 1881,' pp. 203–06.

Image, Selwyn. 'The Serious Art of Thomas Rowlandson.' *Burlington Magazine*, 14 (Oct. 1908), 5–16.

Johnson, E. D. H. 'Special Collections at Princeton: V. The Works of Thomas Rowlandson.' *Princeton Univ. Library Chronicle*, 2 (Nov. 1940), 7–20.

Klingender, F. D. *Hogarth and English Caricature*. London and New York, 1944. Pp. ix, xi, 22–23, *et passim*.

Lynch, Bohun. *A History of Caricature*. London, 1926. Pp. 55–60.

Maraini, Antonio. 'Alcuni acquarelli inediti di Thomas Rowlandson.' *Dedalo*, 1 (Dec. 1920), 476–85.

Mather, Frank Jewett. 'Some Drawings by Thomas Rowlandson.' *Print-Collector's Quarterly*, 2 (Dec. 1912), 389–406.

Mayne, Jonathan. 'Rowlandson at Vauxhall.' *Victoria and Albert Museum Bulletin*, 4 (July 1968), 77–81.

Mayor, A. Hyatt. *Prints & People: A Social History of Printed Pictures*. New York, 1971. Figs. 205, 602–06, and facing pages.

———. 'Rowlandson's England.' *Metropolitan Museum of Art Bulletin*, New Series, 20 (Feb. 1962), 185–201.

Meier, Kurt von. *The Forbidden Erotica of Thomas Rowlandson*. Los Angeles, 1970.

Nagler, G. K. 'Rowlandson, Thomas.' *Neues allgemeines Künstler-Lexicon*. Munich, 1835–52. XIII, 503–05.

Oppé, A. P. *English Drawings, Stuart and Georgian Periods . . . at Windsor Castle*. London, 1950. Pp. 85–88.

———. 'Rowlandson, the Surprising.' *Studio*, 124 (Nov. 1942), 147–58.

———. *Thomas Rowlandson: His Drawings and Water-colours*. London, 1923.

P[apworth], W[yatt]. 'Thomas Rowlandson, Artist.' *Notes and Queries*, 4th Series, 4 (31 July 1869), 89–91.

———. 'Thomas Rowlandson.' *Notes and Queries*, 4th Series, 4 (4 Dec. 1869), 490.

Paulson, Ronald. 'The Artist, the Beautiful Girl, and the Crowd: The Case of Thomas Rowlandson.' *Georgia Review*, 31 (Spring 1977), 121–59.

———. *Rowlandson: A New Interpretation*. London and New York, 1972.

———. 'The Tradition of Comic Illustration from Hogarth to Cruikshank.' *Princeton Univ. Library Chronicle*, 35 (Autumn–Winter 1973–74), 35–60. (Also published in *George Cruikshank: A Revaluation*, ed. Robert L. Patten. Princeton, 1974, pp. 35–60.)

R., S. 'Thomas Rowlandson, Artist.' *Notes and Queries*, 4th Series, 4 (11 Sept. 1869), 224–25.

Riely, John C. *Samuel Collings' Designs for Rowlandson's Picturesque Beauties of Boswell.* New York, privately printed for The Johnsonians, 1975.

Rienaecker, Victor. 'Rowlandson Prints.' *Print Collector's Quarterly*, 19 (Jan. 1932), 11–30.

Roe, F. Gordon. 'Rowlandson and Landscape.' *Old Water-colour Society's Club, Annual Volume*, 25 (1947), 21–30.

————. *Rowlandson: The Life and Art of a British Genius.* Leigh-on-Sea, 1947.

Rothrock, O. J. 'Rowlandson Drawings at Princeton: Introduction and Checklist.' *Princeton Univ. Library Chronicle*, 36 (Winter 1974–75), 87–110.

Royal Institute of Painters in Water Colours. *The English Humourists in Art.* London, 1889. [Catalogue of the exhibition held at the Institute in June 1889].

Samuels, Allen M. 'Rudolph Ackermann and *The English Dance of Death.*' *Book Collector*, 23 (Autumn 1974), 371–80.

Schiff, Gert. *The Amorous Illustrations of Thomas Rowlandson.* [New York], 1969.

Sitwell, Osbert. *Famous Water-colour Painters VI—Thomas Rowlandson.* London, 1929. (Introduction, rev. and enl., in *Sing High! Sing Low!* London, 1944, pp. 117–35.)

Sitwell, Sacheverell. *Narrative Pictures: A Survey of English Genre and its Painters.* London, 1937. Pp. 13–17.

Sparrow, Walter Shaw. *British Sporting Artists from Barlow to Herring.* London, 1922. 'Morland, Rowlandson, and Ibbetson,' pp. 145–63.

Stephens, F. G. 'Thomas Rowlandson, the Humourist.' *Portfolio*, 22 (1891), 141–48.

Summerson, John. *The Microcosm of London, by T. Rowlandson & A. C. Pugin.* London, 1943; rev. ed., London, 1947.

Sutton, Denys. 'The Cunning Eye of Thomas Rowlandson.' *Apollo*, 105 (April 1977), 277–85.

Thornber, Harry. 'Thomas Rowlandson and his Works.' *Manchester Quarterly*, 5 (April 1886), 97–117.

Tooley, R. V. *English Books with Coloured Plates 1790 to 1860.* London, 1954. Pp. 20–25, 328–54.

V[ollmer], H[ans]. 'Rowlandson, Thomas.' *Allgemeines Lexikon der bildenden Künstler*, ed. Ulrich Thieme and Felix Becker. Leipzig, 1907–50. XXIX, 127–28.

Waller, A. Bret, and James L. Connelly. 'Thomas Rowlandson and the London Theatre.' *Apollo*, 86 (Aug. 1967), 130–34.

Wark, Robert R. *Drawings by Thomas Rowlandson in the Huntington Collection.* San Marino, 1975.

————. *Ten British Pictures 1740–1840.* San Marino, 1971. 'Rowlandson's "Mrs. Siddons Rehearsing,"' pp. 67–77.

————. *Rowlandson's Drawings for a Tour in a Post Chaise.* San Marino, 1964.

————. *Rowlandson's Drawings for The English Dance of Death.* San Marino, 1966.

Williams, Iolo A. *Early English Watercolours and Some Cognate Drawings by Artists Born not later than 1785.* London, 1952. Pp. 137–42, 195–96.

Wilton, Andrew. *British Watercolours 1750 to 1850.* Oxford, 1977. 'Thomas Rowlandson,' pp. 16–21.

Wolf, Edward C. J. *Rowlandson and his Illustrations of Eighteenth Century English Literature.* Copenhagen, 1945.

Wright, Thomas. *A History of Caricature & Grotesque in Literature and Art.* London, 1865. Pp. 480–88.

Young, Art. *Thomas Rowlandson.* New York, 1938.

Zigrosser, Carl. '"The Microcosm of London."' *Print Collector's Quarterly*, 24 (April 1937), 145–72.

Plates

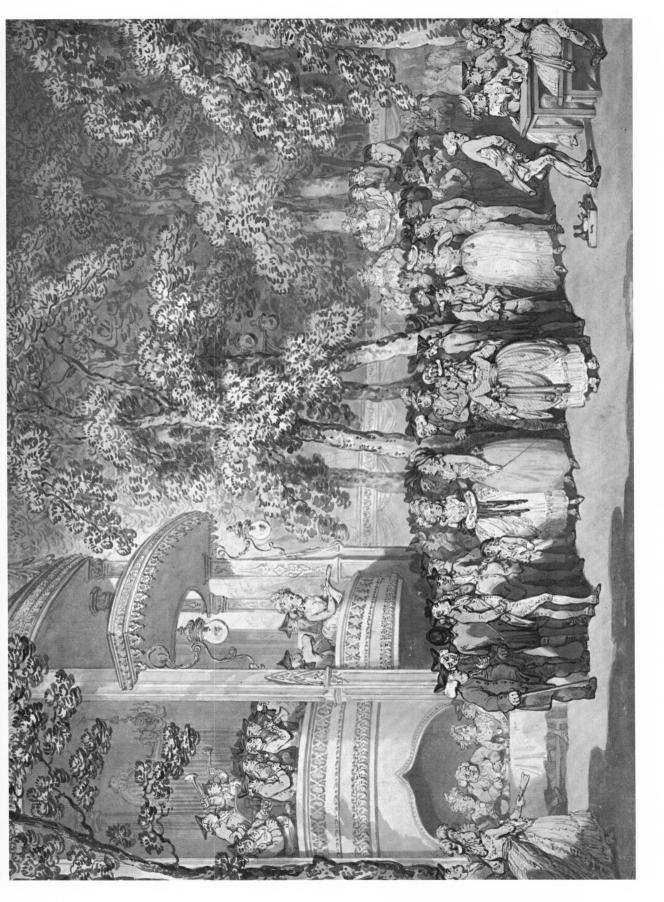

PLATE I *Vauxhall Gardens* (Catalogue No. 4)

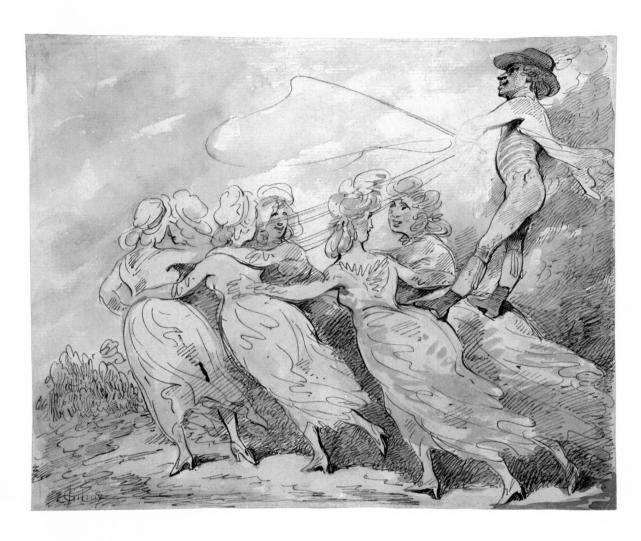

PLATE II *A Man Driving a Team of Six Girls* (Catalogue No. 1)

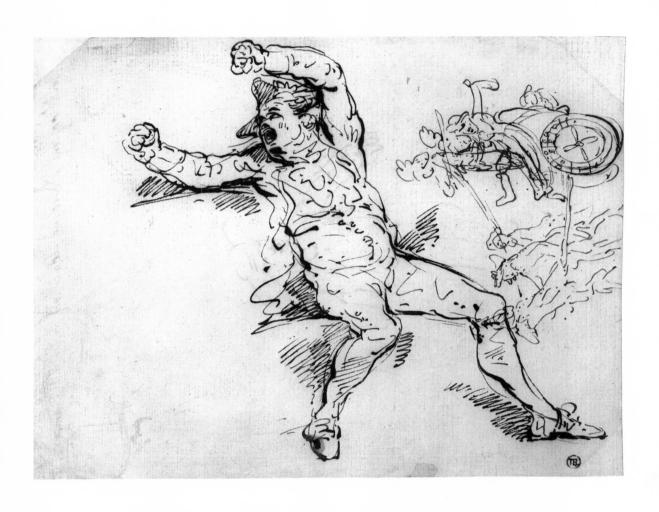

PLATE III *Study of a Shouting Man* (Catalogue No. 2)

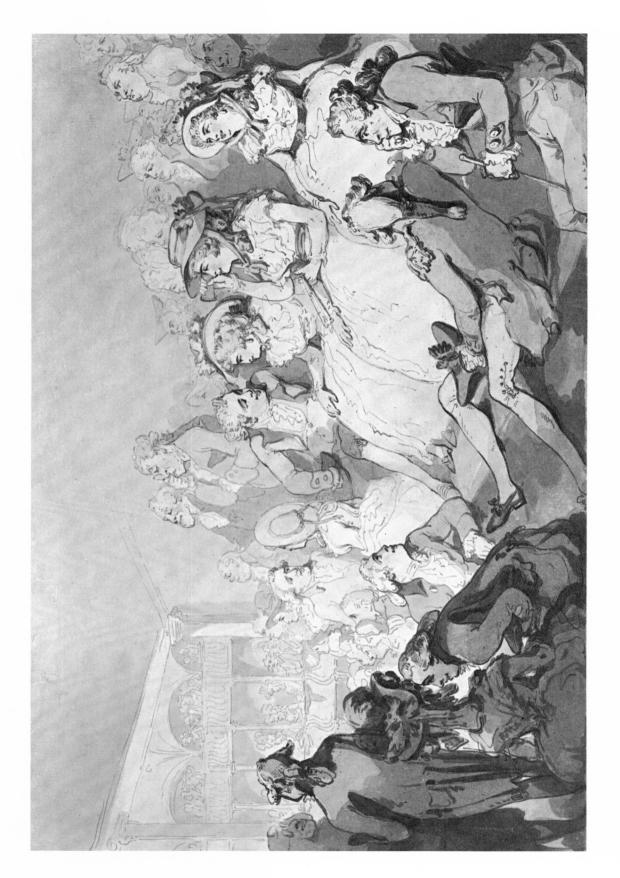

PLATE IV *An Audience Watching a Play* (Catalogue No. 5)

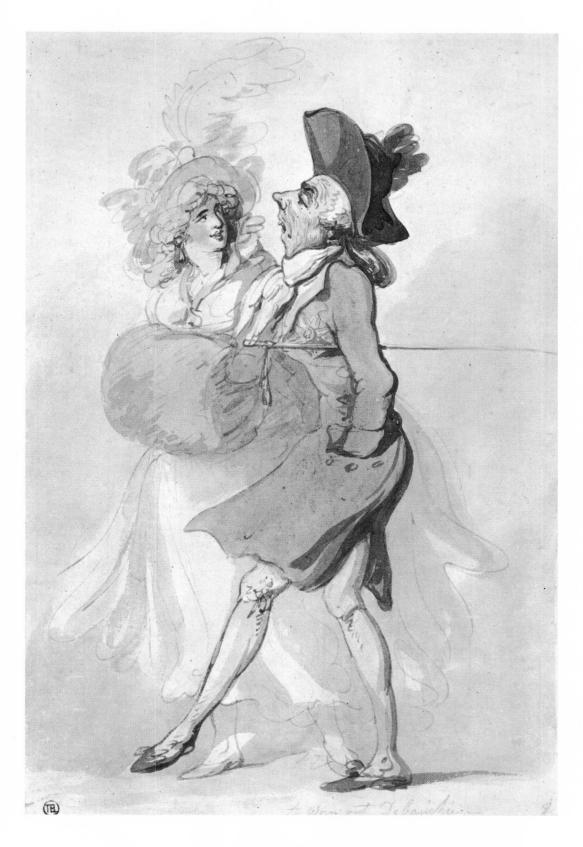

PLATE V *A Worn-out Débauché* (Catalogue No. 38)

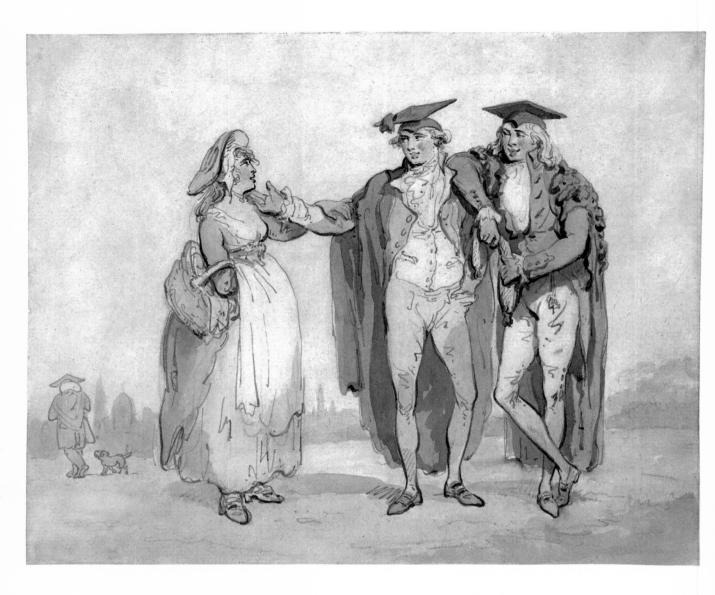

PLATE VI *Bucks of the First Head* (Catalogue No. 6)

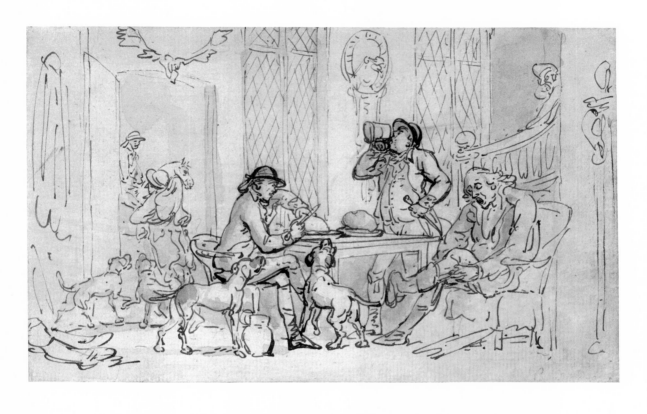

PLATE VII *The Hunt Breakfast* (Catalogue No. 12)

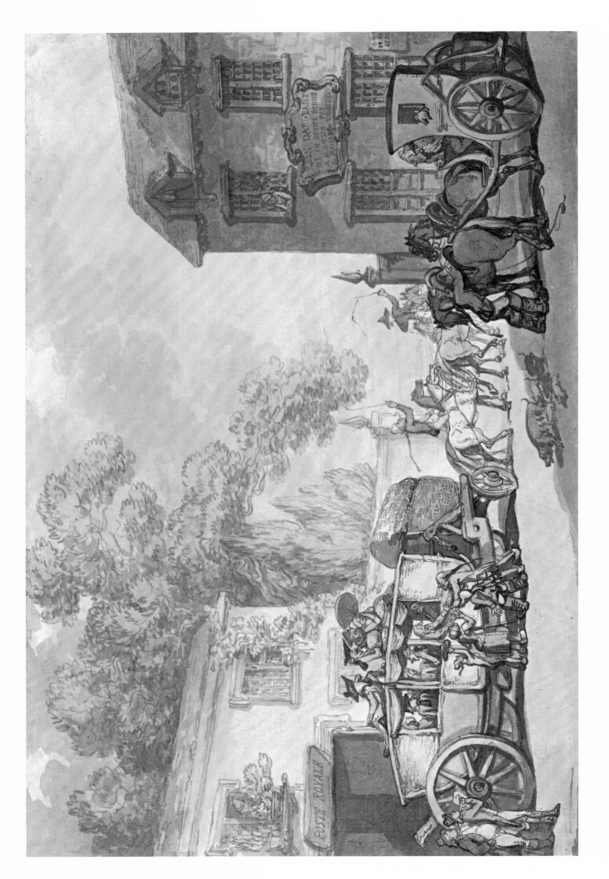

PLATE VIII *Travelling in France* (Catalogue No. 42)

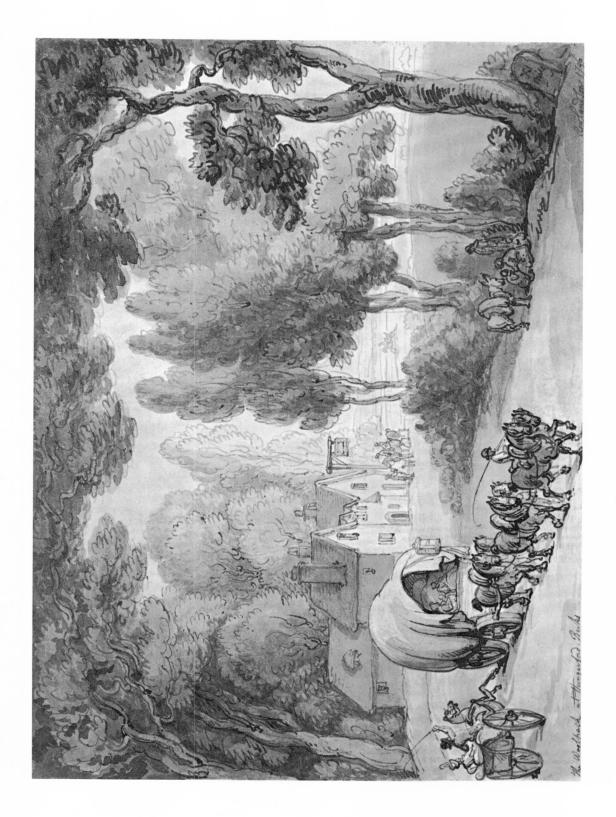

PLATE IX *The Woolpack Inn at Hungerford, Berks* (Catalogue No. 69)

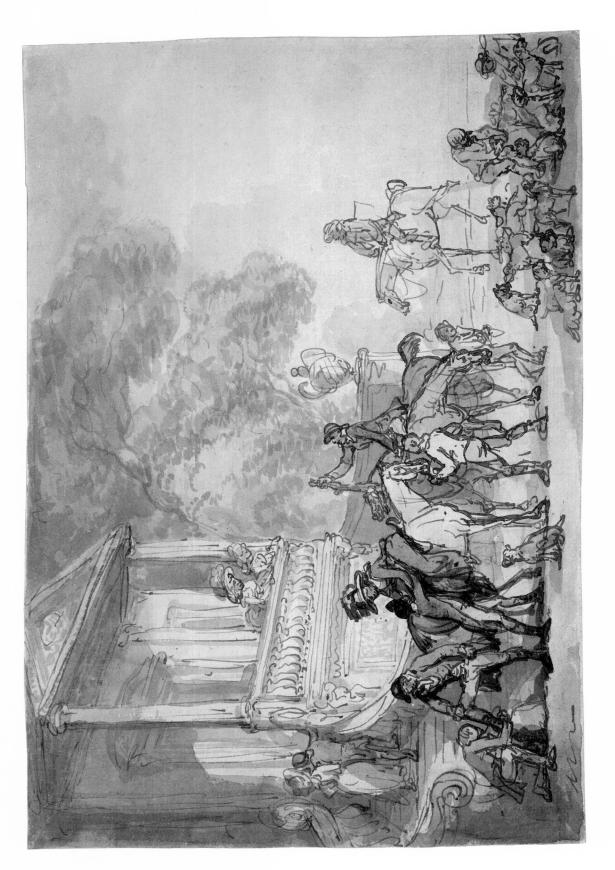

PLATE X *The Return* (Catalogue No. 13)

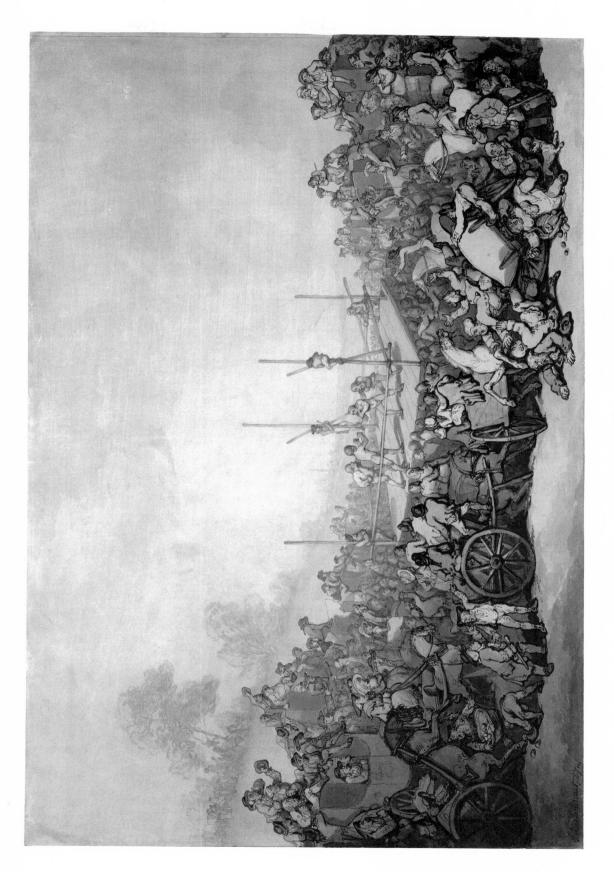

PLATE XI *The Prize Fight* (Catalogue No. 14)

PLATE XII *The Register Office* (Catalogue No. 78)

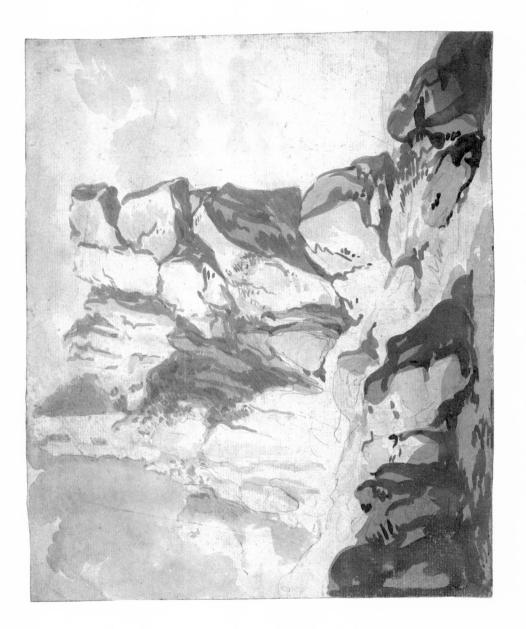

PLATE XIII *Tintagel Castle, Cornwall* (Catalogue No. 15)

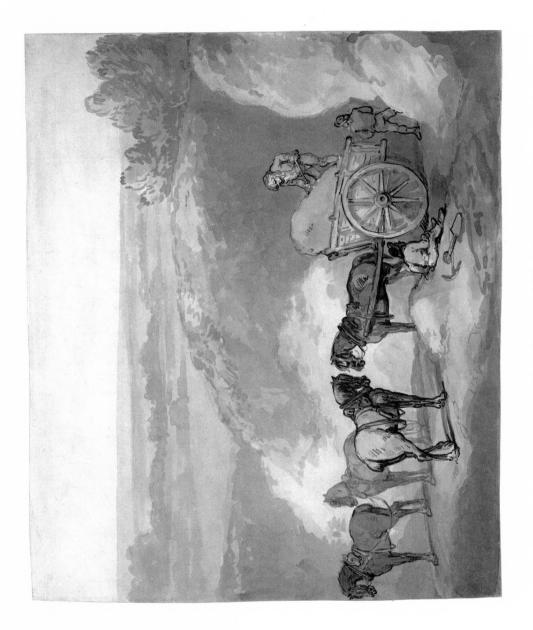

PLATE XIV *Loading Sand* (Catalogue No. 16)

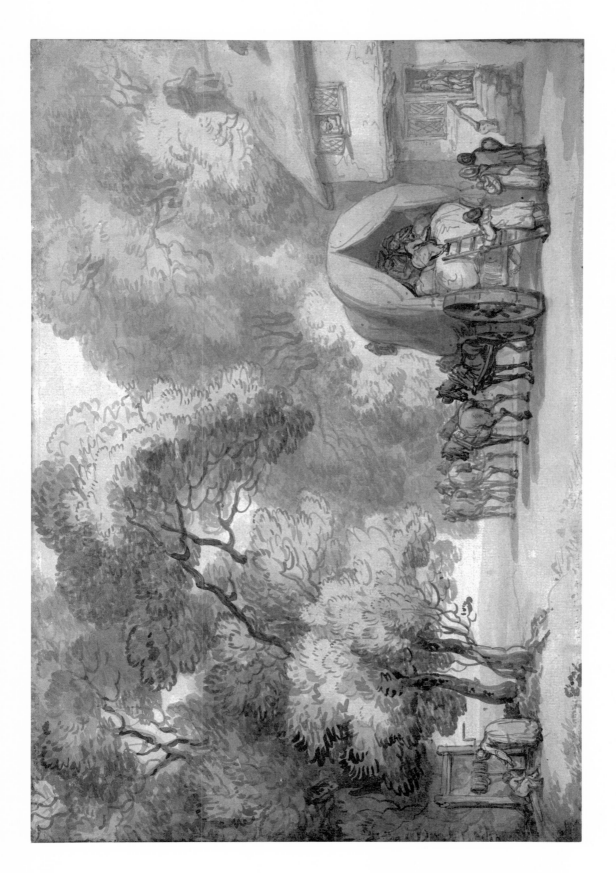

PLATE XV *A Carrier's Waggon* (Catalogue No. 17)

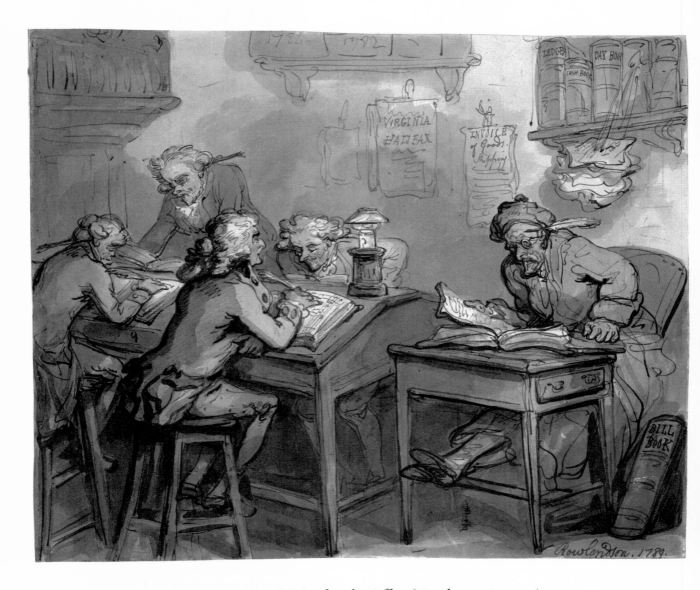

PLATE XVI *A Merchant's Office* (Catalogue No. 22)

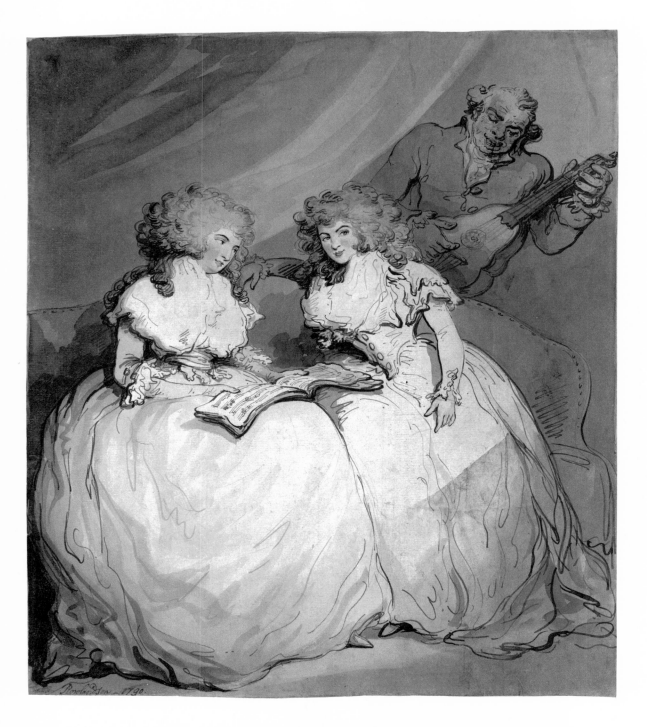

PLATE XVII *The Duchess of Devonshire and Lady Duncannon* (Catalogue No. 23)

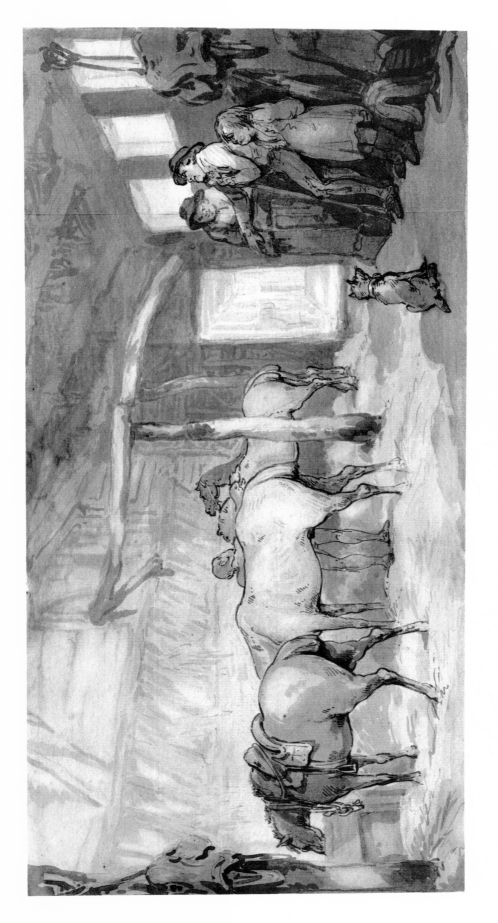

PLATE XVIII *The Stable of an Inn* (Catalogue No. 25)

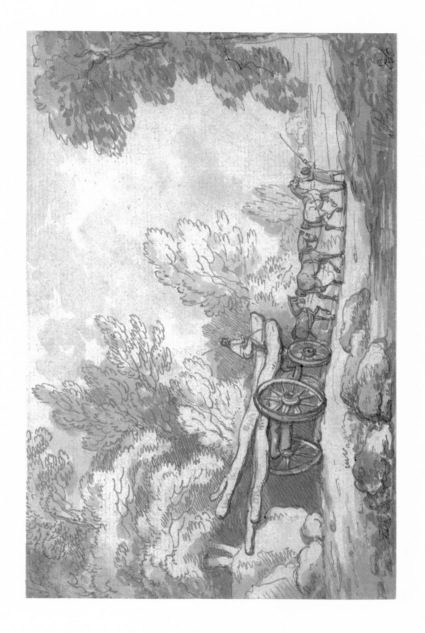

PLATE XIX *A Timber Waggon* (Catalogue No. 28)

PLATE XX *View of the Market Place at Juliers in Westphalia* (Catalogue No. 33)

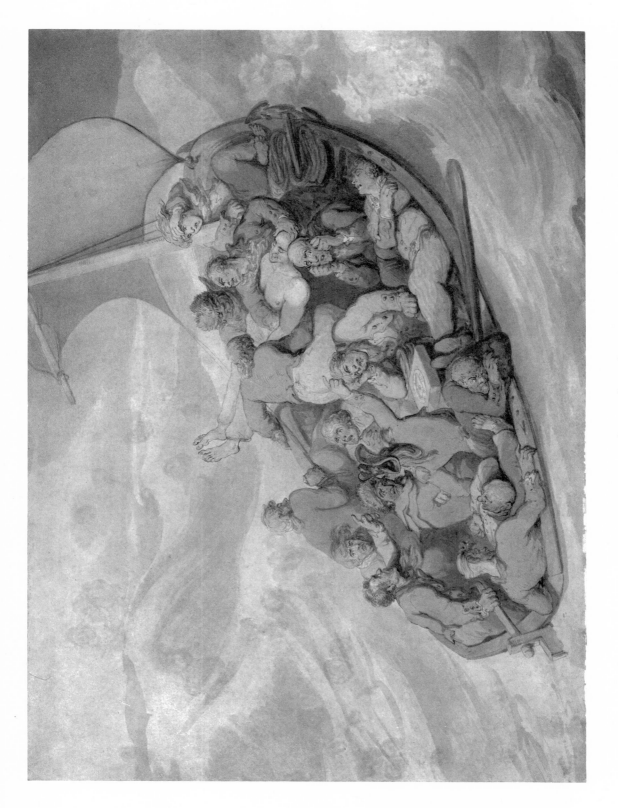

PLATE XXI *Distress* (Catalogue No. 36)

PLATE XXII *The Connoisseurs* (Catalogue No. 37)

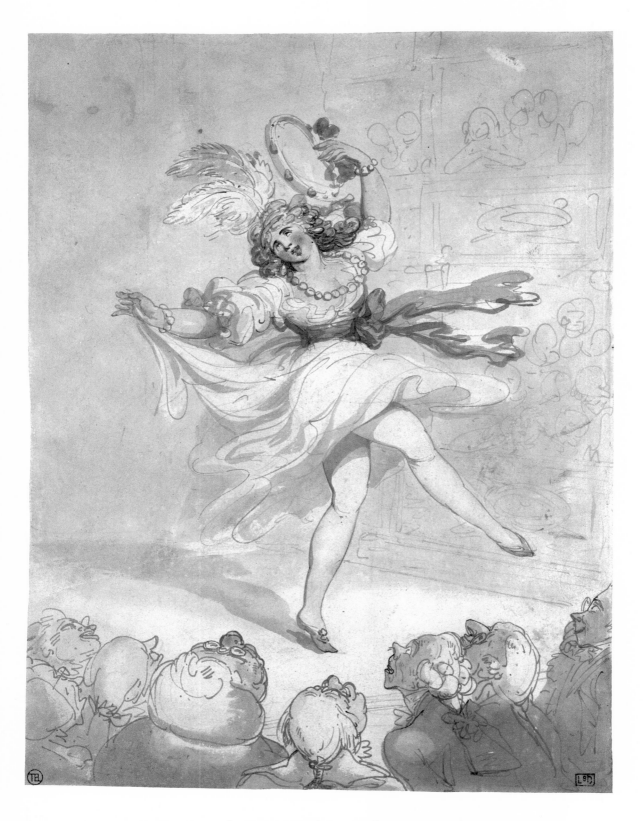

PLATE XXIII *Female Dancer with a Tambourine* (Catalogue No. 39)

PLATE XXIV *Scenes at Bath: Overturn on the Circus Hill* (Catalogue No. 52)

PLATE XXV *The South Gate, Exeter* (Catalogue No. 65)

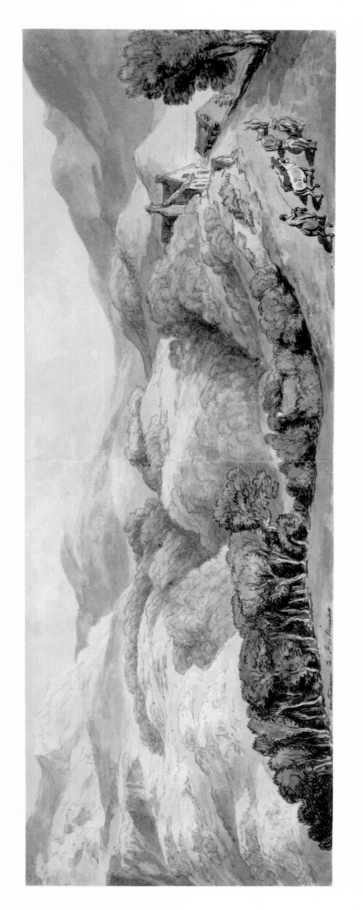

PLATE XXVI *Entrance to Festiniog, North Wales* (Catalogue No. 61)

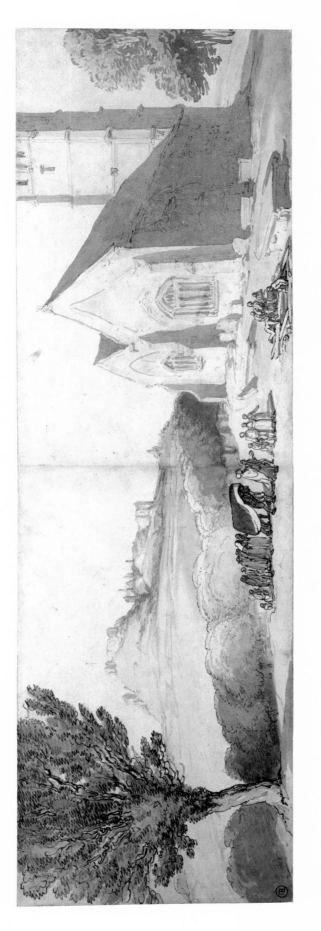

PLATE XXVII *A Burial at Carisbrooke, Isle of Wight* (Catalogue No. 62)

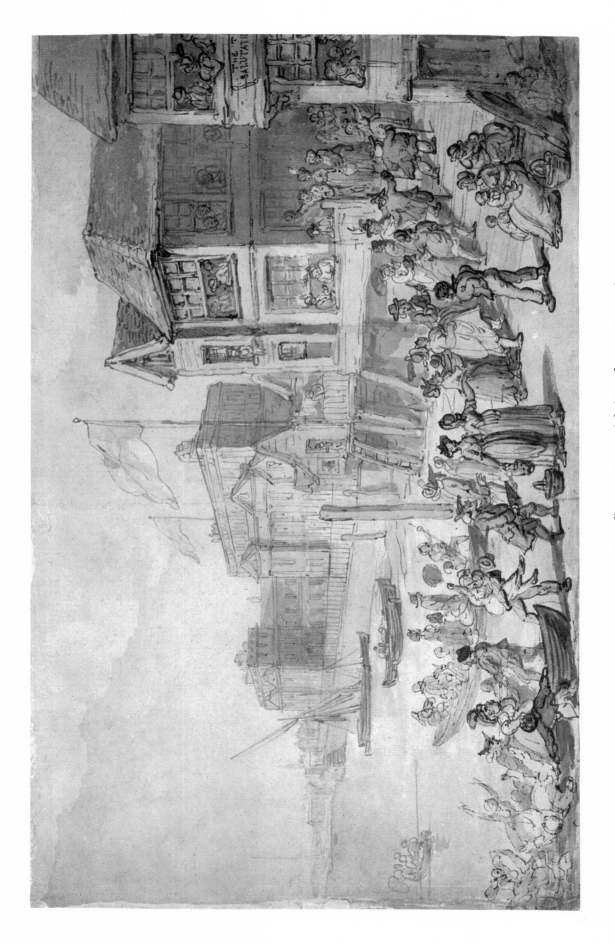

PLATE XXVIII *Landing at Greenwich* (Catalogue No. 72)

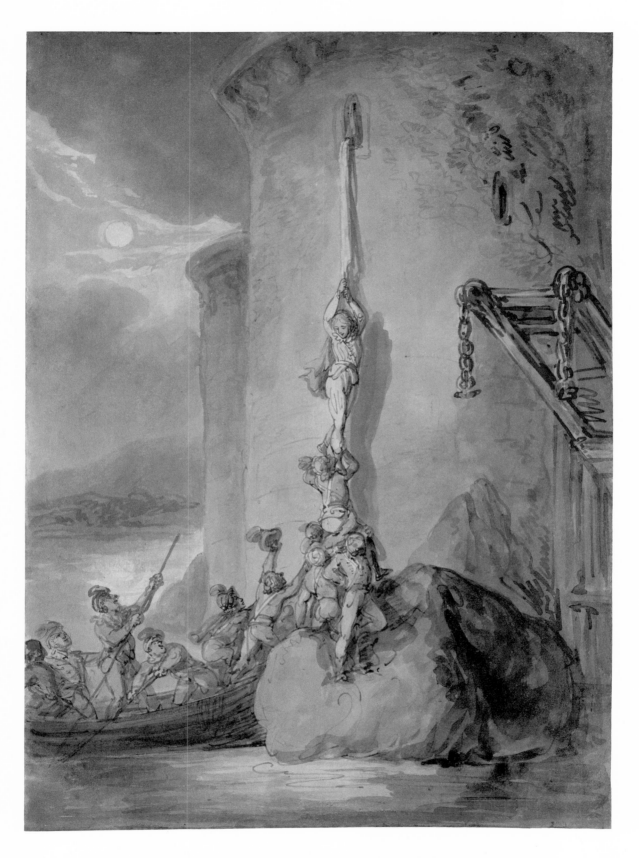

PLATE XXIX *A Military Escapade* (Catalogue No. 73)

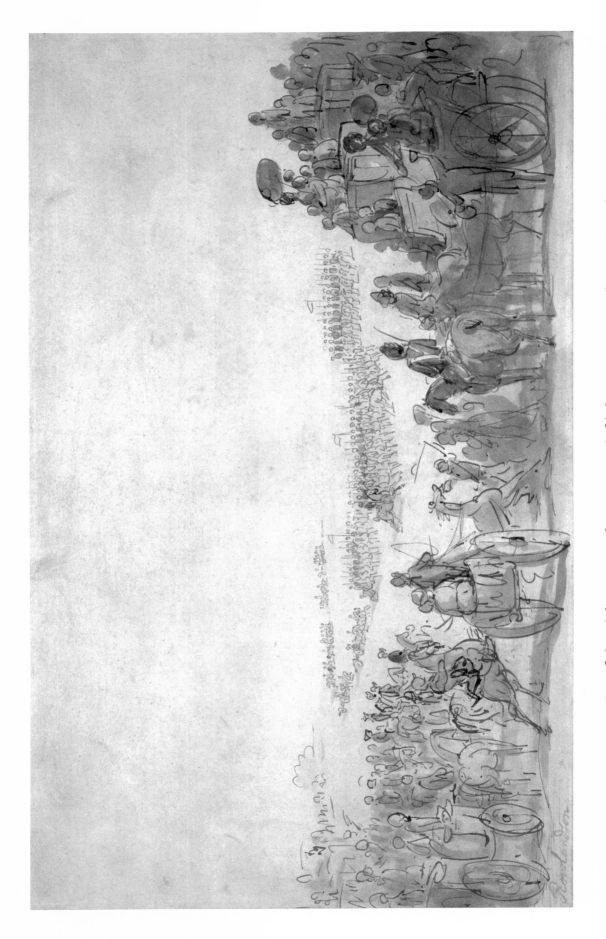

PLATE XXX *Review of the Light Horse Volunteers on Wimbledon Common, 5 July 1798* (Catalogue No. 74)

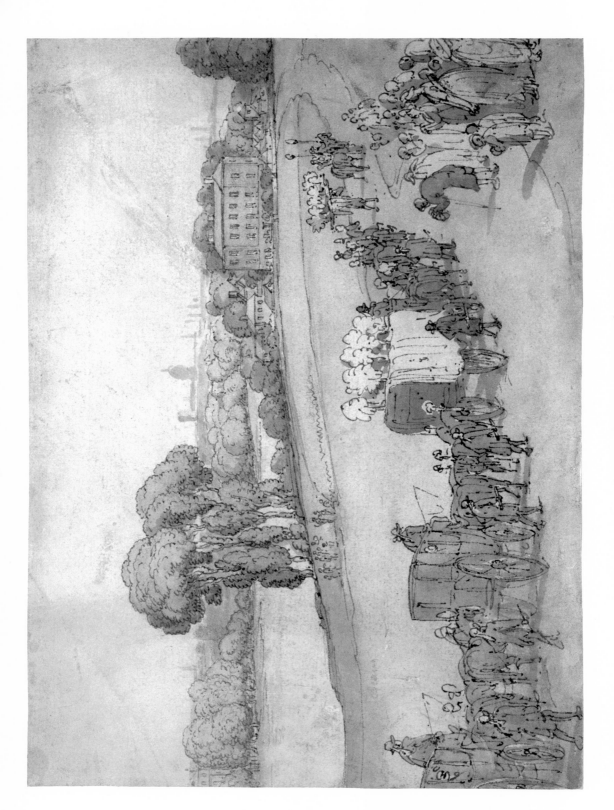

PLATE XXXI *A Funeral Procession* (Catalogue No. 85)

Amuses himself at an Inn with reading the Poetry on the Windows

PLATE XXXII *Doctor Syntax Copying the Wit of the Window* (Catalogue No. 94)

PLATE XXXIII *Death and the Débauché* (Catalogue No. 103)

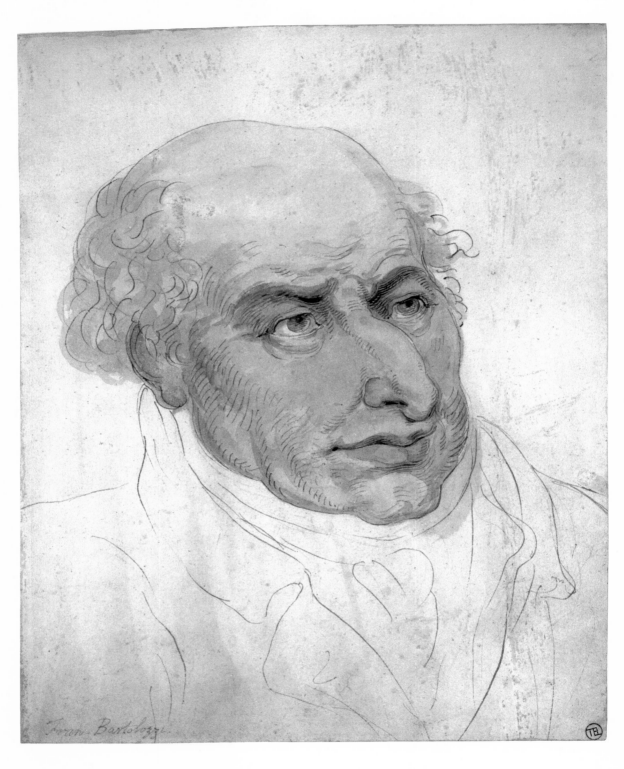

PLATE XXXIV *Portrait of Francesco Bartolozzi* (Catalogue No. 111)

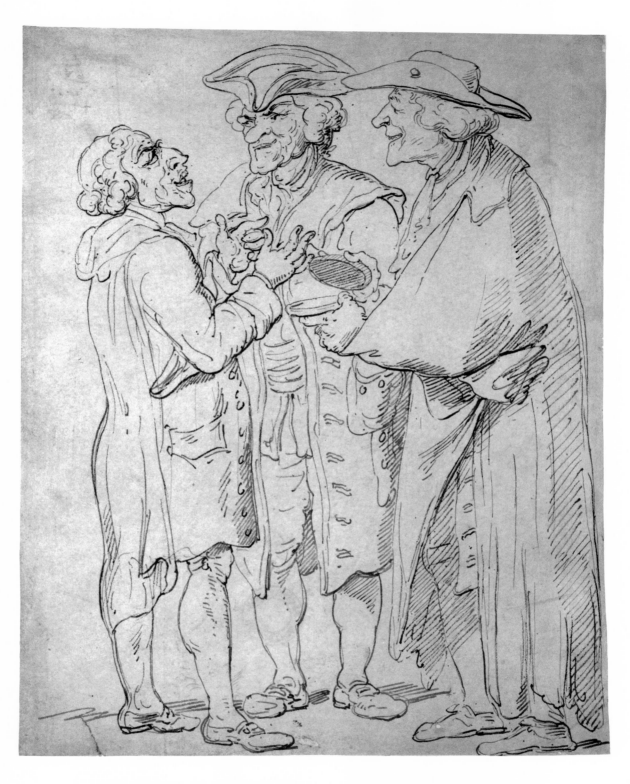

PLATE XXXV *Three Full-length Figures of Men Talking* (Catalogue No. 113)

PLATE XXXVI *Bodmin Moor, North Cornwall* (Catalogue No. 120)